D0903863

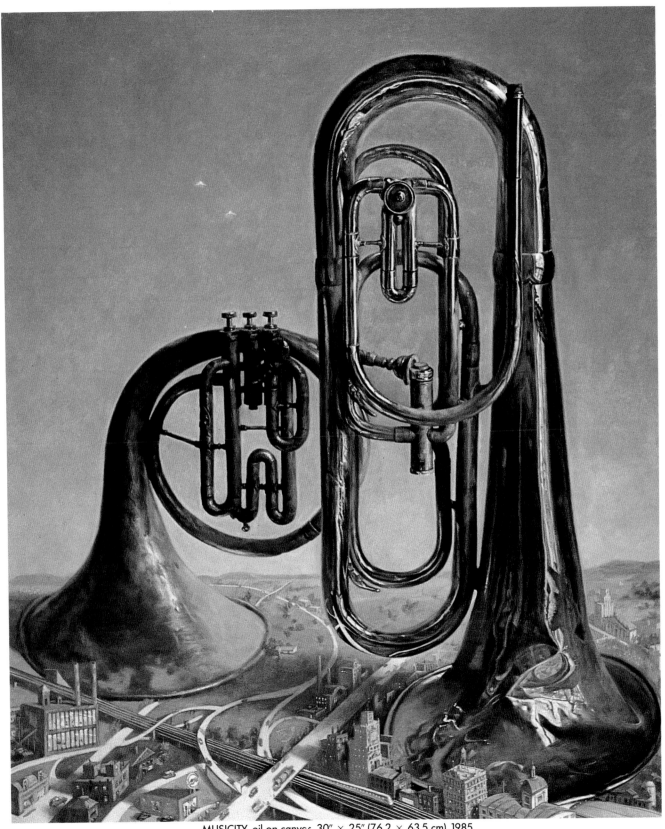

MUSICITY, oil on canvas, 30" × 25" (76.2 × 63.5 cm), 1985

LIGHT
FOR THE ARTIST

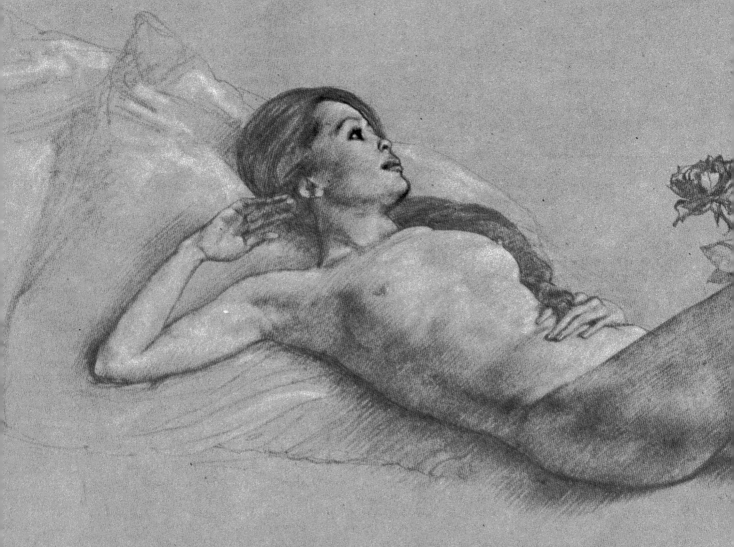

Ted Seth Jacobs

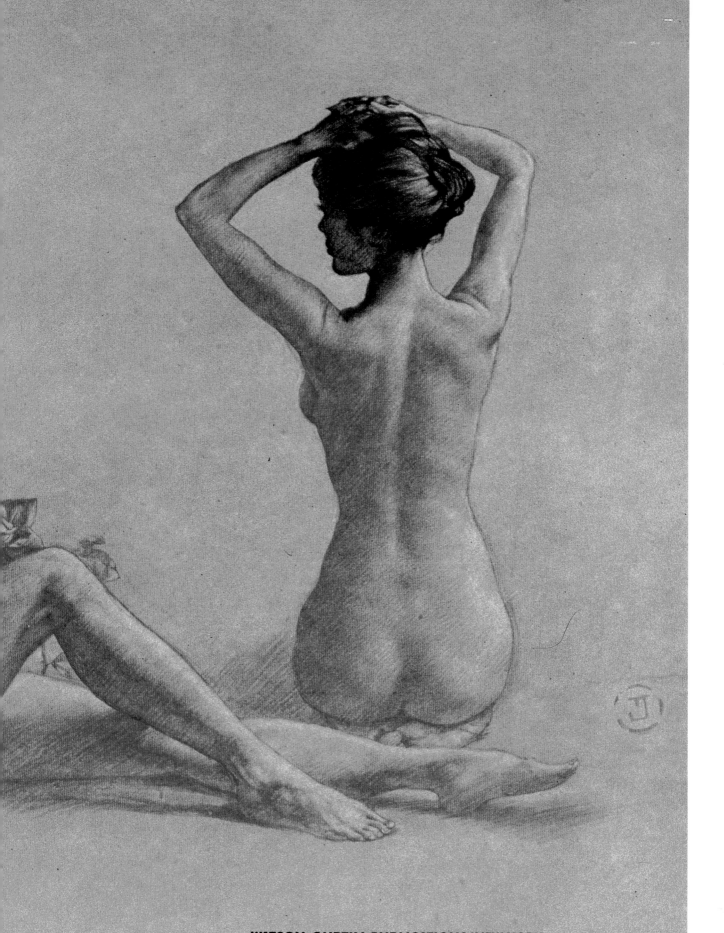

WATSON-GUPTILL PUBLICATIONS/NEW YORK

Previous Page:
MINORI WITH ROSES,
black and sanguine conte
on prepared paper, 16″ × 24″
(40.6 × 61.0 cm), 1976

Pages 6–7:
CHANTAL,
black conte on
prepared paper,
17″ × 15″
(43.2 × 38.1 cm), 1986

Copyright © 1988 by Ted Seth Jacobs

First published 1988 in the United States and Canada by Watson-Guptill
Publications, a division of Billboard Publications, Inc., 1515 Broadway,
New York, N.Y. 10036.

Library of Congress Cataloging-in-Publication Data

Jacobs, Ted Seth.
 Light for the artist / by Ted Seth Jacobs.
 p. cm.
 Includes index.
 ISBN 0-8230-0760-X : $27.50
 1. Art—Technique. 2. Light in art. 3. Light. 4. Visual
perception. I. Title.
N7430.5.J33 1988 87-34497
750′.1′8—dc19 CIP

Distributed in the United Kingdom by Phaidon Press Ltd., Littlegate
House, St. Ebbe's St., Oxford

Manufactured in Japan

First Printing, 1988

1 2 3 4 5 6 7 8 9 / 93 92 21 90 89 88

\mathbf{M}y fellow students
are encouraged to develop and improve upon
what I have presented here, and so this short study
is dedicated to all those artists of the future
who will become members of a very ancient fraternity,
by carrying forward the search for
an understanding of light.

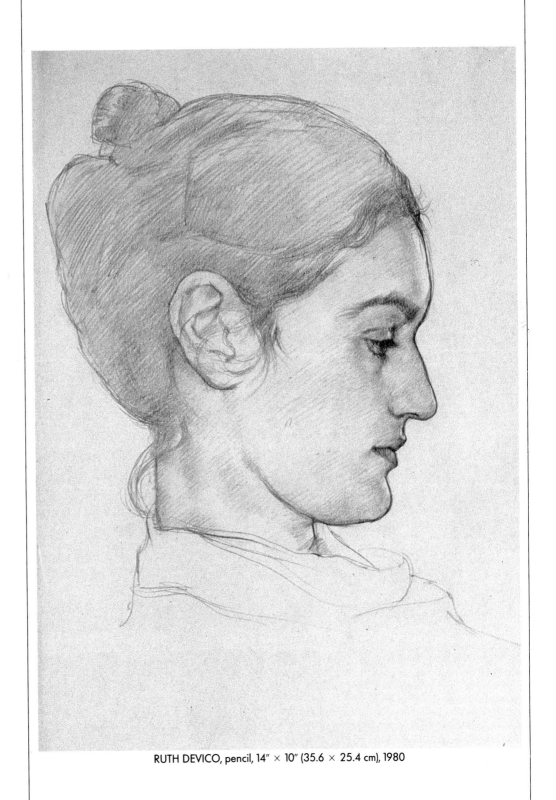

RUTH DEVICO, pencil, 14″ × 10″ (35.6 × 25.4 cm), 1980

CONTENTS

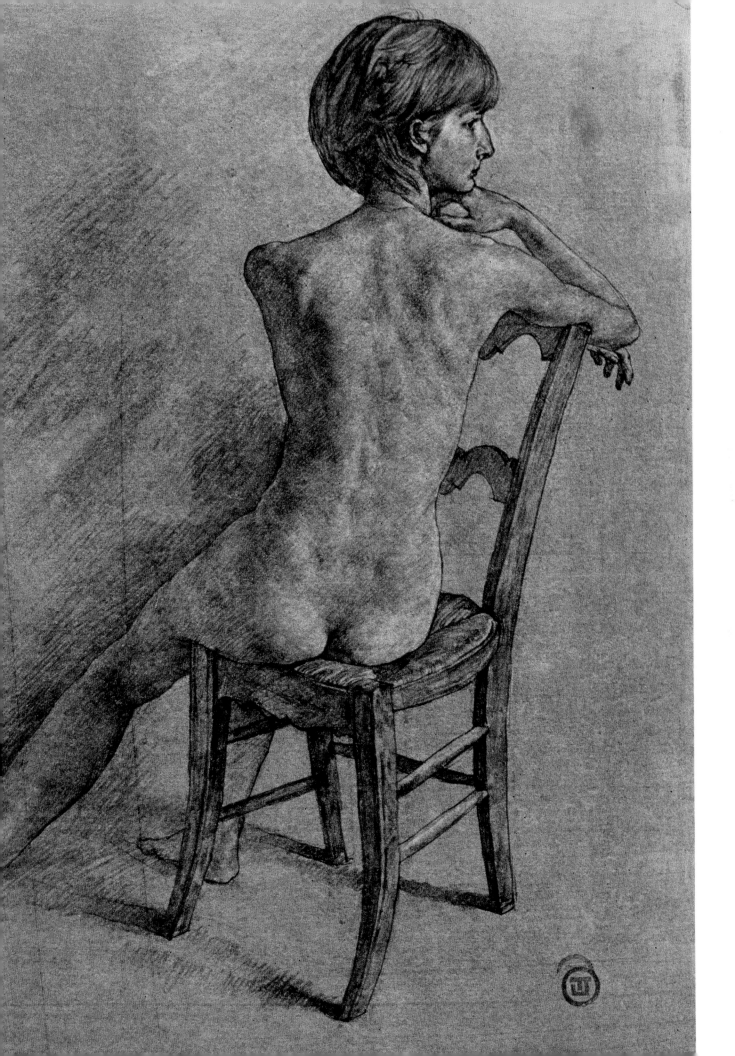

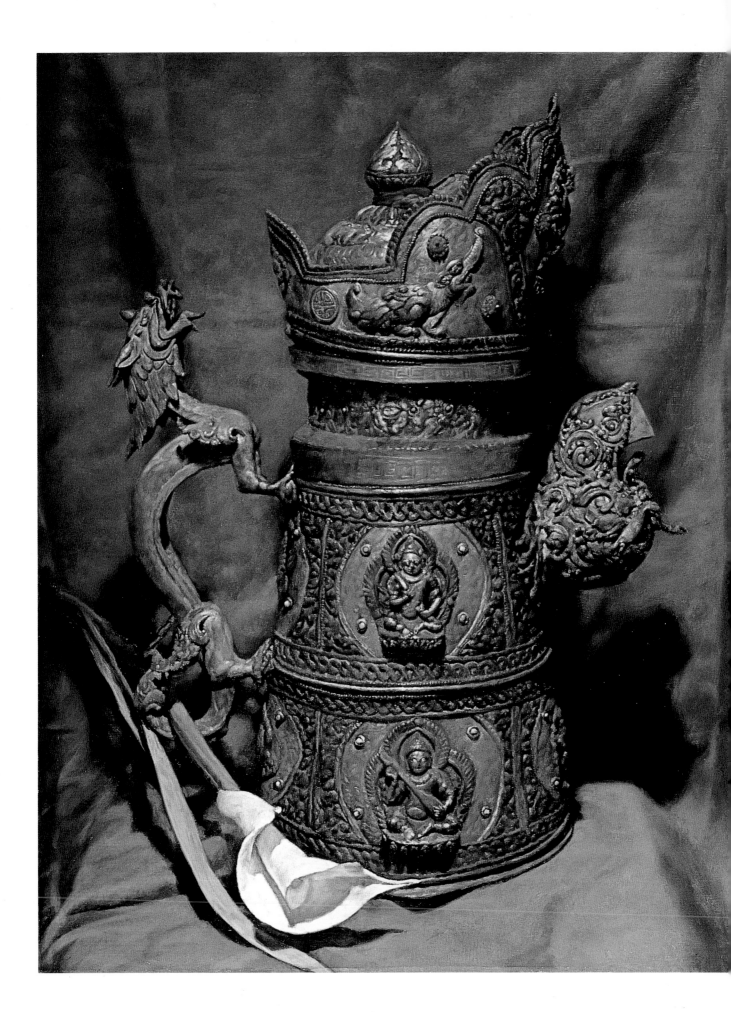

PREFACE

ALTHOUGH I AM NOT a research scholar and do not pretend to have an exhaustive knowledge of the field, I have not yet seen a book designed for the artist that treats the subject of light in great depth and detail. In the books I have found, light generally occupies only a relatively brief chapter. This lack is curious and unfortunate, since the artist who wishes to suggest what is seen is necessarily involved with the actions and effects of light. Also, in many of the chapters on light effects that I have read, the principles given did not seem to agree with what I saw in nature. Too often, writers and teachers put together an artificial system, which produces an artificial look. These systems are usually coherent within themselves but are not based upon what we see. I have tried, to the best of my abilities, to base my conclusions on long and careful observation. This book is a greatly expanded and detailed development of the brief section on light in my previous work, *Drawing with an Open Mind.*

This is not a book about how to paint or draw in the strict sense of the words. Although there are some indications about method, the real purpose here is to give you an understanding of what you see. If you know how to look, you can work out how to get that vision down on canvas. It is much more important to understand the underlying principles and philosophy. As your deep understanding develops, you will naturally learn which methods and materials are best for you.

This is not a book about expressing your ideas or creating art. I would prefer to give you the means, the intellectual tools, so that you will be freer to express your nature. Learning the actions of light is as important to the artist as mastering the scales is to a musician. Without that mastery, expression is blocked; with it, the musician can sing freely and play out the subtlest nuances of feeling. I want to give you a vocabulary of light effects. Without it, how can you express yourself?

After forty years of varied teaching experience, it is apparent to me that many weaknesses and erroneous tendencies are virtually universal. I hope that the information in this book will help guide the artist to a clearer understanding of light and form.

As you might expect, many of the actions of light described here have been known for centuries. However, since the advent of nonrepresentational art, a large body of past knowledge about light, including some very basic ideas, has been virtually lost. This phenomenon is observed over and over in art schools—even among students who have been studying for many years. For this reason, I presume to hope that besides the student, even the professional artist may find here useful material about light. Very frequently my students remark that even after years in art schools, they never before heard of many of the principles I teach—including some I think of as very basic.

Perhaps photographers and cinematographers will also find it useful to have a clearer exposition of the principles underlying light effects. Grasping these principles will greatly improve your ability to convey emotion and meaning through the orchestration of light effects. No matter what your level of experience, whether beginner, advanced, or professional, I think that you will find very useful, and sometimes surprising, material in this book.

Here, as with my previous book, I wish to show you the profound differences between the visual images transmitted through the eye and the vast, complex, deeply ingrained symbolic conceptions that we attach to these images. It is my belief that most of our difficulties in drawing and painting—and perhaps in life!—arise from our inability to clearly distinguish these two functions. Although it is very difficult in practice to separate word from image, to the extent that we succeed, life seems to become much clearer and lighter.

OFFERING,
oil on canvas
applied to panel,
27″ × 23″ (68.6 × 58.4 cm),
1988 (work in progress)

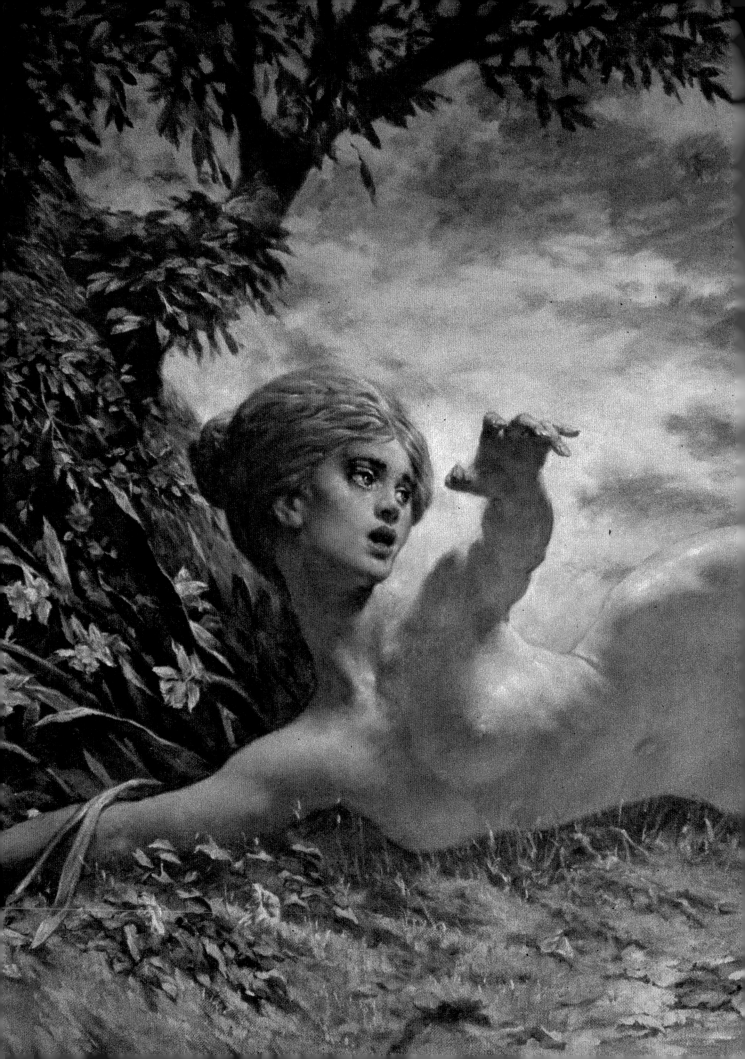

SYMBOLISM AND PERCEPTION:
Word versus Light

DAPHNE,
oil on canvas, 29" × 45"
(73.7 × 114.3 cm), 1988
(work in progress)

LIGHT, ALTHOUGH it constitutes such a large part of our sensory information and is virtually omnipresent, may, paradoxically, remain consciously unnoticed. It may be assumed that one of our first impressions upon entering this world might be of light. It is the companion of our waking hours. Without it, we are encouraged to enter the world of sleep. Our whole conception of existence and the world around us is linked with light. Our perception of things—what we call the outer world—*insofar as it is visual*, is made *only* of light. This visual grasp of our experience is so deeply ingrained that we easily overlook the factor of light as we think and react in relation to perceived objects. We customarily don't react as directly to light as we do to the world it reveals. This tendency to identify ourselves with the objects of perception, rather than with the process of perception and its medium of light, causes us enormous difficulties when we try to paint what we see.

LIGHT AND OUR EXPERIENCE

Our perception of existence is not, of course, only visual. Besides what we register by sight, through its medium of light, our conceptions of our own existence and the so-called outer world are formed also by touch, taste, smell, hearing, and our various faculties of imagination and cognition, along with whatever other psychic powers we may possess. However, for the artist who wishes to suggest how things look, the important element is light—the key to the visual process.

The Two Hidden Factors. Two important points emerge out of all this; they could be called "hidden" factors.

The first is that whenever we look at an object, whenever we see anything, our grasp of its existence and reality is not only visual but incorporates a host of other elements: memories, other sensory impressions, evaluations, and qualifications. In other words, while looking at things, we perceive them not only by the action of our eyes but with our whole being. We "see" things in the context of our total experience of life.

The other "hidden" factor is that most if not all of the time, light is in some form a part of our experience. This omnipresence of light is "hidden," in the sense that we tend to focus our attention more on objects than on the light reflecting from them.

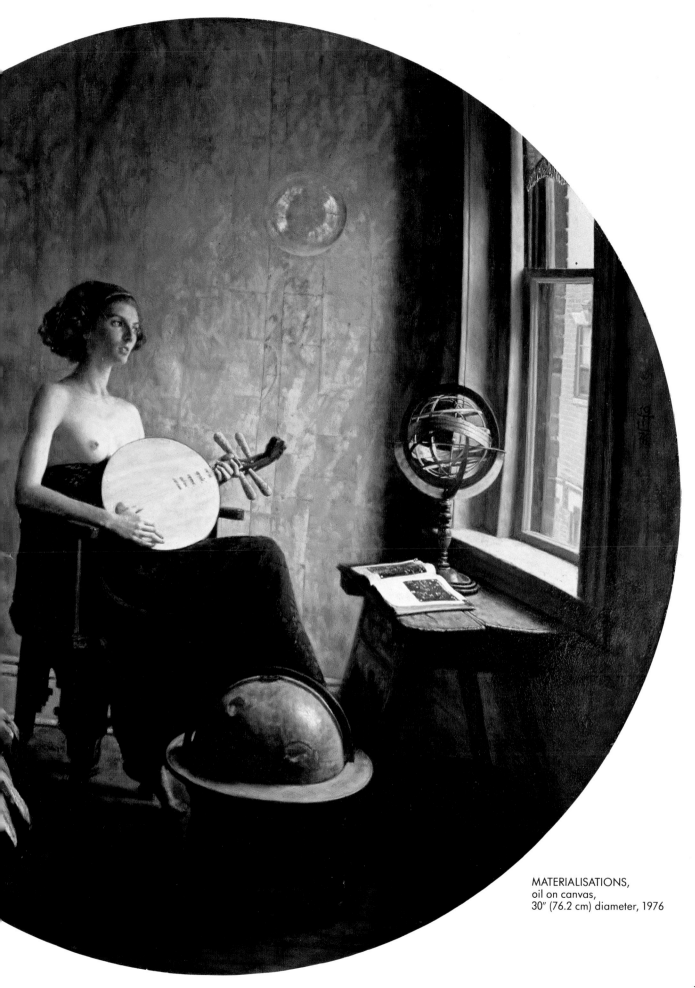

MATERIALISATIONS,
oil on canvas,
30" (76.2 cm) diameter, 1976

THE CREATION OF SYMBOLS

For the artist, the problem is that although these so-called hidden factors may be necessary and useful for everyday living purposes, they create a host of problems when he or she tries to suggest only what is seen.

For example, in the everyday sense we can identify a piece of paper as white and the ink printed on it as black, but for painterly purposes, if we think of the paper as white we may easily fail to notice its particular shade or kind of white. In fact, visually it is not at all white, in that everyday sense. It is a certain light reflection. Our eyes register that particular reflection of colored light, as the totality of our experience registers "a piece of white paper." Our global contact with paper has synthesized an image of paper, a symbol. Our eyes act as a lens registering variations of light. Most of the difficulties in representational painting are due to a confusion between these two processes.

The Linkage of Word to Symbol.
Accompanying each of these synthesized experiences, or created symbols, is a name, a word. This linguistic identification of things also tends to obscure our perception of visual phenomena. We all have a deeply ingrained habit of "translating" our visual impressions into verbal-symbolic terms. If, as representational painters, we want only to suggest what we are seeing, this verbal-symbolic habit creates a sort of highly distracting "noise," or background static, that interferes with our visual reception. When we look at a piece of paper, we more or less automatically think "white, something to write (or draw) on, something to read, to turn over, to tear up." All these generalized notions of paper distract our attention from the information the eye-lens is transmitting. It requires a tremendous effort and a great deal of training to be able to better separate the purely visual image from the symbolic noise.

STRIPPING AWAY PRECONCEPTIONS

Quite simply, the more attention we pay to the appearance of objects as a manifestation of light effects, the less we pay to the symbolic forms. That is because symbols and names represent abstract generalizations, whereas each effect of light is

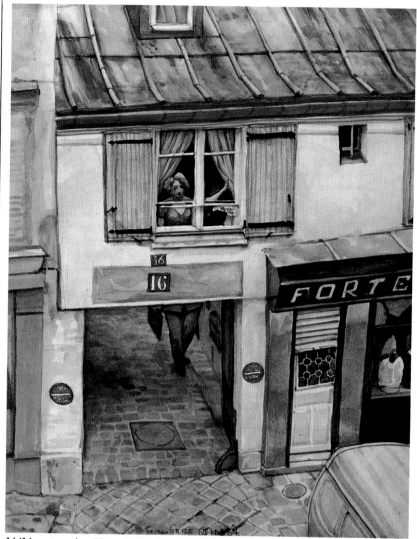

16/16, watercolor, 10″ × 8″ (25.4 × 20.3 cm), 1984

We see whitewashed walls, yellow wooden shutters, people, and cobblestones. But do we notice the diffuse daylight that reveals to us these named objects?

STRASBOURG ST. DENIS, PARIS, pastel over pencil, 12″ × 9″ (30.5 × 22.9 cm), 1982

We must try to forget all our ideas about buildings, about perspective systems, about the nature of materials, and ask ourselves: What do things actually look like to the eye, as shown by the effects of light?

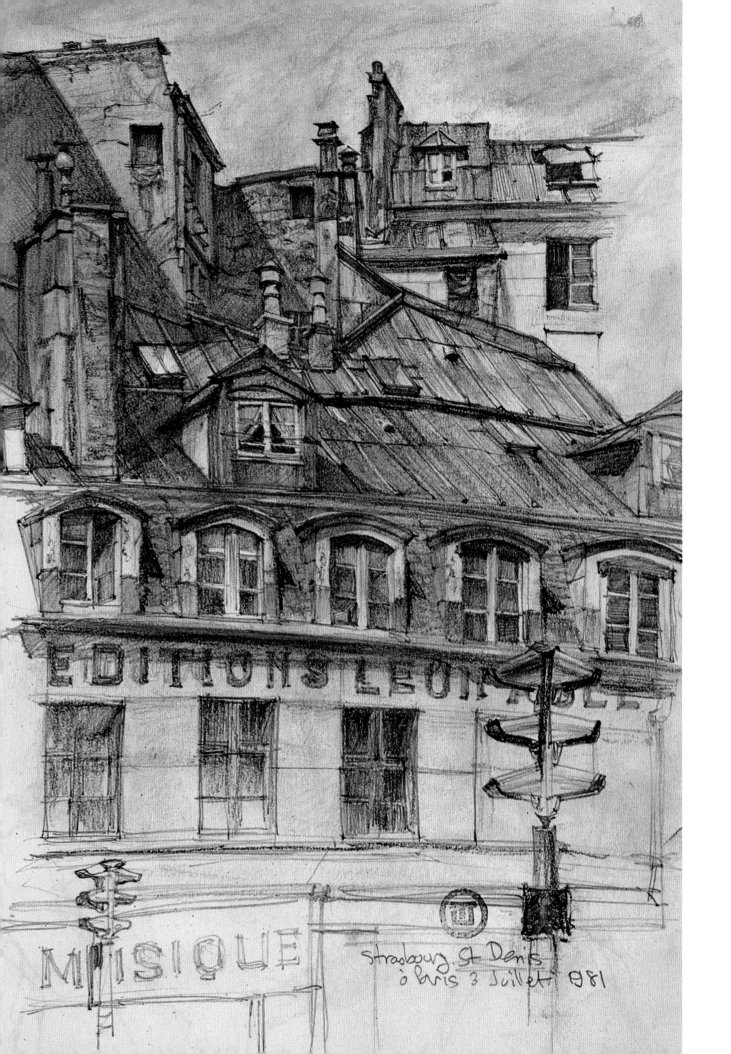

EDITIONS LEONARD

MUSIQUE

Strasbourg St Denis
à Paris 3 Juillet 81

unique and specific. For example, the amount and kind of light reflected from this piece of white paper depends upon very specific factors, such as the type and color of the light source, the angle of its reflection to your eyes, and the smoothness of the paper. There are a great many of these factors, and we shall try to look at all of them. What the eye sees at every given moment is an ephemeral but unique light effect. If we see an object as a transient effect, as the result of passing but specific circumstances, it then becomes more difficult to conceive of as a permanent, generalized symbolic entity. These two ways of perceiving our experience tend to cancel each other out.

In effect, in order to clearly grasp the effects of light and find their equivalents in paint, we must progressively strip away our symbolic preconceptions and verbal identifications. The study of light gradually but *automatically* de-symbolizes our interpretation of what we see and dissolves our symbolic preconceptions about the world.

The key to this method is to constantly compare what we find on the canvas or paper with the seen effects of light. What we put on the canvas is a guide to what is in our minds. By comparing what we put on the canvas to the observed model, we find various discrepancies. These distortions are the expression of our symbolic ideas. They represent our failure to notice what the eye is transmitting. We paint our preconceptions and prejudices. These prejudices are materialized on the canvas and can be studied for as long as we wish. That combination of light effects that we call our model remains also before us. What is necessary is to constantly refer the one to the other. By so doing we develop a reflex for noticing inconsistencies between the two. As compared with the harmonious relationships observed in the model, elements of the work of art in progress will seem to leap out at us because of their disharmony. We must never let these dissonances remain uncorrected. They will distort the entire delicate balance of the picture surface and propagate a chain reaction of discordant notes. Since our true subject is nonsymbolic light, the presence in our minds of symbolic word-forms will cause us to falsify our match of picture to model. All our symbolisms

The visual image is a manifestation of light effects. The study of light automatically de-symbolizes our interpretations.

THE OPEN WINDOW, oil on canvas, 24" × 30" (61.0 × 76.2 cm), 1978

are too general to suggest the specificity of light effects.

If we focus our attention upon the effects of light, rather than trying to force appearances to fit our symbolism, it will weaken our attachment to symbolic interpretations of our experience, and these interpretations will fall away from us one by one, like so much unnecessary mental baggage. In this way we allow light to guide and instruct us. That, then, is the importance of this process: to learn from observation, rather than attempting to force observations to fit a preconceived symbolic system. In this way, light and its effects become our wordless teacher.

As we learn more about suggesting only visual appearances, we come to realize that the eye does not exactly "see" a host of qualities that we ascribe to the world. For example, it is a little surprising, and difficult to understand, that weight is not *seen*. What is seen is a light effect that may show us the effects of weight. For example, the pressure of a head on a pillow is caused by the weight of the head. But weight itself is felt, not seen. It is recognized by the tactile sense. Experience has taught us that whatever we touch or try to lift has weight. But for our purposes light is weightless, and what we see is only light.

I have used the quality of weight as, I hope, a clear example. Similarly, an infinity of other qualities that we ascribe to things are supposed, or known by nonvisual experience, rather than seen. In fact, virtually *any* verbal description we can give of an object belongs to this class of presupposed qualities and is not seen by the eyes. The eyes transmit an image, the light effect, and the mind attaches to it a mass of conceptions. We have acquired conditioned responses to our visual stimuli. In that sense, we carry within us a mass of prejudice and preconception.

For example, if we make an imitation flatiron out of lightweight plastic, it could trick someone into thinking it was as heavy as a real iron, because the eye cannot see weight. Although all such preconceptions about the qualities of things seen are useful for purposes of everyday life, they prove extremely troublesome to the painter. Because of these prejudices, we pay surprisingly little attention to exactly what the eye transmits. We tend to qualify as white such diverse things as paper, a person's skin, a shirt, snow, part of the eye, and teeth. These suppositions tend to blind us. Besides each object being a different variety of

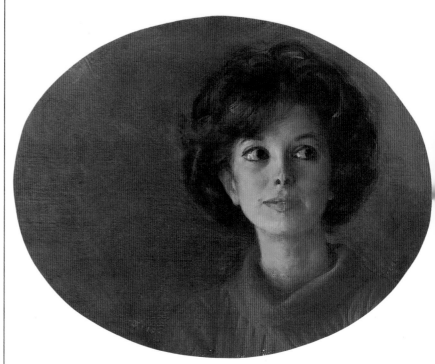

JULIENNE MARIE, oil on panel, 8″ × 10″ (20.3 × 25.4 cm), 1965. Collection of Julienne Marie.

When we meet people, light is our hidden companion. Our optical experience is of colored light and nothing more. And yet, how many associative factors interpose themselves when we look at a face!

BANK STATEMENTS, oil on panel, 8″ × 10″ (20.3 × 25.4 cm), 1967. Collection of Ann Bellah Copeland.

We must train ourselves to register the infinite range of colored values. We do not see papers, we see light reflections.

WISDOM: YUM, oil on panel, 9″ × 15″ (22.9 × 38.1 cm), 1979

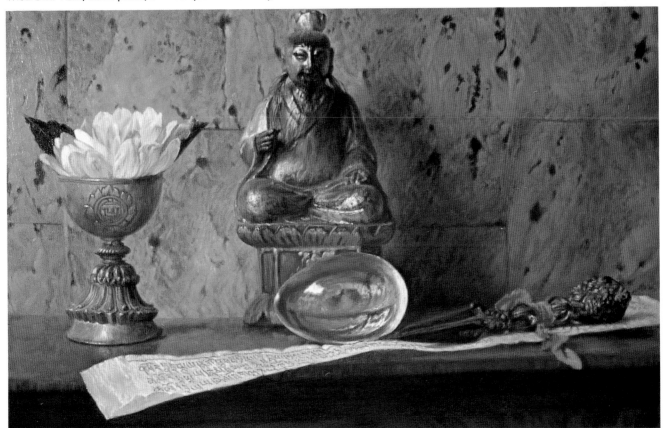

PRACTICE: YAB, oil on panel, 9″ × 15″ (22.9 × 38.1 cm), 1976. Collection of Frederic Bradlee.

These two still-life pieces were conceived as a pair and are meant to symbolize two aspects of the mind: the active, projective, and the passive, reflective. They also demonstrate the two aspects of art: the definite and the obscure, hard and soft, Yin and Yang. What is on the canvas shows us what is in our minds. Symbolic ideas distort the perception of the image transmitted by the eyes.

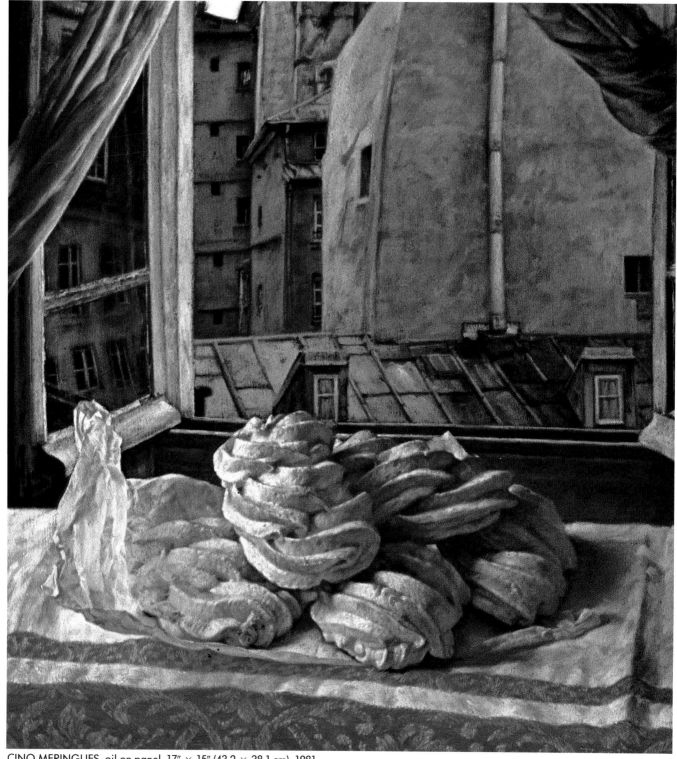

CINQ MERINGUES, oil on panel, 17″ × 15″ (43.2 × 38.1 cm), 1981

If we suggest the effects of light, the painted image will suggest all the qualities of weight, texture, softness and hardness, and such, because we will see in the painted image all that we see in the actual objects. By painting light we will re-create all the attributes of form.

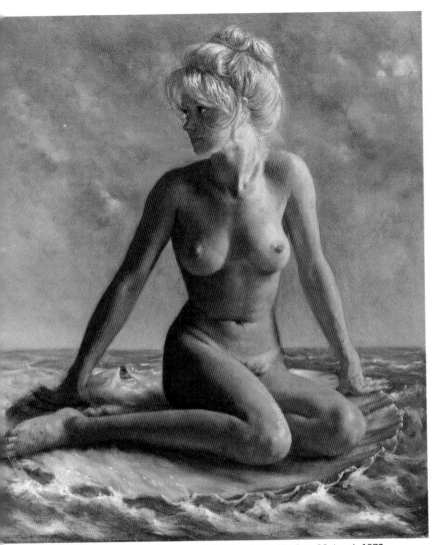

VENUS ANADYOMENE, oil on panel, 13¾" × 12¾" (34.9 × 32.4 cm), 1972

The human body is one of the most deeply entrenched strongholds of our symbolic preconceptions. As a subject, therefore, it provides a particularly challenging opportunity to deverbalize what we see. Perhaps this can be called a painting of the female nude, but it is equally a painting of light on form.

white, each is also seen, at each moment, under a unique light effect. All qualities such as whiteness are necessarily very general. In the actual specific case, nothing can be called "white."

A Few Cautionary Remarks. If we wish to practice this de-symbolizing method, we must remain rigorously alert. The habits of symbolism are deeply ingrained. We are accustomed to experiencing life in words. We grow up with an enormous accumulation of symbolic reference, and we create a vast structure of personal symbolism. Very often, painters symbolize light itself. It is very easy to create a sort of personal, stylized light and assume it corresponds to observed effects. Indeed, finally, every painter creates a personal light. I don't mean to suggest that this is a fault. I do think it is necessary to realize the difference between what the eye sees and what we create as art.

We ought always to remember that rather than reproducing the effects of light we can only suggest them. We can at best only create a painted interpretation of the process of vision. If nothing else, our range of possible effects is severely limited by our materials. We work with paints and chalks, canvas and paper. The "materials" of the sight process are the living organisms.

Early on, I spoke of artists who wish to suggest or represent what is seen. The following remarks refer implicitly to only that approach. In art there are perhaps as many styles and approaches as there are artists. It is not my intention in this study to make any judgments or express preferences for any particular approach or style. However, I would remind those artists who wish to suggest what is seen that their basic subject is light. Light is the medium of vision. If you can capture the effects of light, you will automatically suggest all the qualities we attribute to things, such as weight, texture, and such, because you will then have suggested these attributes as they are perceived by the eye.

In this approach we may think of the eye or the visual process as neutral, like a mirror that reflects whatever it sees with no opinion whatsoever attached. No preconceptions. No prejudices. No qualifications. No words. No names. No opinions at all!

THE NATURE OF LIGHT:
Its Structure, Action, and Effects

THE VISIT OF THE BEY,
oil on canvas, 20″ × 24″
(50.8 × 61.0 cm), 1988
(work in progress)

Writing a rather analytical study of light is somewhat intimidating. Viewed from our human scale of observation, light seems at once cosmic and nearly immaterial. How can we hope—in fact, why should we wish—to pin down such an elusive element? How can we quantify this paradoxical living entity, ever-changing and ever-present? And what could be more exquisitely subtle in its appearance?

Within these limitations, I find it is still possible to say something useful to the artist on the basis of what we can observe about light by using nothing more or less sophisticated than the human eye. We all have in common this faculty of sight. If we pay attention to what it is constantly showing us, we can learn a great deal.

THE DIRECTIONAL QUALITY OF LIGHT

Perhaps the first observation that we can make about light—and one that will remain of paramount importance—is that it comes from somewhere. Visible light has a source. Natural or mechanical, from a sunny or cloudy sky, from lamps, candles, fire, or firefly, it radiates outward from a point of origin, from some energetic source.

If light is radiating from a source, it is going somewhere. That is to say, it has a directional orientation. For us earthlings, the immediate source is Aton, our sun (I say "immediate" because I don't think there is as yet any conclusive knowledge about where the sun and all else ultimately came from).

This light originating with our sun can be channeled and presented to us through secondary sources such as windows, lamps, or cloud cover. The light effect that we painters are called upon to suggest in any given situation comes from a given source. Whatever subject we see before us is lit from a certain direction. In cases where there is more than a single light source, each source has its own directional aspect. It is necessary for artists to know where the light is coming from whenever we look at a model or imagine a subject. Otherwise, our symbolic ideas will insinuate themselves between our awareness and our process of vision, and we will fail to notice the effects of the light. This is often as much the case for advanced artists as it is for beginners. We must be very alert!

Determining the Direction of Light.
How exactly can the direction of the light be established? Although at first glance this question may seem unnecessary, it is in fact not always easy to determine the exact angle of the light arriving on the model. One simple and sure method is to look for the cast shadows. Every opaque object blocks the passage of light and casts its shadow after itself. These shadows are, so to speak, thrown "behind" the object, in the *same direction* as the incoming light. Their exact shape is conditioned by the shape of the object upon which they fall, but overall they lie along the line of the arriving light ray, like an arrow reaching its target.

For example, if the light is from the right, the cast shadow will be thrown toward the left; if the light arrives from below, shadows will be cast upward. Even cast shadows that are diffuse and blurred will still be thrown in the direction of the arriving light. An experiment can be made that clearly shows this directional principle. If you place an object on a tabletop in lamplight, you can find the point on the edge of the cast shadow that corresponds to that point on the subject. If you connect these points with a thread and pull it taut, you can then extend the thread in a straight line that will pass through the center of the light bulb.

By habitually noticing where the cast shadow falls in relation to the model, we can establish the position of the source of light. This can be useful, for example, painting indoors when we know the light is arriving through a window but cannot otherwise determine its exact angle of incidence.

From Source to Subject.
Following from the idea that light comes from the direction of its source is the conclusion that it is then propagated through space. It has a trajectory. Given the scope and dimensions of our usual models, it is not necessary for artists to question whether light is bent as it moves through the cosmos. For our purposes, we may treat light as moving in widening rays in a straight path from source to model.

REFLECTION: LIGHT BOUNCING OFF A SURFACE

This idea that light moves in straight beams from its source leads us to two vitally important conclusions. The first is that light, like almost

WOMAN WITH A BICYCLE, oil on canvas, 20″ × 30″ (50.8 × 76.2 cm), 1972

The cast shadows on the ground indicate where the light source is located. For example, connect the hub of the front wheel with its cast shadow on the ground to find the angle of the light source.

THE COMET KOHOUTEK, oil on canvas, 18″ × 24″ (45.7 × 61.0 cm), 1974

In this composition, I wished to use the curiously shaped lamp and the light it radiates as a metaphor for the comet that is visible through the window. Despite the literary content of the scene, the painting itself is essentially a study of light effects. In the same manner, the nineteenth-century Italian genre painter Chierici used highly anecdotal subject matter as a vehicle for brilliant paintings of the effects of light on form.

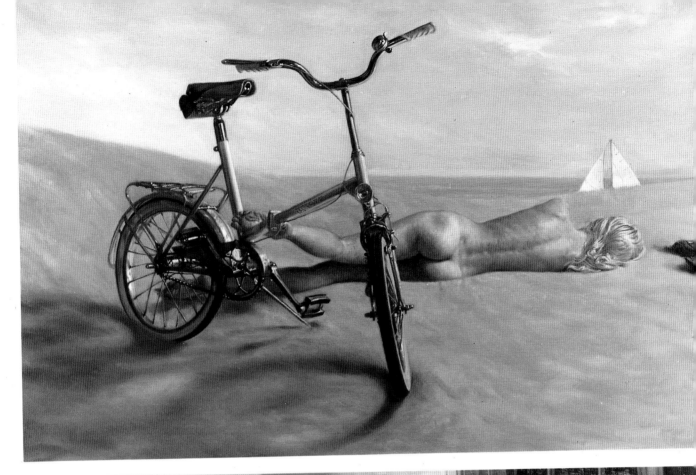

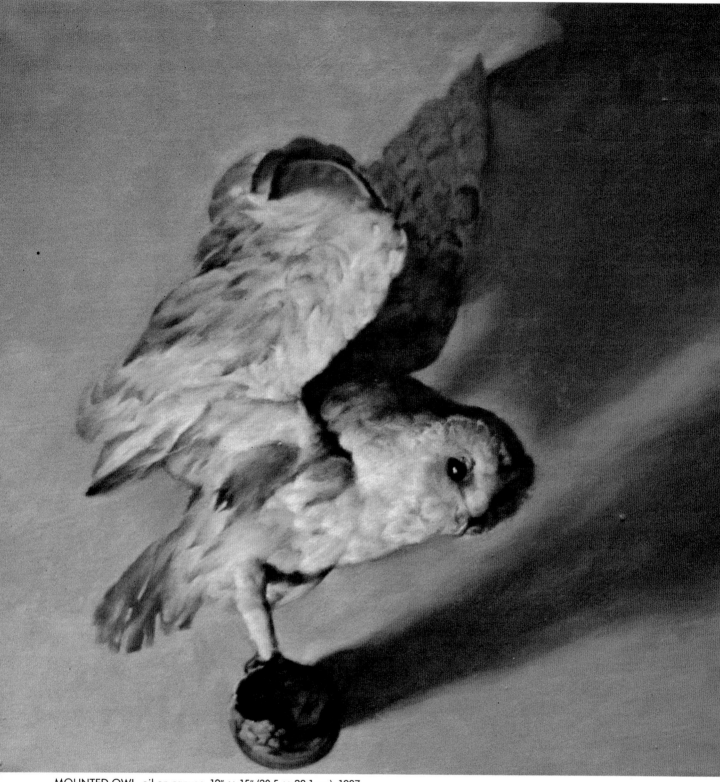

MOUNTED OWL, oil on canvas, 12" × 15" (30.5 × 38.1 cm), 1987

In this subject, the light arrives from the lower left and throws cast shadows upward, toward the upper right. These can be seen on both the owl and the wall. It is instructive to make pictures with the light coming from directions other than those you usually see.

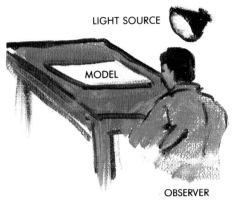

LIGHT SOURCE

MODEL

OBSERVER

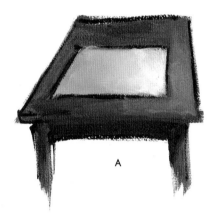

A

This is a schematization of how the same model will appear from two different positions of the observer.

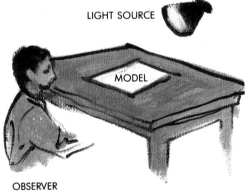

LIGHT SOURCE

MODEL

OBSERVER

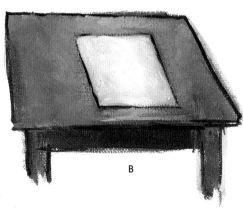

B

anything thrown or propagated, bounces off a hard surface. The part of light that our eyes register has apparently bounced off an object. The direction of its reflection follows the law of incidence and reflection, which states that light bounces from a surface at the same angle as that of its arrival, but in the opposite direction. It moves much as does a ball thrown against a wall. If we throw a ball from a wide angle, it will bounce off the wall at that wide angle in the opposite direction. If we throw the ball directly in front of us, it will bounce back to us. It is necessary to understand and remember this principle. Besides its general applications, it is responsible for some rather special effects in the case of highlights and light reflected into the shadow.

The Reflective Shift. The effects of light—the distributions and gradations that we see on the model—do not look the same from different points of view. These effects depend upon the positions, relative to one another, of model, observer, and light source. Because these relative positions produce different angles of incidence and reflection to our eyes, it is very important to understand the law of incidence and reflection. Because of the effects of that law, the gradations of light, known as "values," are not distributed in a uniform progression—a smooth, descending curve of intensity. The reflective action of light can cause what will appear to us as an uneven gradation. The value changes can be displaced, or "shifted," because of reflective effects.

For example, if we keep the light and model in the same place, but change our own position as observer, moving to face the light source, the lighter values on the model will shift toward us, even though the light source has not moved. The gradation of value will seem reduced, or "flattened." This "reflective shift" is, of course, always happening everywhere, but in some situations it becomes, if you will pardon the expression, "glaringly" apparent.

Imagine a sheet of paper lying on a tabletop, under a lamp fixed in place. The illustration shows how the paper will appear to us if we move from position A to position B. As we move to B, the brighter values are displaced toward us by the angle of reflection. The gradation of value from position B appears flatter, less varied from light to dark.

What we see are relationships caused by positional factors.

SHADOW: THE ABSENCE OF LIGHT

The second vitally important conclusion that derives from the action of light moving as a beam from a source is that it can only illuminate what lies in its path. Only part of any three-dimensional object will face the light. Whatever parts do not receive light will fall into what is called "shadow." Shadow, then, is the opposite of light, its absence. If we wish to suggest what is seen, this division of everything into light and shadow is one of art's most important principles.

In nature we find both dark lights and light shadows, but for convincing results the artist ought always to distinguish which is being represented. The suggestion of something seen will be considerably weakened if the artist is confused about what is in light and what is in shadow.

A Word About Half-tones. If we consider that light travels in beams, it is impossible to conceive logically of a plane that is not facing either toward or away from those rays. Although some parts of an object face more and some less directly into the light, I cannot conceive of an object that is turned neither away from nor toward the source. I cannot imagine a mysterious angle or plane that lies somehow between light and shadow. Probably what is meant by "half-tones" is what I call the darker lights, that is, those surfaces still receiving some light but not turned very directly into its path. The semantic distinction is important because the concept behind the idea of a half-tone tends to produce excessively soft and indecisive work.

LIGHT MOVING THROUGH SPACE

The fact that light emanates from a source produces another extremely important effect. As light leaves its source and travels in widening beams through space, it decreases in intensity. It pales on its journey. Of two stars of the same innate brightness, the nearer will appear more brilliant. Light entering a room through a window drops off quite noticeably in strength as it travels through space. The same is true for light radiating from a lamp or fixture. This effect can clearly be seen on a blank wall, where the section nearer the source

BRIE,
oil on canvas, 22″ × 20″
(55.9 × 50.8 cm), 1981

Shadows occur where the curves of the boxes turn away from the beams of light. These are called "form shadows" and should not be confused with "cast shadows" that are projected by one form onto another.

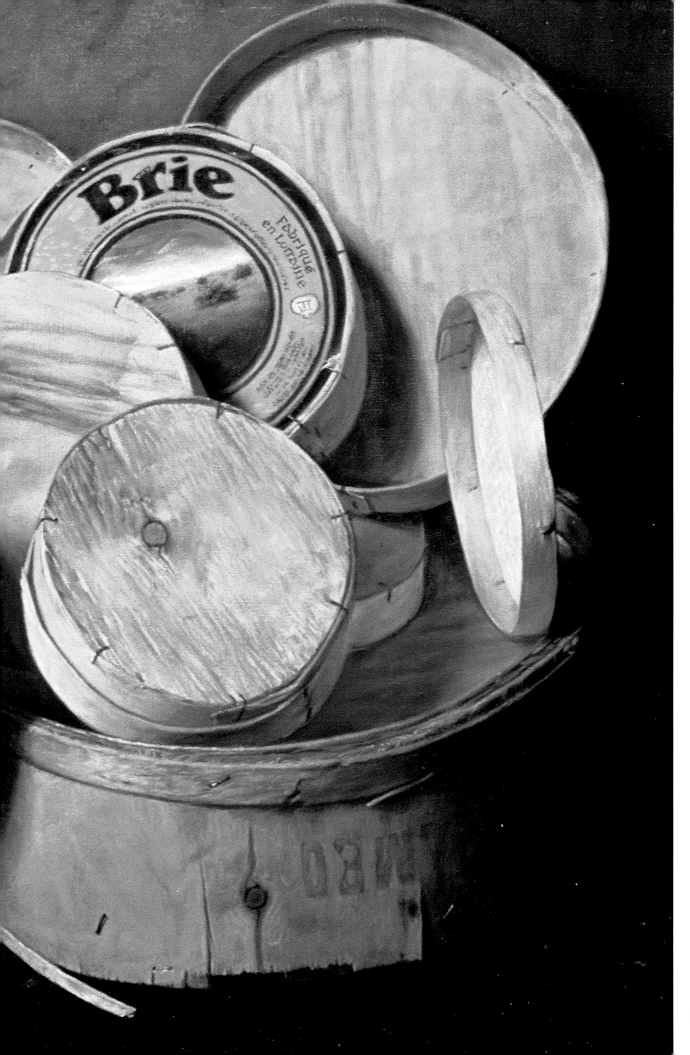

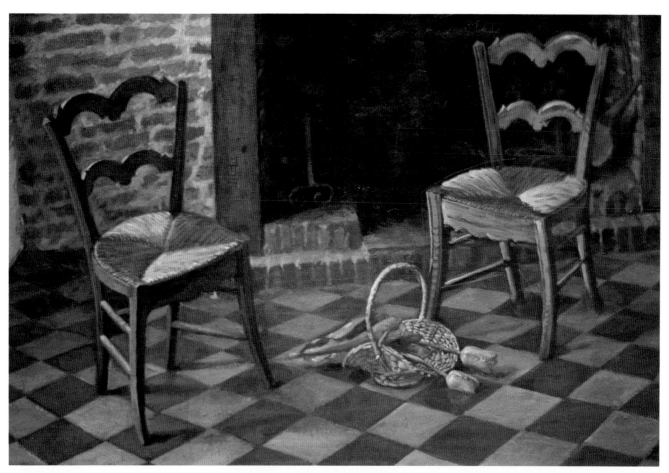

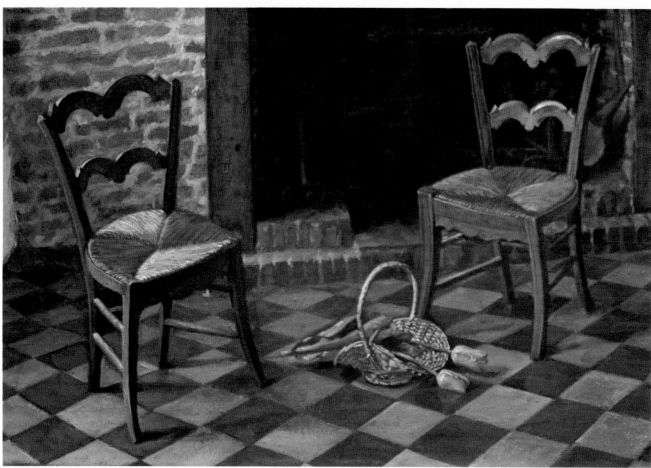

The light source in both these paintings is at the upper left. In this incorrect version, the chair on the right is placed much farther from the light than the chair on the left but has been painted in inappropriately high values. It is therefore in harmony with neither the space around it (which has been properly darkened) nor its position relative to the light source. This dissonance gives the picture the feel of the expressionistic style, which is characterized by raw emotional power produced by exaggerations and distortions.

Here, the values of the right-hand chair have been darkened to a lower key so that its position in space corresponds with the amount of light falling on it relative to both the light source and the surrounding area. This orchestration of the amount of light to the space gives a sense of rational balance, of power through restraint and control, which is quite different from the explosive, anarchic strength of expressionism.

of light will be brighter than the farther areas. We can see a fairly even progression of intensity across a wall lit by a single source. It is vitally important for the artist to represent this gradual diminution in intensity. Because of our attachment to symbolic preconceptions, it is quite easy not to notice it. This is a very common fault among students and even sometimes with the more experienced.

The opposite fault is that some painters greatly exaggerate these gradations. This is a stylization of the light effect. Of course, unless the artist is trying to suggest natural effects, questions of stylization are really questions of taste. If we do wish to represent what we see, we must try to find the best possible match in paint and avoid all distortions or stylizations in any direction. Not too much this way, not too much that way. As in Sanskrit, "*Neti Neti.*"

Creating Space with Light. If we suggest the effect of light diminishing as it travels through space, it follows that we can create the illusion of space by the way we distribute light. The reader will, I hope, have noticed that there is a coherence and progression to this approach to the study of light. Each proposition derives naturally from the preceding assumptions. The effects of light appear to be universal and consistent. There seems to be a unifying principle underlying all observed effects of light, equally applicable to the marvelous source in the sky and the flare of a match. Coherent relationships are necessary if we wish to create a convincing suggestion of the seen world. This question of consistency will be discussed at greater length, but it underlies and unifies all the specific cases discussed here.

Imagine, for example, that we are painting an interior scene where the light enters through a window on the left. Now, imagine that we draw one chair near that window and place another much farther away from the light. If we paint the same intensity of light on both chairs, it will be as if they both occupied the same position or were at the same distance from the window. There would then be an anomaly, or contradiction, in our painted room that would produce an unconvincing suggestion of space. The drawing would suggest that our chairs were in different parts of the room, while the amount of light, or value, would suggest that they were both in the same place. Our painted room would not seem "real" because it would not be consistent with what we are accustomed to seeing.

Our painted space would seem visually distorted. It is crucial for the value to be in perfect agreement with the spatial placement. Value and drawing must be in a logical relation. At every point, the light's value represents a spatial value. Like a symphony conductor, we must orchestrate all our notes, or values, harmoniously in relation to the position of the light source. Our pictorial space will then sing true.

ORCHESTRATING LIGHT EFFECTS

If we approach painting purely as a study of the appearance of light effects, in the final analysis we are not representing objects. We are trying to represent the process of vision. We are trying to find a painted equivalent for a complex set of relationships. Rather than painting things, we are painting the relations between them.

As mentioned earlier, the visual appearance of all things is an effect of light reflections registered by the eyes. The world we see is an optical effect, an illusion. Generally, the world around us is quite convincing. It looks "real." Perhaps we equate reality with how we are accustomed to see things. This real-looking world appears to be perfectly consistent. All the tonalities and light effects we see seem to exist in a logical, harmonious relation to the light source and to each other. I believe that a work of art is convincingly real when it imitates this harmonious consistency.

If we wish to create this sense of consistent reality, we must consider our subject, our model, in its totality. When we look at any model, we see the whole object in its surroundings. It is, so to speak, a finished picture with everything in place. But we are obliged to create our painted world one stroke at a time, piece by piece.

To see our subject as a set of relationships, however, we must avoid looking at it as a collection of separate elements. If our true subject is the totality of its relations, it is reasonable to study *that* subject: to look at the whole rather than at isolated parts. We must see the model as a set of relationships. We must orchestrate the light so that each tone is painted in relation to all the others. Rather than focusing our attention on small, isolated places, we should look at our subject as a field of vision. We need to constantly physically move

our eyes and study each part as an element in the whole field. At the risk of repetition, I stress this because the most common tendency is to become absorbed in one small area at a time. We tend to easily forget to scan the whole field and compare each tone with all the others in that field.

Suggesting light is, in fact, a process of discrimination. We are required to register very fine nuances. Painting equals differentiation. We are all a little lazy and careless. We tend to repeat ourselves and put the same tonality everywhere. This is not painting. We must develop and refine our sensitivity to extremely slight variations. By repeating the same tone, we eliminate the suggestions of a source of light. We eliminate the sense of space and also of form, of dimensionality. Without the variation of tones, we cannot suggest the effects we see. Variation is the scale we play upon. Without it, all is flat and there is no "music."

SCALES OF LIGHT AND COLOR

What the eye sees could be described as a field made up of colored lights, of flashes registered in our awareness. In this sense, our visual impressions cannot be divided into separate elements. As artists, however, what we have to work with is a set of paints. They do not come out of the tube ready-mixed in all the tonalities we require. Although what we see is an indivisible colored light, in order to suggest it with paint we need to make mixtures. In drawing, we need to create a range from light to dark. It takes a great deal of analysis and much time and experience to learn how the paint colors mix.

When we mix our colors to suggest a particular observed patch of light, we find that our mixtures create different kinds of effects. Each time two or more colors are mixed, they undergo transformations. Usually a mixed color is less intense, or pure, in color than a single color out of the tube. The mixed paint has undergone what is called a chromatic change.

Chroma: Color Intensity. One scale, then, is called the chromatic. It represents the range from purest to least pure color. It can be thought of as a graduated scale beginning with the pure color out of the tube and ending with a colorless gray. This definition of a chromatic scale is based upon the idea of an original pure color that can be progressively diluted.

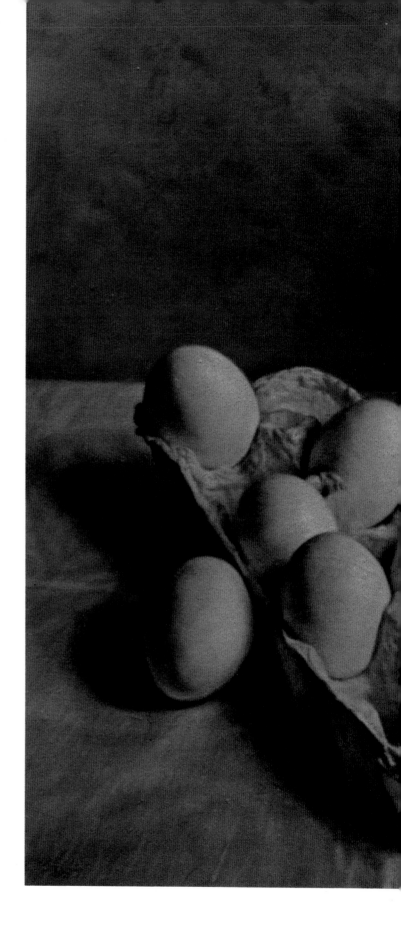

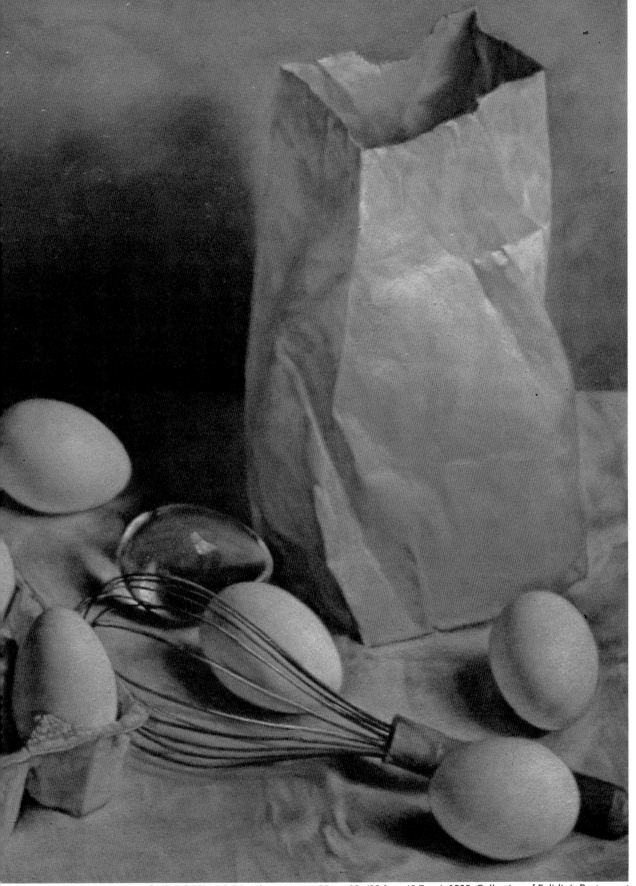

ONE DOZEN EGGS, oil on canvas, 15″ × 18″ (38.1 × 45.7 cm), 1985. Collection of Felidia's Restaurant.

Painting requires the differentiation of extremely delicate nuances. Painting is variation and the study of relationships. Each egg is at a different distance from, and tilted at its own angle to, the light source, which is off to the upper right.

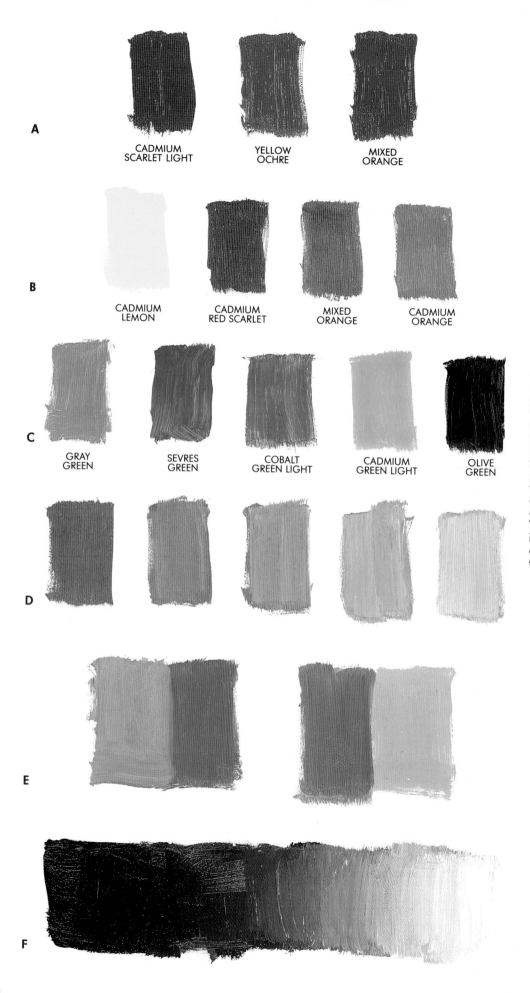

A

CADMIUM
SCARLET LIGHT

YELLOW
OCHRE

MIXED
ORANGE

B

CADMIUM
LEMON

CADMIUM
RED SCARLET

MIXED
ORANGE

CADMIUM
ORANGE

C

GRAY
GREEN

SEVRES
GREEN

COBALT
GREEN LIGHT

CADMIUM
GREEN LIGHT

OLIVE
GREEN

D

E

F

In figure A, cadmium scarlet light and yellow ochre are mixed to produce orange. The mixture has reduced the chroma. Figure B shows cadmium red scarlet, cadmium lemon, a mixture of the two, and cadmium orange. The mixed orange is not as chromatically intense as the adjoining patch of pure cadmium orange. This illustrates some of the reduction in chromatic range that can be caused by a "limited" palette. Figure C consists of five different greens—gray green, Sevres green, cobalt green light, cadmium green light, and olive green—illustrating the variety that exists within a hue family. In figure D, we see cadmium scarlet progressively lightened with white. Note that besides the changes taking place in the value scale, the hue and chroma change with each gradation. The cobalt violet tint in figure E produces different field effects when placed next to two different mixed colors. Field effects vary in intensity but are present everywhere. The value scale in figure F is generated by adding increasing amounts of white to black paint.

However, we can also think of every color mixture we make as a new and original color in itself. In this case, there is no chromatic scale.

Some painters prefer to work with the fewest possible colors (called a "limited palette"). The disadvantage to this method is that mixed colors are not quite as chromatically intense as their counterparts out of the tube. For example, an orange made of red and yellow loses some chromatic intensity as compared to tube orange. The limited palette reduces our available chromatic range.

Hue: Kinds of Colors. The paints on the palette come in certain colors, such as reds, blues, and greens. The kind of color of a paint is called its hue. Among the greens for example, there are yellowish greens and bluish greens. We can mix a range of variations in hue from yellowish to bluish green. This gives us a scale of hue as well as chroma.

Value: Light to Dark. Our colors can also be graded according to how light or dark they are. For example, a lemon yellow is lighter than a cadmium red. The relative lightness of color is called its value. Our value scale goes from very light to very dark, with an infinite gradation in between. The study of value relationships underlies all of painting. Value is fundamental in suggesting the effects of light.

As mentioned, our colors are at their highest chromatic intensity straight out of the tube. Therefore, when we add one color to another in order to change the value, we simultaneously change the chroma and the hue. For example, if we lighten cadmium red light by adding white, the chromatic intensity will also be reduced, or grayed, and the hue will be shifted toward a cooler type of red. Therefore, any paint mixture causes changes in all three scales.

Field Effect: Interactive Tones. Our colors have another characteristic: Their appearance changes depending upon what is adjacent to them. This optical quality of all colors on a surface could be called the "field effect." Field-effect modifications occur in all the scales.

Contrast: Clarity and Variety. Without light, there is darkness. With no light at all, there is absolute darkness. We seldom encounter absolute darkness in everyday life. To fully understand the effects of light, we must understand what happens in its absence. Without light, we do not see. Everything becomes black-ness, and all differences disappear. Darkness tends to smother differences, reduce all contrast and definition. Darkness blurs such distinctions as colors, forms, and textures. Light, conversely, defines. Things become distinguishable as soon as we turn on a light in the darkness. With light, we see variety. Light shows us changes of color, gradations of value, contrasts, textures, chromatic changes, forms and detail. The action of light, then, is to define, as the action of darkness is to obscure. In order to suggest the effects of light, we must learn how to suggest the effects of darkness. A large part of painting consists in showing this opposition.

The impulse to define is a characteristic of people who are drawn to art. What many artists don't sufficiently understand is that in order to paint light, we must define equally well what is obscure and what is clear. We must define the relative absence of definition—what is vague—as well as what is sharp. We thus work with yet another scale: that of relative contrast. The contrast scale must be very carefully orchestrated since it is just as important as our other scales. If everything is defined as clear and sharp, the art will appear artificially hard and highly stylized.

Mixing Paints. Painters work, then, with a set of scales of graduated intensities. Our mixtures permit us to range up and down these scales. The intermixture of our colors allows endless possible variations. Our range of effects is infinitely subtle. Whenever we mix paints, we must keep in mind that variations are being effected in the three scales of chroma, hue, and value. When we place one stroke of paint next to another, we create field effects.

When trying to match an observed effect by mixing paints, we must consider all three color scales. For example, we may be able to modify all these scales in the right direction to suggest the desired effect by adding only one color to a mix. Conversely, if we are not careful, we may change a mixture correctly in one scale but incorrectly in another. For example, if we add white to raise the value of cadmium red light, we may inadvertently lower the chroma too much. If we then try to lighten the value by adding a lemon yellow, we may change the hue too much. We need to look for the best solution: the color or colors that will cause the desired modifications in all scales.

Incidentally, most beginners tend to

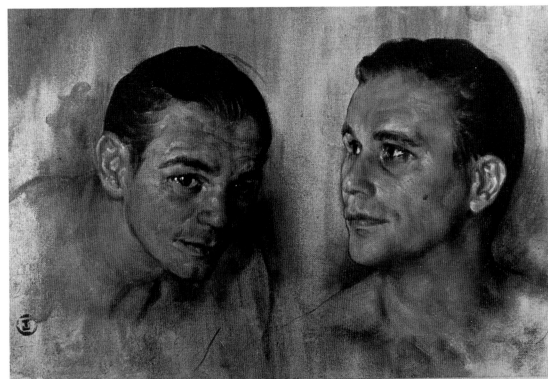

PORTRAIT STUDIES OF EDWARD PAWLIN,
oil on canvas, 16″ × 24″ (40.6 × 61.0 cm), 1962.
Collection of Marguerite Thompson.

This study was painted using a mono-chromatic underpainting, with all the color added in transparent glazes. This style creates lovely effects, but I abandoned it because changing the hue and chroma along with the value is awkward with this technique. Glazes tend to tint large areas uniformly.

PORTRAIT OF DAVID PENNA,
oil on canvas, 20″ × 22″ (50.8 × 55.9 cm), 1980

**We must be just as careful
to define obscurity as to suggest
what is sharp and clear.**

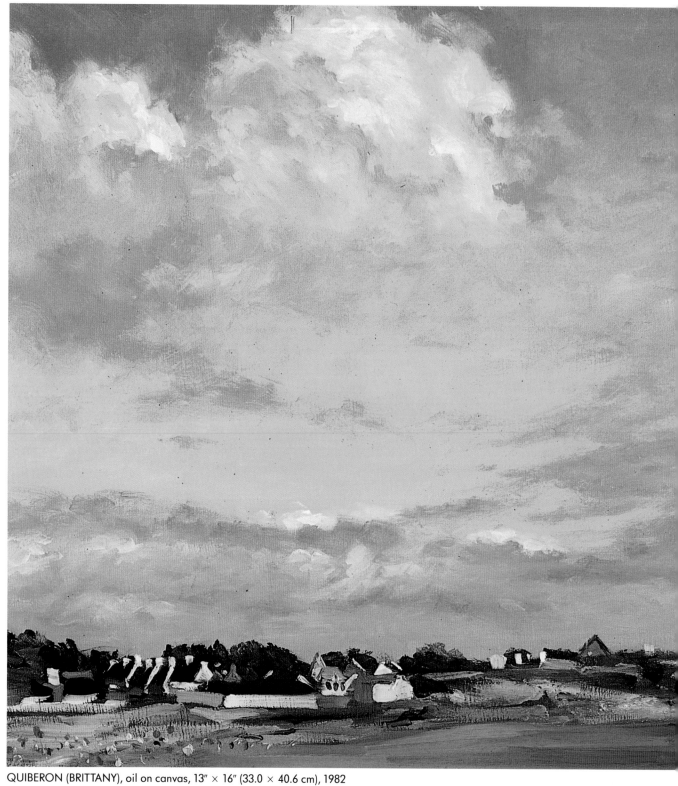

QUIBERON (BRITTANY), oil on canvas, 13" × 16" (33.0 × 40.6 cm), 1982

It is very useful, and good training, to capture ephemeral effects in quick studies by concentrating only on the true tones. This type of study is a bit more developed than the *poster*, which is discussed later. In this sort of study, fearlessly match what is happening in the painting with what you see until you find the best paint mixture. Keep your mind open! Nature is always surprising.

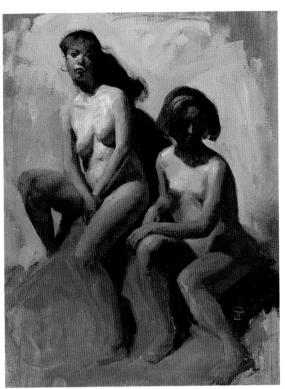

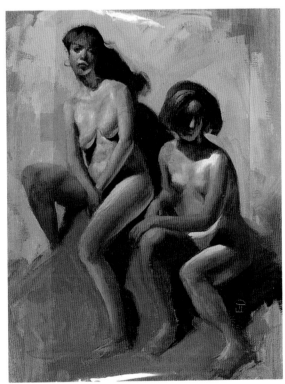

The tones in this painting (top) are harmonious and correct. I added anomalous tones (bottom) by painting on an acetate overlay. Note how they jump out of context.

mix for the hue and ignore value and, secondarily, chroma. This is caused by our habit of registering nameable symbolic characteristics, such as color, rather than effects of light. Usually we require a lot of training before we pay equal attention to variations of all the scales.

It is useful to remember that if any one of our scale effects is not in its proper relationship to the others, we cannot create our best match. The effects we see are not separated into scales. If the mix for hue is not good, the chroma will also be incorrect. If the value is wrong, the hue will be too. Each scale, so to speak, resonates in the others.

Orchestrating Scales. In order to correctly suggest what we see, we must orchestrate all our scales. They must be in consistent and harmonious relation. An incorrect contrast on the picture surface will be caused by any disharmony. A patch of paint will seem to "jump," or pop out of context. We must analyze the inconsistency when this happens and determine in which scales it is occurring.

We must constantly scan the picture surface in search of such anomalies. If one is found, it should be corrected immediately, because otherwise it causes a chain reaction of inconsistent relationships. Mistakes engender mistakes. The picture surface is like an extremely sensitive sort of skin. If it is irritated at any point, the whole surface will be disturbed. We should try to build on a relative degree of "rightness," from best match to best match. Then, whatever we put down and allow to remain contributes toward the coherence of the picture. We then build from strength to strength. We must maintain a very "honest" attitude toward our picture.

There are various ways to recognize inconsistencies. They may "jump out" like little explosions on the surface. Inconsistencies may seem to "come forward" too much or, conversely, create "holes" in the picture surface. Look at your painting as if it were a completely abstract arrangement of colors. Compared to the model, do some of these colors seem to come forward too much? Does a patch of color not come forward enough?

Inconsistencies may also seem to create a sort of knot of unusual tension that interrupts the flow of the picture's surface. The best way to pick out anomalies in the picture is to constantly scan it in comparison to the model.

When an error jumps out at us, we

must determine which of our scales is causing the trouble. I advise less experienced artists to check first for a mistake in value.

SHADOW AND FORM

In painting, the absence of light is called "shadow." Wherever the light does not strike, there is shadow. Since light beams cannot turn back on themselves, they fall upon those surfaces that face them and leave in shadow surfaces turned away from their path.

Since any point on a form is either in the light or in the shadow, the shadow will have a particular and specific shape. This is a very important phenomenon. The shape of a shadow is determined by three factors: One is the shape of the form, the second is the position of the source of light in relation to that form (known as the "direction of the light"), and the third is the observer's position.

We artists generally work on flat surfaces such as paper or canvas. We are, however, suggesting a three-dimensional world. When we think about the light direction, we must remember to situate it in three dimensions. If, for example, we think of the light direction as coming from the upper right, we must also decide how far forward or back it is in the area of our subject.

Geometric and Organic Shapes. There is a radical difference between the shapes of things made by nature and those manufactured by man. Although nature is capable of producing some startlingly geometric forms, most living creatures, and especially we humans, are irregularly shaped. Our shapes are adapted to carry out specific functions. Unfortunately, many books about how to paint and draw present the human form as a collection of simplified geometric shapes. For example, the head may be described as an egg shape, or the eyes as spheres, along with many squarish planes and slices, cubes and cylinders. It is important to remember that none of these abstract geometric forms exists on the body. Humans are human-shaped. We contain no surface shapes that are perfect geometric solids. Strictly speaking, there are also no such things as sharply defined planes. Some forms do face one way and others another way, but they all slide very smoothly and subtly into one another. Since all human forms are full and rounded, there are no sharply cut top, side, or underplanes.

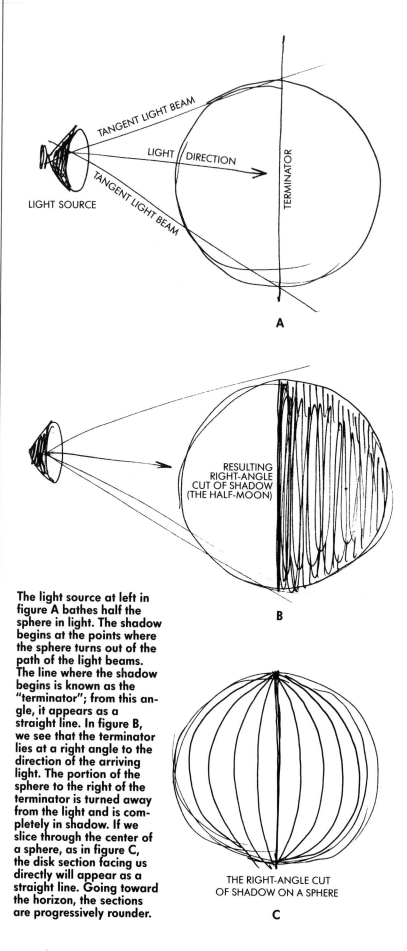

A

B

The light source at left in figure A bathes half the sphere in light. The shadow begins at the points where the sphere turns out of the path of the light beams. The line where the shadow begins is known as the "terminator"; from this angle, it appears as a straight line. In figure B, we see that the terminator lies at a right angle to the direction of the arriving light. The portion of the sphere to the right of the terminator is turned away from the light and is completely in shadow. If we slice through the center of a sphere, as in figure C, the disk section facing us directly will appear as a straight line. Going toward the horizon, the sections are progressively rounder.

THE RIGHT-ANGLE CUT OF SHADOW ON A SPHERE

C

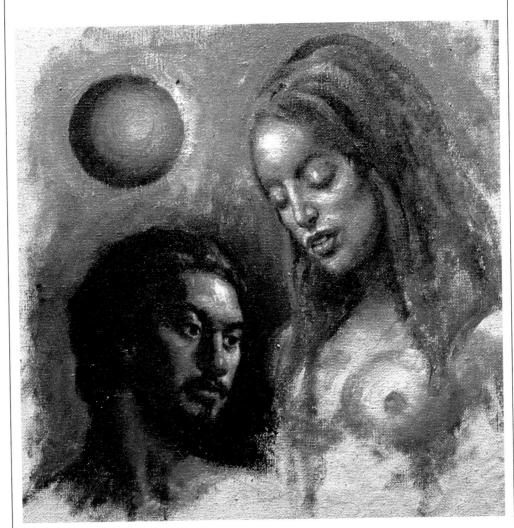

In the stylized, incorrect rendering at upper left, the gradations of value are painted as concentric circular movements, parallel to the contour of the sphere. The forms of the head at upper right are modeled in movements and gradations of value that run parallel to the contours of each form without regard to light direction. The forehead is modeled like the illustrated sphere, for example, and the modeling of the cheek follows the direction of the cheekbones. The portrait at lower left illustrates a less obvious but equally incorrect interpretation of the movements of light and shade that is quite widespread, especially among portraitists. Here, the shadow is shaped to fall exactly along the edges of the supposed side planes that run down the side of the whole head and are subdivided into the side plane of the forehead and the side plane of the cheek and jaw. Also, the shadow is shaped to lie along the horizontal underplane of the chin. These configurations subtly ignore the cut of light *across* the form due to directional factors.

Similarly, some human forms are rounder than others, some squarer, some more ovoid, but we must be careful not to create another kind of symbolic thinking from these geometric generalizations.

Nonetheless, in studying the fundamental actions of light on form, geometric shapes have a useful place.

Shadow on a Sphere. Let us put aside more poetic considerations and study the simple physics that determines the shapes of shadow on a sphere.

When we put a sphere in the path of light, it will always be exactly half in light and half in shadow, because it is the same shape in all directions. This does not mean that we will always see equal amounts of light and shadow. However, it is useful to remember that regardless of what proportions we may see, a ball lit by a single source is always half in light and half in shadow.

In our diagram, we see exactly half the sphere, or moon, turned toward the light. The line down the middle represents where the light ends and the shadow begins. Note that our diagram represents a sphere and not a flat disk. In astron-

omy, the line that divides light and shadow is called the "terminator." When we fill in the shadow area, a "half-moon" effect is seen.

Notice that the shadow's edge is a straight vertical cut. It may be confusing to imagine a perfectly straight line on the surface of a round ball, but that is how it appears when seen head-on. If, for example, we draw longitudinal lines on a globe, the line facing us head-on will appear straight. As our longitudes move away from the center they become less and less straight; at the horizon they are perfectly circular.

It is also important to notice that in all these diagrams, none of the lines within the circle is parallel to the outline. When we draw or paint the shape of the shadow on our models, this non-parallelism becomes very important. Art teachers and art instruction books often advise the student to put in the shadow parallel to the outline. This is not in accord with what we observe in nature. These concentric configurations are to be avoided on living forms.

These examples of parallelism are rather obvious, but in more refined work

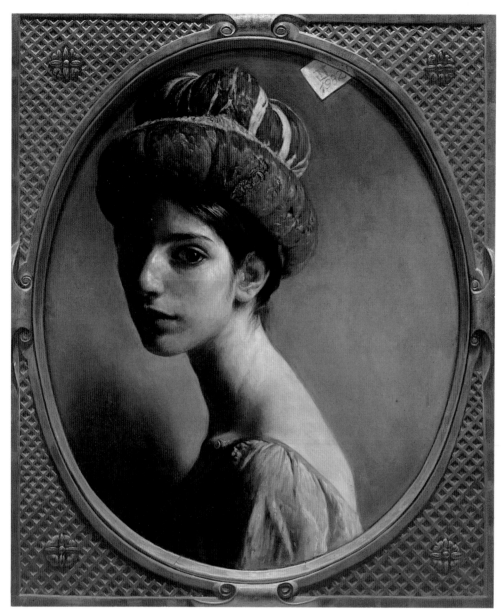

THE SQUASH PRINCESS, oil on canvas (frame painted in trompe l'oeil), 22" × 20" (55.9 × 50.8 cm), 1982

Light and shade patterns wash across these forms in nonparallel (non-concentric) patterns. Where the form is more cylindric, as in the neck, the pattern is more nearly parallel to the contours. It is not perfectly parallel to any outline.

These diagrams illustrate the proportions and shapes of light and shadow when any of the three elements—light source, observer, or model—is moved. A sphere is always exactly half in light, half in shadow. When we see more of the light side, the shape of the shadow is said to curve "with the light." When we see more of the shadow side, the shape of the shadow curves "against the light."

In the top diagram, the observer (OB) is directly opposite the light source. The light source and the observer remain stationary, and the model (M) orbits around the light. Each position of M shows the configuration of light and shadow that the observer will see. In the center diagram, OB is directly opposite the model; both are stationary. The light source (LT) orbits around the model. Each M shows how the model will appear to the observer when the light is in that position. In the bottom diagram, the light source is directly to the right of the model; both are stationary. The observer orbits around the model. Each sphere shows how it will look to an observer at each position.

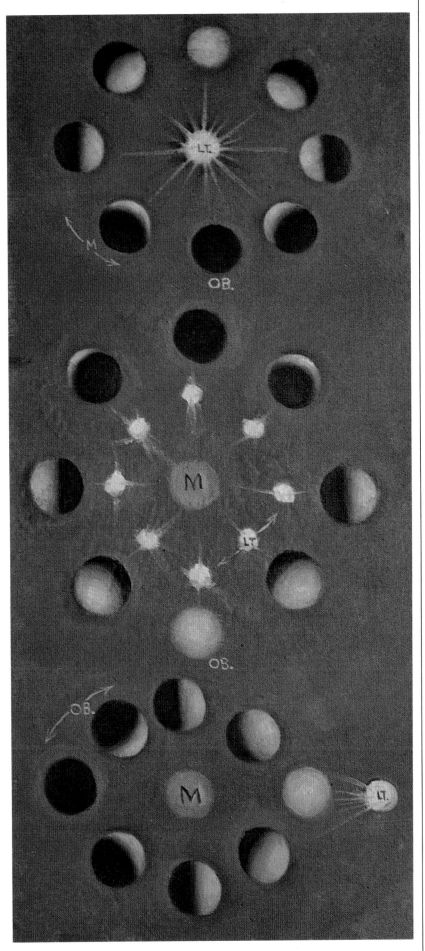

the same mistake may not be so apparent. We can find this error in most nineteenth-century French academic (Beaux-Arts) paintings and drawings of the figure and even in the work of some artists who were trained in that tradition and later rejected it.

On a sphere or an oval, the edge of the shadow will never be parallel to the edge of the form. It will more closely approach parallelism as it moves from the center of the form toward the edge, but it will not become parallel until it reaches the edge—at which time it disappears.

Proportions of Light and Shadow. The three simple factors that determine the amount and shape of shadow we will see are as follows:

1. the position of the light source (the direction of the light),
2. the position of the model, and
3. the position of the artist or observer.

If any one of these three positions is changed, both a different proportion and a different shape of light and shadow will appear.

For example, if you put the light behind the sphere, opposite you, you will be looking into the shadow; the model will be between you and the light. If you place the light where you are, you will see only the light side of the model. The first is called back-lighting and the second front-lighting. When the light is halfway between the back of the sphere and you, you will see the ball as half in light, half in shadow. If you move the light from that position around toward you, you will see the shadow become progressively thinner and less straight as it moves toward the edge of the sphere. As the diagram shows, these effects are clearly seen in the phases of the moon. In this diagram the positions of the light and the observer are fixed, while the moon-model orbits around the light.

We can produce the same effects by fixing the positions of the light source and the model and moving the artist around the model. In this diagram, the only difference from the preceding configuration is that the light is always on the right side of the moon. The understanding of these effects is equally useful when painting from a model and when working from imagination.

Light and Shadow on Simple Forms. Our first proposition, that a sphere is always half in light and half in shadow, represents a critically important principle: The shape of the shadow on a sphere lies at a perfect right angle to the

direction of the light. This is true no matter how we shift the positions of our three factors—light, model, and observer—and regardless of the proportion that we see of light to shadow.

The sphere is equally curved in all directions. It is turning toward and away from the light equally in all directions. Let us now see what happens when a form turns only in one direction.

The Cylinder. The cylinder can be described as a flat rectangular plane rotated around a central axis. Since it is rounded in only one direction, it turns toward and away from the light in only one direction. For this reason the shadows on a cylinder, unlike those on a sphere, *are* parallel to the edge of the form. Even when we tilt the cylinder at different angles to the light, the shadows remain parallel to the outline. In this respect the cylinder resembles the cube or other rectangular solid.

Rectangular Forms. Rectangular forms have no curvature, so those sides that are not facing the light fall into shadow and the edges of the shadow *will* be parallel to the outlines.

Oval and Egg-shaped Forms. These forms are something of a cross between the sphere and the cylinder. They are not equally round in all directions. Therefore the shadow edge does not lie perpendicular to the direction of the light. However, the more spherical the oval, the more closely the shadow approaches the right-angle-to-the-light configuration. We can find the angle at which a shadow will lie on an irregular ovoid form by observing the angle of the light. The shadow will begin where lines representing the light rays are tangent to the edge of the form.

This concept of variability of the angle at which shadows fall across forms is very useful to us when painting human forms. The shapes on the body change constantly, from more rounded to more oval, cylindrical, and square. The tilt of the shadow changes accordingly. Remember that the shape and angle of shadows are determined by three factors: the direction of the light, the shape of the forms, and your position.

The Gradation of Light Intensity on Cylinders and Cubes. Earlier, it was mentioned that the brightness of light decreases as it travels outward from its source. This decrease in intensity produces a gradation of value that lies *perpendicular* to the direction of the light ray. This is a very important principle. Be sure you understand it clearly.

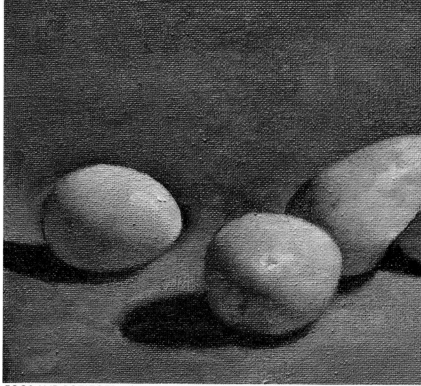

EGGS AND POTATOES, oil on canvas, 12″ × 18″ (30.5 × 45.7 cm), 1987

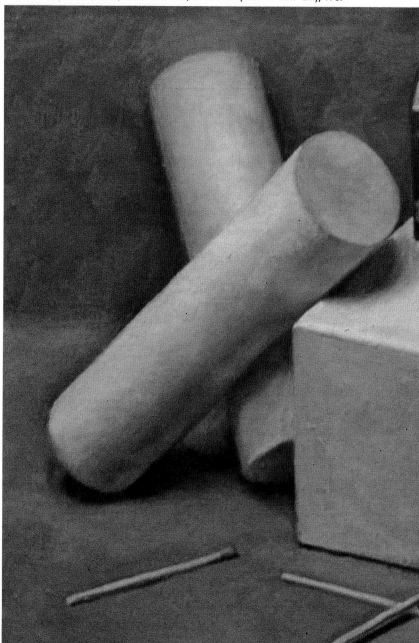

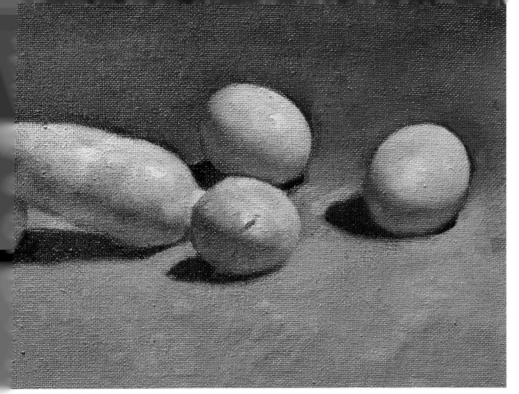

The light source is at upper right. Notice the subtle changes in the angulation of the shadows. If we lay a straightedge so that it connects the two ends of each crescent of shadow, we get the angle of the whole shadow across each form. The large potato, fifth from the left, being more cylindric in shape, has a shadow that more closely parallels the contours. The second potato from the left turns its rounded end toward us, so that we see a right-angle-to-the-light cut of shadow across its form. Notice the egg at far left. It is turned broadside to us, so that we see more of its ovoid-cylindrical shape. Compare it to the egg at far right, which turns its rounded end toward us. The cut of the shadow on the egg to the right is more perpendicular to the light than that on the egg to the left. Where the forms are more spherical, or present their rounder aspects to us, the shadow is more perpendicular to the light. The shadow is less perpendicular on the more ovoid forms, and even less so on the cylindrical forms. Notice, too, the lengthening of cast shadows on the ground as forms move farther from the light.

On cylindrical and cubic forms the shadows will lie parallel to the contours of the form. This is the opposite of what we see on round, oval, and all human forms.

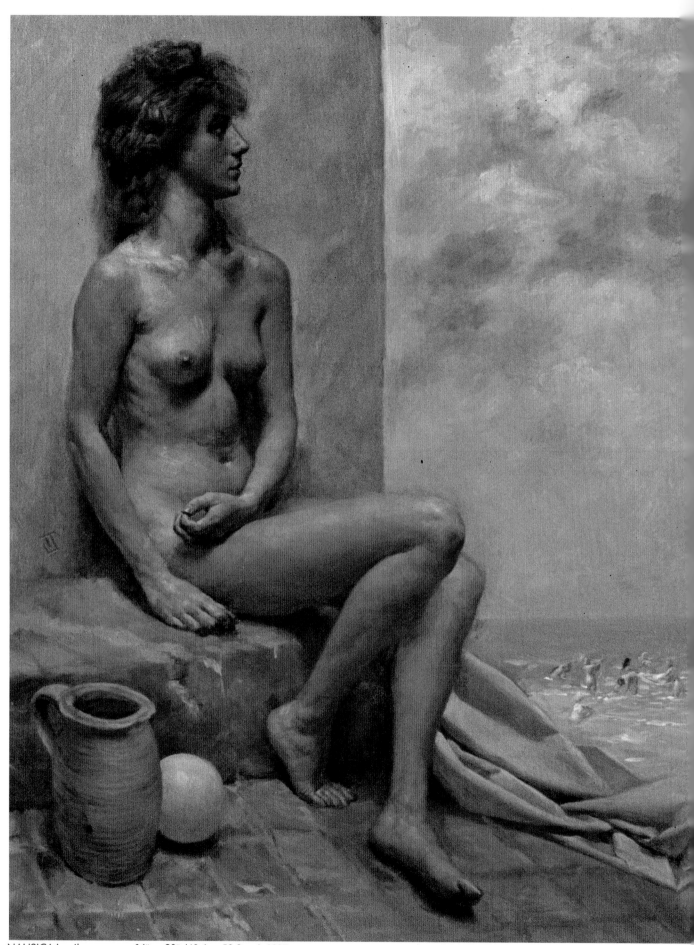

NAUSICAA, oil on canvas, 16″ × 20″ (40.6 × 50.8 cm), 1987

Even though this quick study was done in a somewhat diffuse north light, we can still easily see that each form shadow cuts across the forms at a particular angle. For example, on the rounder shapes of the breasts, the shadow is at a right angle to the light source (a skylight overhead and in front of the model). On the more cylindrical forms, such as the arms and the near leg, the shadow is more nearly parallel to the contours of the forms. Again, on the sole of the near foot, the shadow is only slightly angled across the squarer form. Notice, too, the arm resting in the lap. The squareness of the wrist causes the shadow to lie almost parallel to the contour, but immediately above, where the forearm swells into more roundness, the shadow cuts more sharply *across* the form, in a nonparallel configuration. Similarly, compare the rounder part of the rib cage, just above the navel, to the more ovoid section at the side, to our left.

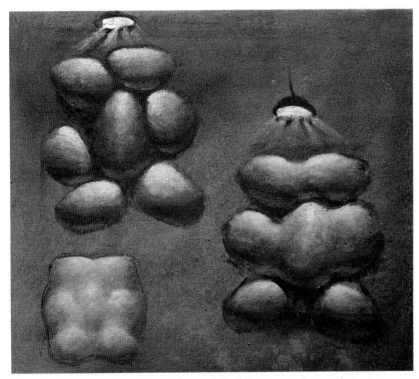

At upper left, a group of irregular rounded forms, stuck together at various angles, is illuminated by an overhead light. Notice the slight changes of angle of each shadow and the distribution of light on each shape. The part of each form turned most directly toward the light receives the most light; that area is called "the top of the form."

At right, the various forms are fused together somewhat. The light washes across the tops of the forms.

At lower left, the forms are further fused and connected at their junctures. It is important to see the spread of light from side to side, across the forms turned toward it. This shows us the unifying effects of one light direction on a multiplicity of forms. It is also very important to understand, from these three examples, how the light and the lighter values are "shaped," so that they wash across the top of the form. This shows how you can simultaneously paint the shape of each form and the direction of the light. You will see this effect on the human figure. Make sure you understand it thoroughly!

On a flat plane, such as a wall, this gradation appears smooth and continuous, but for a moment imagine that it takes the form of progressively darkening zones or ribbons. At what angle must we lay these ribbons on the wall in order to suggest both the gradation of light and the direction from which it comes? For example, if the window or light source on the wall is at the upper left, the gradation of light will darken going in the opposite direction, toward the lower right. The only way we can produce this effect is to lay our darkening ribbons down perpendicular to the arriving light ray. Any other angulation for our ribbons will seem to change the light direction. This effect of a perpendicular-to-the-light decrease in value is present on all forms. It is a characteristic of light itself.

On cubic and cylindrical shapes there is a double action of light. One effect of gradation is caused by the turning of the cylinder's form in one direction. As we have seen, the shadows on cylinders and cubes lie parallel to the outlines. The other effect of gradation of value, on both the cylinder and the flat planes of a cube, is caused by the decrease in intensity of light traveling through space. This gradation lies perpendicular to the direction of the light. We need to suggest these two effects.

We can also imagine the light as arriving in curtains or straight-edged waves that wash *across* whatever is in their path. If we imagine various forms lying in the path of these light-waves, we develop a clear idea of how light graduates directionally down *across* a form. This helps us to understand the perpendicular action of light. It helps us to grasp the fact that light on form is not amorphous but shaped, like shadow. This quality of shapeliness is common to light on all forms. It is one of the most important principles of light.

UNIFYING WASHES OF LIGHT

The directional nature of light gradations on form creates a pattern. It is like an overriding musical theme. The same action of light, occurring on forms from the largest to the smallest, produces a consistent directional effect—like washes of light— across the model.

Imagine that we put together, any old way, a variety of irregular rounded forms. Then imagine a light coming from one direction and falling on our ag-

glomeration. The forms are tilted every which way. The light is coming from *one* direction. The unidirectional character of the light imposes a unifying effect on the variously tilted forms. Although the shadows tilt at different angles, the gradation of light is perpendicular to the source. As we have seen, if the values do not graduate perpendicularly, the forms will not correctly turn toward and away from the light. The effect on these forms is like a wash of light passing over them, across them. This wash of light passes over not only the model but our whole field of vision. Whatever light falls upon receives this patterned effect.

If we imagine our various forms as being lumps of clay, we can see what would happen if we smoothed them all together somewhat. The wash of light across forms can be seen more clearly in this case. It is important to see this patterned wash of light on the figure. Without it there is a loss of unity and consistency. Remember, the tendency of light is not to travel with the form but to cut across it.

CAST SHADOWS

When forms turn their volumes away from the light, they fall into what is called "form shadow." There is a second kind of shadow, caused by another effect of light striking volumes. All opaque forms block out the light behind them. They project a zone of non-light, or shadow, behind themselves. These projected shadows are called "cast shadows." If another object enters this zone, the cast shadow will fall upon it. These cast-shadow zones extend into space. It is also useful to remember that these zones are three-dimensional. We can see the shadows cast by an airplane or cloud upon the earth, as well as that of a hand upon this page.

Cast shadows also have relatively clearly distinguishable shapes. The shape of a form shadow depends upon the direction of light and the shape of the turning form. The shape of a cast shadow depends on the direction of light, the shape of the form blocking the light, and the shape of the form upon which the cast shadow falls.

The outside contour of the cast shadow is a projection through space of the shape of the terminator onto the surface of the receiving form. Cast shadows take the shape of the form they lie upon, as would a very thin, supple cloth thrown over an object. It is therefore important

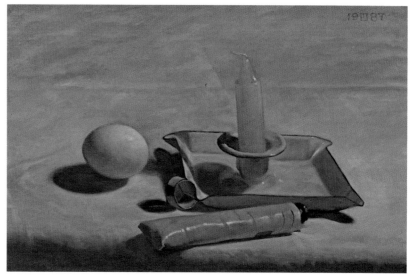

WHITES ON WHITE, oil on canvas, 8″ × 12″ (20.4 × 30.5 cm), 1987

Using this quick still-life study as our example, we can observe various effects caused by cast shadows. In the following three illustrations, I have repainted portions of the picture on an acetate overlay to vary the shadows.

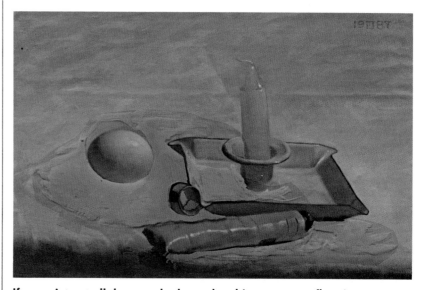

If we paint out all the cast shadows, the objects seem to float in space. They also become more "sculptural," in the sense that they lose the look both of something seen and of something illuminated. Without cast shadows, the various objects seem closer to our verbal-symbolic definitions: egg, tube, candle. We also no longer sense the speed of light in the picture. The objects seem heavier, more "material."

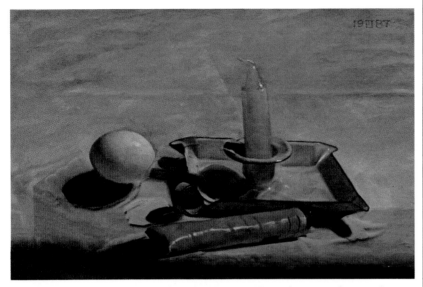

Notice how the shapes and tilts of various surfaces become distorted when the contours of cast shadows are incorrectly drawn. The cast shadow of the egg seems to indicate a light source coming from a different direction than that indicated by the form shadow. The cast shadow on the inclined rim on the left end of the candle-holder appears to flatten down the metal rim. The dish-shaped wax-catcher at the candle's base is also flattened. The cast shadow from the right-hand point of the holder makes the tabletop tilt downward. And notice how the cast shadow thrown behind the paint tube no longer follows the shape of the table's edge; this common fault is due to careless observation.

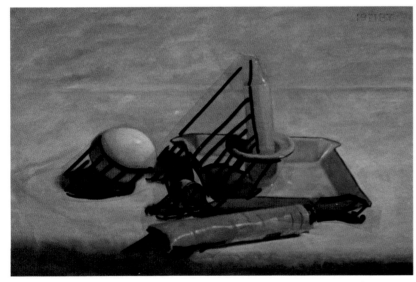

This illustration shows the three-dimensional zone of cast shadow. Notice that the cast shadow is projected from the terminator. Anything entering this zone will receive cast shadow.

to draw the shape of the cast shadow very carefully. If the edge of the cast shadow is incorrectly drawn, it will appear to deform the surface, flatten it, or hollow it.

Cast shadows also create a very strong illusion of space and dimensionality. They appear to cause the object that projects them to stand out in space. We can see the importance of this effect by painting the same object with and without its cast shadow. With its cast shadow, the object gives us quite a different sense of its place in space and, indeed, seems to create another kind of space around itself.

Different Characteristics of Cast and Form Shadows. The cast shadow is thrown *with* the light direction. In this respect it is opposite to the form shadow, which tends to lie *perpendicular* to the light direction. Cast shadows are thrown with the light; form shadows turn away from it.

Another characteristic difference between cast and form shadows is that generally the edges of cast shadows appear to be more sharply defined. The zone of darkest light is contiguous to the edge of the form shadow. This creates a zone of low contrast or an apparently softer edge. The cast shadows fall upon the light areas of the form with less regard for the softening effects of darker light. Cast shadows appear, also, where a form abruptly intercepts them. The shapes of cast shadows appear more as cutout shapes.

Commonly, the edges of cast shadows are sharp when they are close to the light source, which is to say, close to the cast shadow's point of origination. These edges appear softer as the cast shadow travels farther from the light source. In most lighting situations, all the rays do not arrive from a small concentrated area. Even though they may emanate from one principal source, there is usually some scattering of light arriving from the periphery of that source. These peripheral rays of much weaker intensity cause their own, correspondingly weak, cast shadows. These are called "penumbral" shadows. The multiple penumbral cast shadows radiate outward from the stronger main cast shadow, fanning out from the source of the cast shadow in ever weaker values. They resemble progressively lighter ribbons radiating away from the first cast shadow. The effect of these penumbral cast shadows is to make the shadow edge progressively softer as the shadow

is cast farther from its point of origin. We will find later that the softening effects of penumbral cast shadows play an important role in our contrast scale.

SHADOWS AND REFLECTED LIGHT

So far, shadows have been treated as an absence of light. In most of the situations we encounter, this absence is not absolute but relative. Shadows are rarely black, or totally without light. The law of incidence and reflection has already been discussed, and we learned that light is reflected from most surfaces.

Light Reflected into Shadow. As opposed to the primary light falling directly on an object, the light that bounces back into the shadow is called "reflected" light. This light is reflected into the shadow by surfaces that face toward the shadow and receive direct light. Only those surfaces favorably angled toward the shadow will reflect light into it. Many surfaces near a shadow will reflect light elsewhere. The diagram shows an illuminated ball in space with variously tilted planes scattered around it. We can see which planes will reflect light into the shadow and which will send the light elsewhere.

From this diagram we can also see that, in general, the reflected light tends to come from more or less the opposite direction from the primary light. For example, if the primary light comes from the upper right, most of the reflected light will arrive from the lower left.

Light Reflected into Light. We have just seen how the primary light reflects into the shadows. Let us say, then, that we can distinguish the primary light (which emanates from the source) from the secondary reflected light. In certain circumstances, we can even see a third kind of reflected light, or "tertiary" light. This tertiary light is very weak and is not usually noticed. It appears as a very faint glow *on the surface of the form reflecting the secondary light.* If a ball is thrown into a chimney, it bounces back and forth between the confining walls, trapped in that narrow place. Similarly, reflected, or secondary, light can be trapped between surfaces and bounced back and forth. After being thrown into the shadow, the light ray is then reflected from the shadow back to the surface from which it came—but by then, its luminous energy has been depleted and it

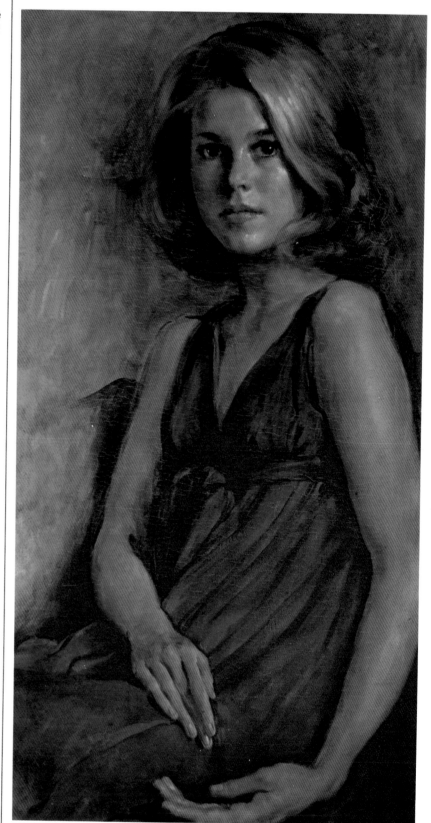

PORTRAIT OF JANE FONDA, oil on canvas, 38″ × 18″ (96.5 × 45.7 cm), 1963

Notice how the cast shadows on the face are most sharply defined nearest their point of origin.

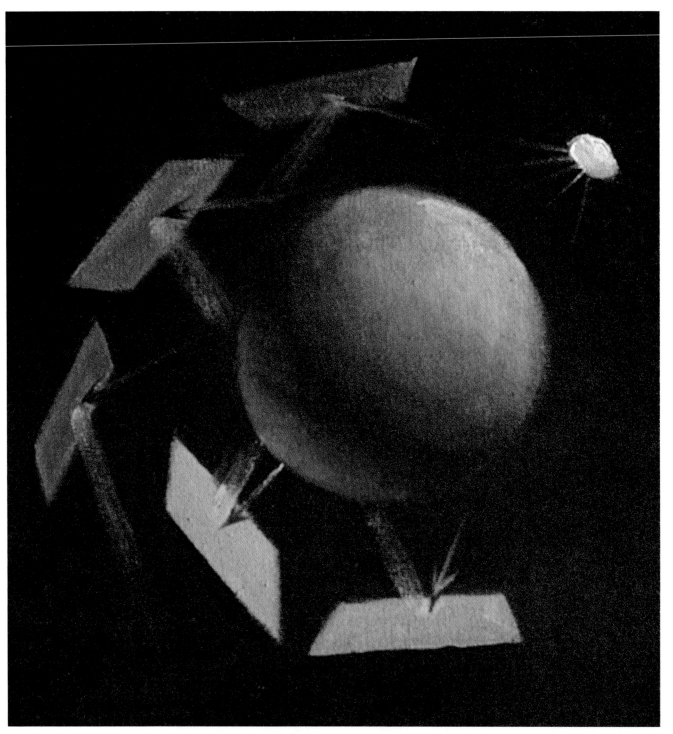

Light is reflected back into the shadows as it bounces off various objects surrounding the model. Our illustration shows which tilted forms will reflect light into the shadow and how much light each tilt will reflect.

The light source is to the upper right; the effects of cast shadows have been omitted. Going counterclockwise around the planes from top to bottom, the first plane receives light at a shallow angle of incidence and is therefore quite dark. It is also positioned to reflect its light away from the shadow on the ball, into space. The second plane receives light more directly than the first and is somewhat lighter. It is also positioned to throw some light into the upper side of the shadow. The third plane is not positioned to reflect light into the shadow at all. The fourth plane is angled most directly of all toward the arriving light rays. Therefore, the shadow will be lightest where it receives that reflected light. The bottom plane is the next most directly angled to receive and reflect light.

Like direct light, reflected light also cuts across the form and is not parallel to the contour of the sphere.

Light arriving from the lamp at upper left first strikes the tabletop (1), then reflects upward into the shadow area of the bowl (2), and is reflected back downward to the tabletop (3). Each time the rays of light strike a surface, they are partly absorbed, so the light reflected from each surface undergoes a spectral change, losing intensity and changing color.

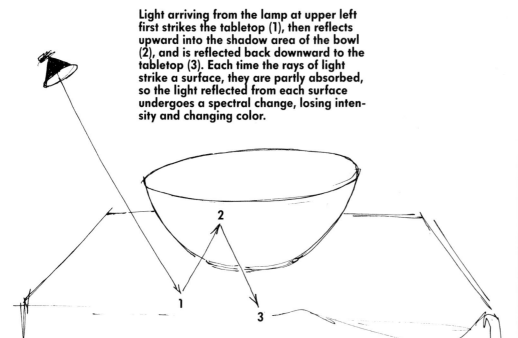

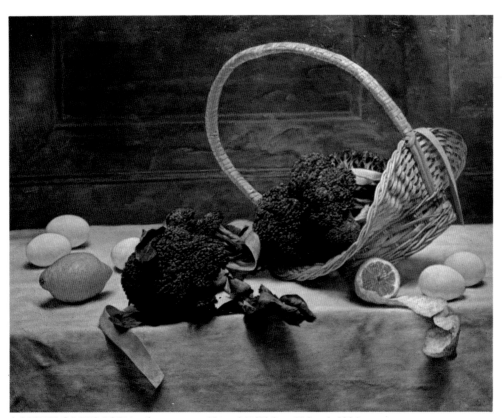

A BASKET OF BROCCOLI, oil on canvas, 20″ × 24″ (50.8 × 61.0 cm), 1986

The tertiary reflected glow can be seen as a faint chromatic aura at the edges of the shadows cast on the tablecloth. This tertiary light is reflected from the shadowed underplanes; its hue derives from the hue of the reflecting object. Because the object absorbs some light and reflects the rest, the reflected rays will not be the same hue as the reflector.

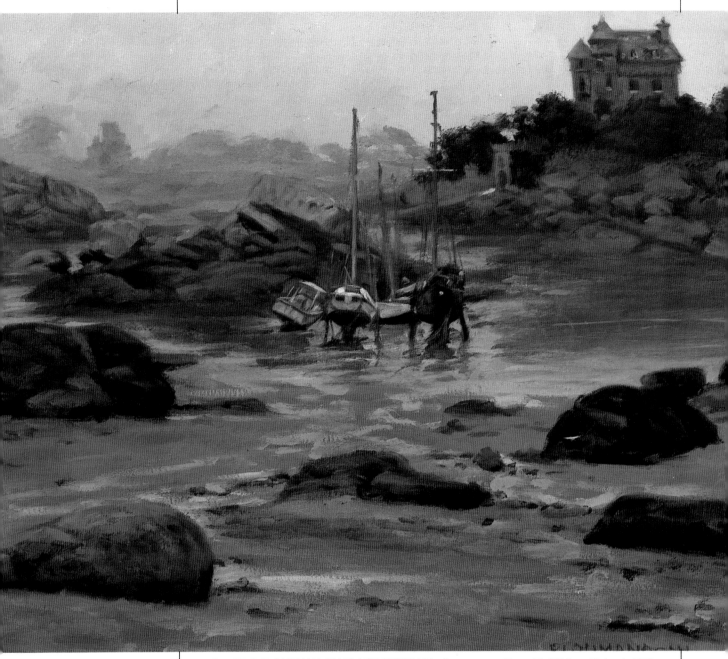

In this painting, we can see the effects of aerial perspective, the lightening of values as forms move farther from us and thickening layers of atmosphere are interposed.

is very weak. This effect can be seen, for example, in an overhead light, where the *underside* of a bowl throws a faint light back downward onto a white tablecloth, as in our diagram:

1. primary light from source
2. secondary light from tablecloth
3. tertiary light from bowl to tablecloth

It is also worthwhile to remember that microscopic particles in the surrounding atmosphere, as well as minute irregularities in any surface, may reflect light into the shadow. Shadows are often lightened by the layers of air between the artist and the subject. This effect is very pronounced outdoors, over large distances. Often, the farther away the subject, the more layers of intervening air and thus the lighter the shadows. There are, however, many possible unusual effects of lighting, as well as subtle extenuating circumstances, so that, like all rules, these should not be dogmatically assumed. Any effect crystallized into a "rule" becomes another symbol. It is more intelligent to accept what the eye finds and then try to deduce the reason. It is not a very good approach to tell nature what it ought to look like.

DEFINING FORM
WITH SHADOWS

We have learned that light diminishes in intensity, or darkens, as it travels from its source. We also know that it bounces, or reflects, from various surfaces. Naturally, then, it reflects more brightly as surfaces are turned more directly toward it and less brightly as surfaces turn away from it—not, by the way, as these surfaces turn away from *us*. This idea, simple as it is, remains one of the key principles of naturalistic painting. Without it, all forms would be painted as flat, since the implication would be that they were all turned toward the light at the same angle. Just as the difference in intensity of light from the source creates space, the variations of intensity caused by the turning of surfaces creates form. Simply put, if the light source is to the upper right of an object, the upper right area of the form will be lighter. If the form turns toward the lower left, it will gradually darken.

The Cut of Light Across Forms. The darkening of light—the direction of the gradations—lies at a right angle to the direction of the light. These gradations do not follow the shape of the form parallel to the outline. They do not move in concentric circles. The gradation of light cuts *across* the form. That is because even though a form may be spherical, the light travels in a line, a ray, from its source. The light does not *curve with* the form but *washes across* it. Neither do the gradations of light travel in the same direction as the rays. The gradations lie perpendicular to the rays. Any system for suggesting the volume of forms that does not follow this principle is not based on the actions of light. This can be clearly seen if we incorrectly graduate the light on a sphere *with* the light direction, rather than *across* it. This type of shading creates an anomaly. Our sphere seems to be rounded in one direction only, not at all in relation to where the light is coming from. In the direction of the light ray, the sphere appears completely flat. This type of shading is therefore symbolic. The same applies to a shading system that lies in concentric patterns parallel to the outline. This sphere is rounded but does not accord with the light direction. This artificial shading system is often taught in art schools and in instructional books. It is not seen in nature. It is, rather, a

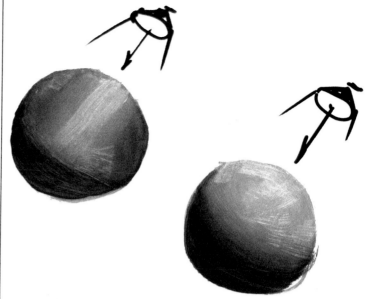

On the left-hand sphere, the light is graduated in the direction of the arriving light rays. This produces a modeling of form in one direction only and gives no sense of the position of the light source. The gradations of value on the center sphere lie perpendicular to the direction of the arriving light rays. This sphere is correctly modeled in all directions, and the modeling indicates where the light source is located. At right, the modeling is in concentric movements, parallel to the contour. This is an essentially non-visual, sculptural rendering of form.

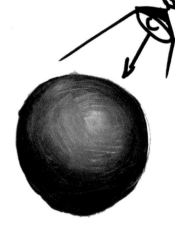

Here, the same subject is seen under two different light conditions. In the sketch at left, the light source is at the upper right of the model, so the lightest parts of the form are shifted to the upper right. As the form turns toward the lower left, it darkens. This is another way of saying that the gradations are arranged in patterns perpendicular to the light source.

In the right-hand sketch, the light is overhead, so the upper center part of the form is the lightest and the values darken as the forms turn downward.

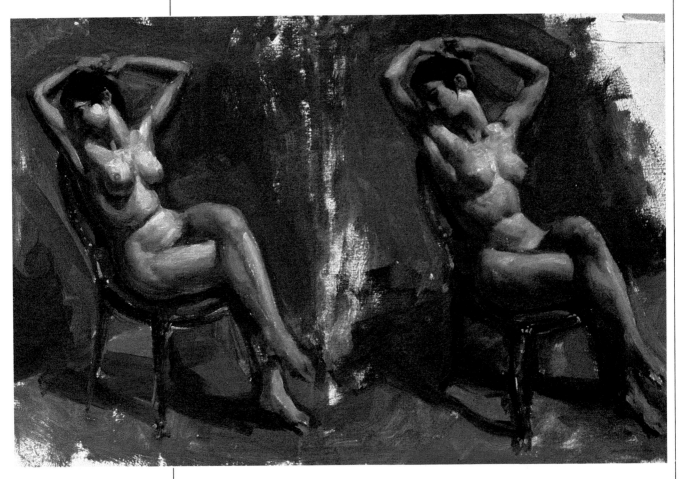

The figure on the left is painted with the "sculptural" approach; the patterns of light and shadow are essentially parallel to the contours. The modeling describes nameable parts of the body, such as breast, arm, and thigh. This sculptural-symbolic treatment has a certain power, conveying great sensuality and a feeling of solid weight. We can see this in the work of medieval painters, early Renaissance artists such as Mantegna and Signorelli, and twentieth-century artists such as Derain, Marsh, and Cadmus.

Contrast the nude on the right. Here the movements of light and shadow cut across the form rather than lying parallel to the contour. This approach takes equally into account the phenomenon of light and the shape of the form, and thus tends to "de-materialize" the appearance of things. Both figures suggest a sense of volume, but one is tactile and the other is visual.

sort of "sculptural" method of "modeling," rather than of *lighting*, form.

These examples with a sphere show the principles of light gradation clearly and simply. When working from the model, however, our symbolic identifications can easily prevent us from noticing these principles in action. It is, for instance, quite common to see the form unwittingly modeled with parallel configurations. In the illustration above, the modeling on the figure at left goes with the form, parallel to the outline. This modeling is symbolic in that the artist is thinking about modeling arms, head, torso, and other forms according to their verbal definitions.

In the figure at right, the patterning, or direction of the shading, tends to cut across the forms at right angles to the light. This suggests the figure as it appears to the eye.

These two somewhat opposite approaches represent what I consider the two major lines of development in Western art. I think of them as the "sculptural-symbolic," contrasted with the "optical-representational."

A Note on Technique. Art students often ask which way the brush or char-

coal stroke ought to go. This is a question of style, which I think is best left to the decision of each individual. In this approach, what *is* important is that the effects of light go in the right direction. The suggestion of light effects can be created by a great variety of techniques, such as hatching, horizontal strokes, verticals, a distribution of dots, or smooth washes. In fact, the same light effect, created by different techniques, will show the effect and hide the technique when seen from a distance.

These remarks apply equally to painting techniques, but it is important to remember that if the brushstroke travels in the direction of the light rays, the value must be constantly modulated. Otherwise, the brushstroke will "flatten" the form. In other words, when the stroke moves *with* the light direction, the artist must find a way to make the light gradations lie *perpendicular* to the brushstroke. Although this is feasible, it can prove difficult to execute. Traditionally, many painters who tried to suggest light found it easier to make the brush travel more or less at a right angle to the light. In that way, the form tends to "turn" almost automatically.

When the brushstrokes and the pattern

of gradations are both going in the same direction, the brushwork immediately suggests the effect of the form turning from the light. Here again, however, we must be careful not to turn this into a rigid system. The perpendicular movement of light is most perfect on a sphere. The shape of most forms we see is irregular and constantly changing in subtle ways. What we must try for is the shape and direction of each brushstroke that will best suggest the effect of light on a particular area of the form. If we try to find the right shape and direction and then compare what we have done to what we see, we can discover the best solution.

Forms on Top of Forms. Compared to pure geometric shapes, such as spheres, cylinders, and cubes, most of the forms we deal with are quite complex. There are all sorts of sub-forms, or smaller forms atop larger ones. There are valleys, ridges, corners, creases, bulges, and many other variations. In trying to suggest these infinitely various complexities, it is difficult to grasp the underlying unity of light effects—their orchestration. However, that is one of the highest goals in painting and drawing. We want to represent all the diversity of life yet not destroy the underlying harmonizing effect of light. Perhaps what is most difficult in art is to walk a middle path between oversimplification and overparticularization, between too soft and too hard, between too broad and too "picky."

Geometric forms are useful because they are simple and uncomplicated. They clearly show the actions of light. From the study of light effects on simple forms, we learn the actions of light in very complex situations. Accordingly, let us again study our sphere.

As we know, if the light comes from the upper right, the upper right portion of our ball will be the lightest general area. The ball will progressively darken as it turns toward the lower left. Very broadly speaking, then, whatever is found in that upper right zone will tend to be lighter than whatever lies in the lower left area, because the lower left is farther from the source and because it is less directly angled toward the light. For these reasons, any smaller form on the surface of a lighter one will darken as the larger form turns from the light. This can be clearly seen in a diagram. We can see how the angle becomes less direct as the sub-forms rotate away from the light. This will appear as a progressive darkening of the values of light on the

All the brushstrokes in the figure sketch at left are applied horizontally, but the light and shadow patterns run diagonally across the forms. We must create slanting gradations with horizontal strokes by controlling the distribution of light so that the upper right part of each form catches more light. Spreading the same amount of light too far across the form, from right to left, will flatten it. In the figure at right, the brushwork is laid on diagonally, perpendicular to the direction of the arriving light. It is quite easy to model the form this way.

In the three head studies, different techniques are used to show the same effects of light. In the top sketch, the brushstrokes are all vertical; in the center, the strokes are blended; and in the bottom sketch, they are pointillist dots. If you look at this page from across the room the technique will disappear and the three studies will show the same light effects.

We can see from figure 1 that one point on each sub-form will be facing directly toward the light; that point will be the brightest on the sub-form. The closer any point on the surface is to the light source, the brighter it will appear because the strength of the light diminishes with distance. Thus, point B will be the brightest, followed by points, C, A, and D.

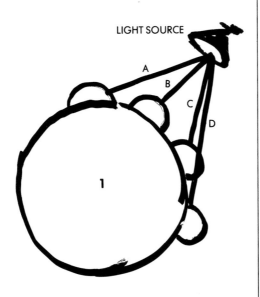

LIGHT SOURCE

1

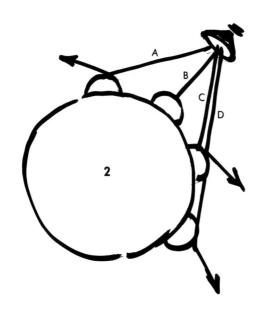

2

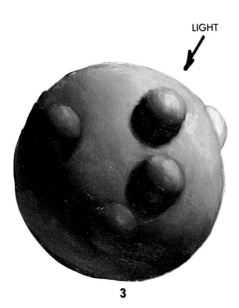

LIGHT

3

Angles of incidence and reflection are illustrated in figure 2. The more direct the angle at which a ray of light strikes an object, the more light will be reflected. A light ray striking the object at a wider angle will produce a weaker reflection. Thus, light reflected from point B will appear brightest, followed by that from points C, A, and D.

Figure 3 shows how sub-forms on top of a larger form will appear when lit by a single source at upper right. Intensity and gradation of light must be very carefully orchestrated.

sub-forms. The illustration shows how this will appear visually.

Using this idea, we can "orchestrate" all our smaller forms to fit in properly with the larger underlying forms. If, for example, we render the light on the lowest sub-form too high in value, we create an anomaly, or contradiction in the data, between the position of the form and the amount of light it receives. This contradiction between drawing and value destroys the illusion of a coherent and consistent reality. When a picture implies a specific light source, the observer subconsciously expects a rational distribution of light. The mind has difficulty finding a reasonable explanation for inconsistencies within the painted world, with the result that the picture containing them will become unconvincing, "unreal."

On each one of our descending subforms, there will be one point that is turned perpendicular to the light. These points, however, will not be equally bright, because of the difference in distances from the source to each sub-form.

CURVES OF LIGHT

It could be said that when light strikes a rounded surface, the value gradation "curves" downward as the forms curve away from the source. In this sense, we can speak of a "curve of value." We see this effect on any curved surface. What occurs is the double action of decreasing light value due to increasing distance from the source and darkening caused by changes in the angles of incident light rays striking the surface.

We must take these two factors into account if we wish to understand what is happening on a model. For example, a part of the model turned directly toward the light may appear lighter than another part that is closer to the source but turned less directly toward it. The curvature of light values can be shown on variously bent planes. Because it underlies what is happening on our models, it is very important to understand how this effect works. The human body, in any pose, always expresses one underlying curve, or a group of curves, and therefore this effect is always present on the figure. The illustration shows these effects on abstract curved planes and on the body.

When we represent curved forms, the curve of line and the curve of light must be in perfect agreement. As the line curves, or moves farther from the light,

the value must be modulated accordingly.

For example, although the head may be closer to the light, it still may be darker in value than the chest if the head is turned less directly toward the light. In order to see more clearly the tilts of a pose, it is useful to walk around the model and observe him or her from a different viewpoint.

As always, observation is our best guide. Special circumstances can produce surprising effects. For example, the illustration on page 59 shows how a point on a curved plane can be higher in value than another point that is closer to the light. It is important to realize that any dogmatic assumptions can prevent us from noticing what the eye registers.

The idea of an underlying curvature that describes the whole form from one end to the other, with its accompanying curve of light, is very important. In the preceding illustration, for example, if we give the various points along the curve the same value, we eliminate the effect of distance between them and "flatten" the form. These value changes are obvious in a diagram, but it is easy, when working from the subtleties of a live model, to become absorbed in separate details and unthinkingly put the same value everywhere. The best way to avoid this error is to constantly compare all points on the model to one another. Try to sensitize yourself to register the differences in value. It greatly helps to constantly scan

This pose clearly shows the correspondence between the curving tilts of the figure and the curve of light distribution. The light source is at upper right.

MOONRISE, oil on canvas, 18″ × 24″ (45.7 × 61.0 cm), 1972

In order to understand the underlying movements of light on form, it is often necessary to mentally eliminate the details of forms—to smooth them out, as we would modeling clay—and imagine the broad, generalized curves we would then find. The modulations of light on these planes are the curves of light. The value intensities must be in perfect agreement with the linear changes and with the drop in strength as the rays of light travel through space. There is an unexpected effect in the figure at right: part of the model's right breast is lighter than her right arm, even though the arm is closer to the light.

the whole pose. Our eyes must "rove" about. When we rivet our focus on an isolated spot, we are no longer looking at the relationships between all the parts, and mistakes become inevitable.

LIGHT AND THE FIGURE

To avoid possible misunderstandings, let me clearly state that no one's head is shaped like an egg. Nor is the human body, like some sort of doll, made out of jointed egg-shaped sections. Nor is it made of spheres, rectangles, or any other geometric shapes. The head is shaped like a head and the body like a body. And yet, and yet, beneath the subtle and complex shapes of the body there seem to lie simpler forms. These underlying basic forms give to the surface of the body a fullness, an amplitude. Without this, forms seem thin, hollow, cramped and

skimpy, or pinched. Without an underlying fullness, forms seem underdeveloped, as if made of small unrelated pieces.

Modeling the Masses. Human form seems to grow outward from a center. It burgeons toward the surface like a ripening fruit. Although each person's head is an individual and characteristic shape, it can be generalized. All the features and smaller forms seem to be set upon a larger and simpler underlying shape. Let us call this simple, full form some kind of an egg.

What is important about our "egg" is how the light on it is distributed, or orchestrated. It is vital that we do not destroy the fullness of the underlying egg as we describe the various surface structures. We must accord each place on the egg its proper value. We must model the form in all its fullness.

An egg shape could be described as a sphere that has been somewhat flattened.

It is as if we rolled a ball of clay unevenly between our hands. An egg is an irregularly flattened sphere, so the gradation of light upon the surface will be "flatter" than on a true ball. The value changes on an egg are less extreme than those on a sphere. On the egg, the light seems to slide farther across the flatter surfaces. The greater roundness of the sphere produces more value change.

In painting the head, then, it is vital to model the essential underlying shape. This is also true for all other parts of the body. The whole upper torso is another sort of egg. The hip section and the stomach are others. The neck has a somewhat columnar form. The arms and legs are tapered cylindrical forms or elongated conics. The eyes and the cranium show an underlying spherical tendency. Although nothing human is mechanically geometric, we nevertheless need to preserve the fullness of all forms by modeling their particular "eggs." This conception of a larger and simpler underlying shape can be clearly seen in old master paintings, sculpture, and drawings. Obviously, this fundamental idea is part of an ancient tradition.

The Question of Planes. Before discussing planes, about which so much has been taught and written, let us first determine what they are. Earlier, it was said that some parts of the body face one way and others face another way. For example, parts of the forehead, the nose, and the chest, can be said to face more forward than sideways. These can be described as the front planes. However, there are no flat places on the body and no geometrically sharp corners where two planes meet. Everything on the body is somewhat curved. The front of the forehead, for example, merges imperceptibly into the side. Even the bridge of the nose is rounded into the sides. The chest too, turns constantly. There are no definite sharp dividing edges on the body, so, strictly speaking, there are no planes. There is a sort of frontality, as well as upward-, under-, and sideways-facing forms. It is important to remember that planes are another artificial, symbolic notion. Artists who do not realize this tend to divide the form too much, into abrupt, choppy sections.

On the other hand, manufactured forms have true planes: the sides of a box, the faces of a pyramid, the top of a can, the facets of a diamond. In painting and drawing the body, what is useful for us is the abstract idea of planarity. Like our unreal but necessary underlying

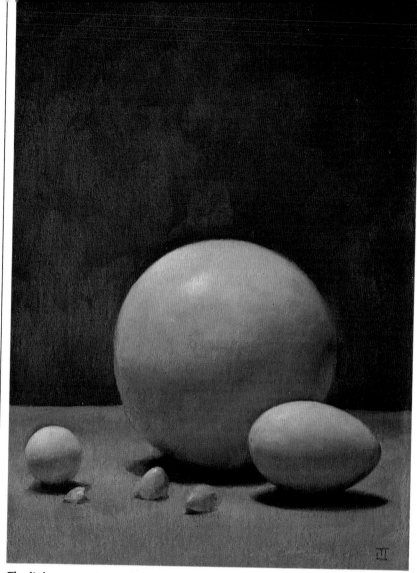

The light source is overhead and slightly to the left. The sphere, being rounder, shows a wider range of value gradation (more easily seen in the light). The ovoid, or egg, being slightly flatter, "flattens" the light, that is, it shows less value variation. When we turn the round end of an egg toward us, as on the left, it looks more like a spherical form.

Note the changing angle of the arc of shadow on each form. On the sphere, it is at a perfect right angle to the direction of the light. On the ovoids, it is more nearly parallel to the contours of the object.

Also notice that the lightest part of the ball (if we ignore the highlight) is the far edge at the upper left. That is the area most directly turned toward the light. Because it curves *away* from us, it appears as a foreshortened area; the value changes are compressed. The cast shadows reflect less light than the tabletop, so there is a darkened area in the form shadow directly above them.

BATHER ON A ROCK, oil on canvas, 12" × 9" (30.5 × 22.9 cm), 1973

Smaller forms, sub-forms, and detail should not be allowed to detract from the underlying fullness of form.

DORRIS IN A HANSOM CAB, oil on canvas, 30" × 36" (76.2 × 91.4 cm), 1964

As the neck merges with the shoulder, the forms tilt upward more and catch more light than the somewhat downward-tilting plane that runs from cheekbone to jawline.

"egg," we need to use a sense of underlying "plane."

This idea of plane means that large movements of form have a certain tilt, or orientation in space. A person sitting in a chair, for example, can be said to have a top plane of lap, a vertical plane of lower legs, and some kind of inclined top plane across the feet. If the arms are placed upon an armrest, the lower arms become another top plane. Please notice, too, that these general planes are seldom perfectly horizontal or vertical when the body is in action. A standing person's chest is generally more uptilted than the abdomen, the neck is usually tilted at a downward

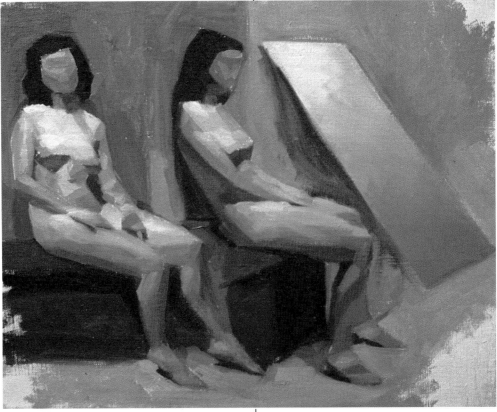

The uptilted chest plane receives more light than the rest of the torso plane, which is turned less directly toward the light. Notice how the whole plane of the lap, including the wrists and hands, can be generalized into one tilted plane washed across by light.

We look more frontally at the figure on the left. If we paint the same pose seen from the side, the downward tilt of the whole head and the slant of the whole torso become more noticeable.

Ignore the separate tilts and parts, such as the head, chest, and lap, and imagine a plane connecting the head to the feet: the tilt of the whole pose. This helps us to understand the top-to-bottom distribution, the wash of light, over the whole pose.

angle, and so on. Each of these tilted planes reflects an appropriate overall amount of light. All the smaller subforms on these planes will also only receive the amount of light appropriate for the tilt of the whole plane. This is exactly the same as our idea about a curve of light, except that now, rather than undulating curves, we are imagining flat, tilting planes. Let us illustrate some planes of our seated pose and the different angles at which light strikes various planes. Remember that a more direct, or acute, angle means a stronger reflection, a higher value.

We notice that the whole forehead-nose plane is angled more toward the light than the nose-chin plane. The neck

is less directly angled than the upturned chest, the chest more than the stomach, and so on. Also, remember that our figure is three-dimensional. Let us "project" a side view of the same pose and study the planes that are not so apparent in the front view.

We can also generalize the whole pose as a tilted plane. Imagine that each pose has a general orientation in space, a tilt. In each pose, the body will present a certain tilt toward the light. It is very important to understand the generalized plane of a pose in order to control the gradation of value over the entire plane. Value changes depend essentially on these factors: first, the diminishing strength of light as it travels through space; second, the tilt of the plane; third, the turning of rounded forms toward and away from the arriving ray of light.

Broad imaginary generalizations are convenient concepts that help us avoid disturbing the orchestration of values by our excessive absorption in unrelated details. The wash of light over the whole plane of the pose, like a diminishing waterfall of light, is a very beautiful effect in nature. We should try to judge its progression without exaggeration in any direction—neither darkening down the progression too much as it washes down the plane nor flattening value changes by spreading the same value over too large an area. Both are stylized symbolic preferences.

Besides the three main factors just mentioned, there are others that influence the value scale. The placement of the observer-artist relative to the positions of the source of light and the model will also affect the determination of values. Another influence is what is called "local color."

LOCAL COLOR

If we dunk something in dark brown paint, it will come out dark brown. If we dye a white cloth sky blue, it will turn sky blue. The inherent natural color of a thing is called its "local color." All local colors have a certain "local" value. Besides being brown, dark brown is darker in value than sky blue. These local colors are an important factor in determining how light or dark something may look.

Like planes, however, the idea of local color is another kind of nonexistent convenience, as far as suggesting light effects goes. A brown shirt, for example,

HENDAYE-FUENTARRABIA, oil on canvas, 8″ × 5½″ (20.3 × 14.0 cm), 1980

A small, very rapid study of the unexpected colorations in nature.

appears to the eye as an infinite number of variations in value, hue, and chroma. At every point it differs from every other point. In that sense, there is no such thing as a shirt being brown. Paradoxically, however, we can take a very generalized view and classify it as brown. Although these distinctions may seem like nitpicking, they are important to the artist. We must remember that all surfaces are broken into an infinity of variations. The idea of a local color is somewhat symbolic. When carried to excess, it produces a very artificial appearance. For example, when painting the brown shirt, if we mix only lighter and darker gradations of our brown local color, the result will look like paint mixtures. It will not be optically convincing. We do not see local colors so much as light effects. The nature of light is such that changes occur simultaneously in all our scales. For example, as the light diminishes, the chroma and hue change with the value. All the other scales change in unison. If, for example, you lighten the browns of a shirt by adding only more white, or any other single color, you are making paint changes but not light-effect changes.

Some painters and teachers make up arbitrary rules about the effects of light on local colors. Some say that in a given situation, for example, nothing on a white shirt can be as dark in value as something on a black jacket. This is an arbitrary assumption based on symbolic ideas of whiteness and blackness. It is better to keep the mind open and learn from observation. Many painters have similarly fixed ideas about the values that can be used in outdoor landscape scenes. I have also heard it as a given that in a picture, nothing in the shadow can be lighter than an object in the light. For example, a white collar in the shadow cannot be lighter than a black jacket in the light. All such formulae should be checked against our optical experience. Do not be afraid to discover the unexpected.

ORCHESTRATING CONTRASTS

One of the important scales we work with is that of contrast. As mentioned earlier, it is the nature of shadow to obscure differences and definition, just as light accentuates them. For this reason, areas of higher contrast generally are found either in the light, or where a light area collides with a dark zone, or where the light meets the shadow edge.

Edge Contrasts. Edges are an important element of the contrast scale. Generally speaking, edges are what happens when one tonality meets another. This occurs, for example, where one object abuts another, such as a shirt collar against the skin or the contour of the head against a background. Edges also appear where the varied edge of the shadow meets the light. Edges exist between changes of value or any other variable, so that, actually, they are everywhere. All these edge effects can be said to form another scale, from very soft to quite sharp. Since, in the last analysis, all edges are the result of interactions within our perceptual process, they are all optical effects. It is more correct to think of them as optical light effects than as physically contiguous elements, such as collar against skin or head against background. If we think of edges in these physical, verbally symbolic terms, we will tend not to notice the optical appearance and its subtle variations.

Variations in Contrast. All our various scales are ways of describing the seen effects of light. They are our tools. Since they all derive from the effects of the light source, they all reinforce one another. They are actually only different ways of describing the same phenomenon. Let us see what sorts of effects happen when we begin to combine these various scales.

For example, if we combine our scale of values with observed effects of form shadows and cast shadows, we find an interesting result in the contrast scale.

When light flows from its source, it is brighter where the form turns more directly toward the light. On the other hand, because less reflected light reaches them there, cast shadows tend to be darker *near the light source* or in the area of a form turned directly toward the light. Therefore, we find a zone where the brighter light values collide with the darker cast shadow values. This creates an area of very high contrast. As a form turns gradually away from the light, it moves down the contrast scale. The light then darkens and the shadows lighten. In the illustration, we can see the high-contrast area of our egg is up in the brighter light zone, where the darkest cast shadows from the sub-forms lie atop the higher light values.

As mentioned earlier, the sharper edges of cast shadows occur at their

1914: THE WAR TO END ALL WARS, oil on canvas, 30″ × 36″ (76.2 × 91.4 cm), 1983

points of origin, which are toward the light source. These dark darks falling with sharp edges across light lights create a high-contrast zone. It is very important to correctly orchestrate the contrast scale from high to low. If everything has equal contrast, the result will be unnaturally hard and flat.

We can arrange our sub-forms on a larger egg to create a somewhat abstract representation of what happens on the human head, as in the illustration on page 69. Although this is a highly abstract schematization, we can nevertheless clearly see where the higher contrasts will be found. We could say that our contrast scale runs upward as we move toward the light source.

We can also see that there is a secondary contrast zone where the light meets the shadow at the terminator. This area is softened by the darkening of the light values as the form rolls toward the shadow. At the terminator, the shadow and the light are both at their darkest on the value scale. Because everything in it is quite dark, this narrow band is often a very low-contrast area. It is the place where all distinctions are usually most obscure: differences, for example, of materials, textures, or local colors. It is difficult to see what is happening in this terminator zone. It should be rendered as it appears to the eye. Do not artificially force definition and contrast into it. We must try to accurately suggest obscurity. The alternation of "lost and found" is very important.

Some people assume that the shadows on sub-forms and their cast shadows ought to be lighter when they are found in the brighter light areas. This is exactly the *opposite* of what usually happens. Shadows become lighter as they turn toward the *reflected* light source. As a form turns toward the *primary* light, it turns *away* from the sources of reflected light, so that any shadows found on forms in that higher direct light area will, in fact, be darker. And, too, the proximity of brighter lights creates a field effect that causes the shadows to appear even darker.

Looking at our abstract head, we can also see that the more intense contrasts fall into a sort of pattern. On the form as a whole, and on all the sub-forms, the

Some of the white forms in the shadow are lighter in value than some of the dark blue and dark green colors in the light.

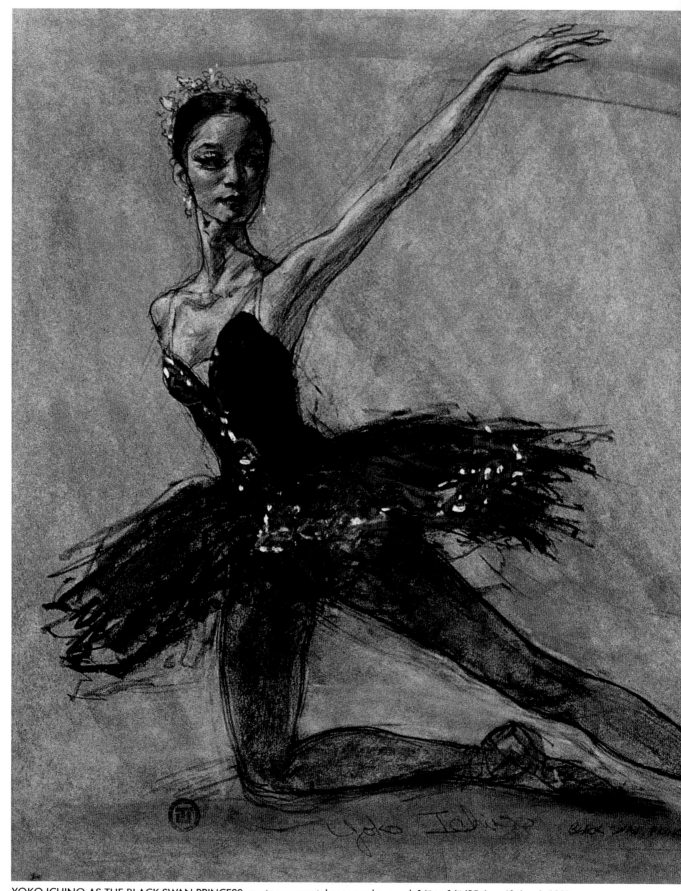

YOKO ICHINO AS THE BLACK SWAN PRINCESS, conte over pastel prepared ground, 14" × 16" (35.6 × 40.6 cm), 1981

Note how the sharper contrasts are found nearer the light source.
Travelling away from the source, we go down the contrast scale.

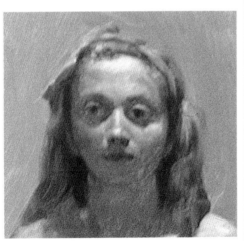

In the top painting, the whole head has been simplified to an egg-like shape and is lit from above. The sharpest contrast is at the top, where the dark hair-edge collides with the bright top of the forehead. Another high contrast occurs where the cast shadow falls on the light upturn of the shoulder. The head in the center is constructed from a large ovoid form with smaller ovoids sculpted into it. The strongest contrasts are found at the top of each sub-form, where the cast shadows fall over the brighter values. The more naturalistic version (bottom) shows the patterning of high-contrast zones.

higher-contrast area appears where the form is turned most directly toward the light source. This is like a recurring theme, found on the large underlying form and repeated in all the smaller sub-forms. The part of a form that is turned most directly toward the light is sometimes called "the top of the form." The placement of the top of the form depends on where the light is coming from. The phrase does not mean the area of the form that turns upward.

Let us look at the patterning of high contrasts as it would appear in an overhead light on our schematic head. Our contrast areas on the whole egg and on each sub-form are all shifted toward the overhead source. This creates a consistent pattern, orchestrated from top to bottom. The shape of the form and the shape of the light effects are in agreement. Also, notice how each light direction emphasizes the patterning perpendicular to it—across the forms.

When there is only one major light source, cast shadows merge imperceptibly with form shadows at the terminator. We do not distinguish the cast shadow inside the form shadow. The two become, simply, shadow.

In cases where there are two or more light sources, we may then see cast shadows as separated shapes within form-shadow areas. We will look at these effects more carefully under a discussion of multiple light sources.

Let us summarize the interactions of light gradations and the contrast scale. What happens can be compared to the interplay in still water of the radiating ripples made by pebbles dropped at different places. The ripples pass through one another while maintaining their separate identities. Moving away from the light source, the light darkens as the shadow lightens. The differences in value between these two decreases as they move away from the light source. As these values progressively come closer, contrast decreases. This typical effect can be schematized as two columns: one for the light, another for shadow. If we look at a figure placed in the same light, we can clearly see the progression on the contrast scale.

HIGHLIGHTS

All optically registered effects can be described as reflections of light. However, the phenomena we call "highlights" present a somewhat special case.

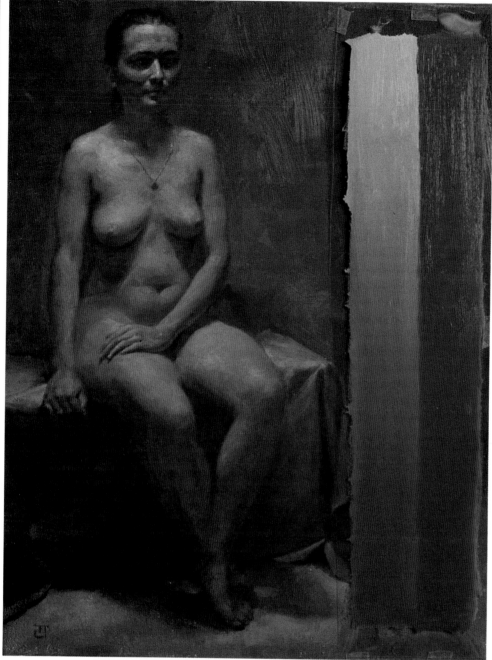

SEATED MODEL, oil on canvas, 13" × 10" (33.0 × 25.4 cm), 1987

Our model is seated under an overhead skylight. The light values will tend to be higher, and the shadow values darker, on the areas of the model that are closer to the light source. Thus, there will be greater contrasts toward the upper part of this figure.

On the right is a generalized schematization of the value progressions of both the light and the shadow, set side by side. These scales represent the amount of light available in space at each point from top to bottom. In both model and scales there is progressively less difference in value between light and shadow as the distance from the light source increases. This is another instance in which you must look for the underlying general gradations on the model, irrespective of value changes caused by various tilts and turns of individual forms. You have to learn to "peel away" the variations and look "under" them to the larger progression of value change.

Highlights are most often found on relatively sharp corners and edges and also on shinier surfaces, where the texture becomes more mirrorlike. We will first discuss these mirrorlike highlight effects.

The Wandering Highlights. Highlights like everything we see, are light effects. They are *not*, so to speak, "pasted" on a certain part of the form like a small, extra-bright postage stamp. They are optical effects, and as such, their apparent position depends on the spatial relationships of our three factors: the light source, the model, and the observer. As we change any one of these locations, the apparent position of the highlight will also change. The highlight will appear on the form in a position determined by the previously mentioned law of incidence and reflection. We will see the highlight at that point where the angle of incidence between the light source and the surface of the form is the same as the angle in the opposite direction between the surface and our eyes. The apparent location of the highlight can easily be diagrammed.

In the illustration at left, the light and the model have remained in position, while the observer has moved. The result is that the highlight moves, or shifts, with the observer. This traveling effect of the

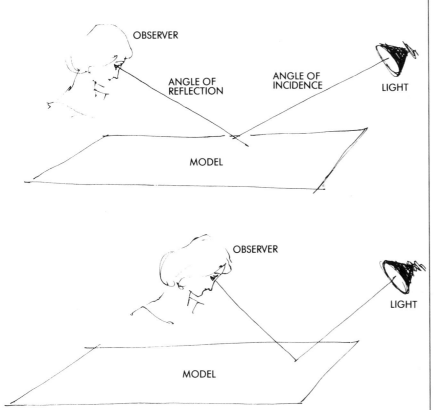

The light and the tabletop remain in the same position. When the observer changes position, the highlight moves with her.

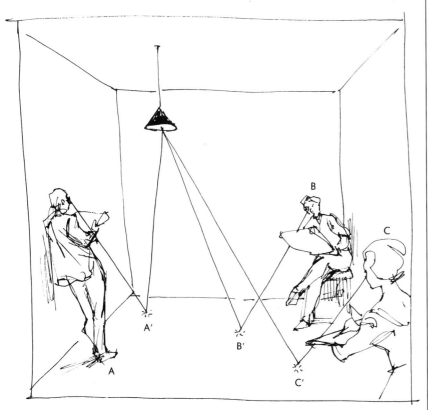

In our sketch, imagine a very shiny floor surface in a room occupied by three people. Because of the law of incidence and reflection, observer A will see the highlight on the floor at A', observer B will see it at B', and observer C will see it at C'

highlight can clearly be seen when we walk along a sunny beach, and the sun's reflection—the highlight—seems to walk with us.

We can also observe this effect by walking slowly around the model and carefully noticing the way the highlight changes position. Incidentally, this conception of a traveling highlight is quite different from what is often said in art instruction books—that the highlight is supposed to always sit more or less in the center of the brightest area.

It is also useful to observe what happens when we place ourselves against the light, on the shadow side of the model. The highlight is displaced toward us, closer to the shadow edge, glaring out of a dark light zone. In this case the highlights are not found in the center of the light area, as we might expect, but are crowded nearer the terminator.

A Different Kind of Highlight. The other type of highlight effect is found on sharper corners, such as the edge of a tabletop, a corner of the forehead, or an inverted creased corner, like the point of a "V." In these cases, the highlight often seems to be concentrated in a narrow area, as if channeled along these corners, and prevented from following its usual perpendicular-to-the-light pattern.

It is interesting to see this action on an irregularly shaped form, such as the body. Sometimes we can distinguish two light actions combined. This happens on shiny and sharply cornered forms, such as along the tibia or down the corner of the forehead. What we may see then is an overall movement of highlight sliding along the corner, while very small shapes within it are pulled perpendicular to the light. It is as if a group of perpendiculars are aligned with the light direction. This effect can be diagramed and also illustrated on a model.

Little Mirrors of the Light. Generally, highlights are mirrorlike reflections of the light source itself. As in our example of sun on sea, each highlight is actually a miniature sun. On the body, too, the shinier the surface of the skin, the more the highlight becomes a tiny reproduction of the source of light. On very shiny objects, such as glass, metal, or porcelain, we can often make out the tiny image of the window or lamp that is the source. For this reason, incidentally, the color of the highlight closely resembles the color of the source.

Because they are mirrorlike images of

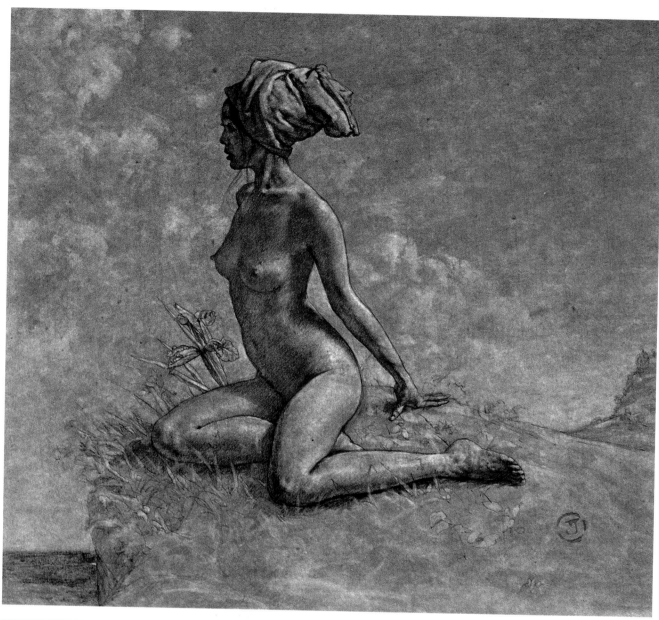

JAPANESE WOMAN AND IRIS,
conte and pastel, 14" × 16"
(36.6 × 40.6 cm), 1976

Highlights are moving along the corners of
the form. However, if we look carefully, we
can see that these large light effects are
composed of separate highlights, each
lying more or less perpendicular to the
light arriving from the upper right. The
alignment of highlights goes one way, the
individual highlights another.

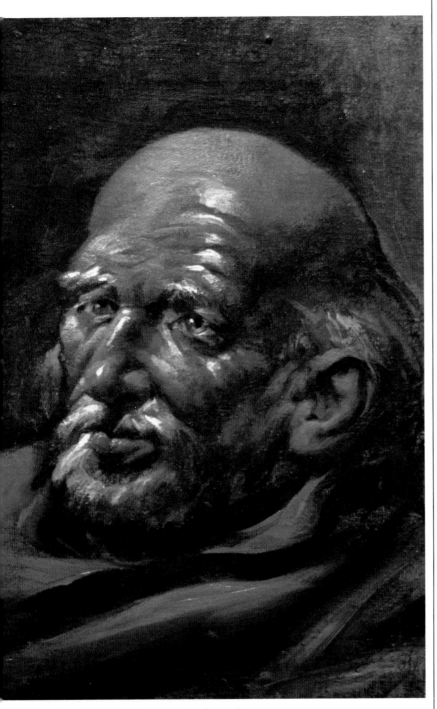

In this rapid study, the form underlying the highlights has not been sufficiently modeled with light. The forehead under and around the highlights looks dirty because it is too dark. The highlights on the nose seem to float above the surface. Overall, there is an unpleasant lack of breadth and fullness, and the treatment seems both heavy-handed and fussy.

the source, the edges of highlights generally are comparatively sharp. If they are shown as too diffuse or soft, they may look more like lighter values than like highlights. This does not mean that they must be uniformly razor sharp. Rather, it is the characteristic of highlights to form into fairly definite little shapes—minute floating islands of light.

Field Effects of Highlights. There is often an interesting field effect around highlights. Being extra bright, they may cause the immediate light area around them to appear to darken. This is a tricky effect to suggest. If we overdo the darkening, the highlight may appear to "float" above the surface, and if we don't darken enough, the highlight may not seem to glisten. In order to judge the value of the light contiguous to the highlight, it is useful to imagine "peeling" the highlight off the surface to see the value of the light "under" it.

It is a common error to be misled by the field effect of a highlight and render the contiguous light too dark. This destroys the fullness of the underlying egg form, so that it seems to sit at a distance beneath the highlight, as if there were a dent in the form. Or the area around the highlight may appear to be smudged darker. The form must be modeled into fullness by light so that the highlight appears to be on the surface and not above it. This is another instance of value creating spatial effect.

The practical difficulty is that if we make the surrounding area too light, we will be left with nothing light enough to suggest the contrast and brilliance of the highlight. In practice, and with experience, we learn how far down we must go "under" the highlight in order to be able to make it shine and yet not "dirty" the light area. When we have a solid grasp of how to model the underlying egg, we can usually avoid these problems.

It is very common in art schools to see a student pop a highlight upon a flat, unmodeled nose or to see an "overmodeled" forehead too dark in the light, where the student has been misled by the field effect of a bright highlight. Another result when highlights are put on an undeveloped piece of form is that the surface takes on a steely or glassy appearance.

In fact, in order to suggest metallic and glassy surfaces, it is usually necessary to paint the highlights as isolated little islands on a darker surface—just the opposite of the way skin is painted. On metallic and glassy surfaces, the underly-

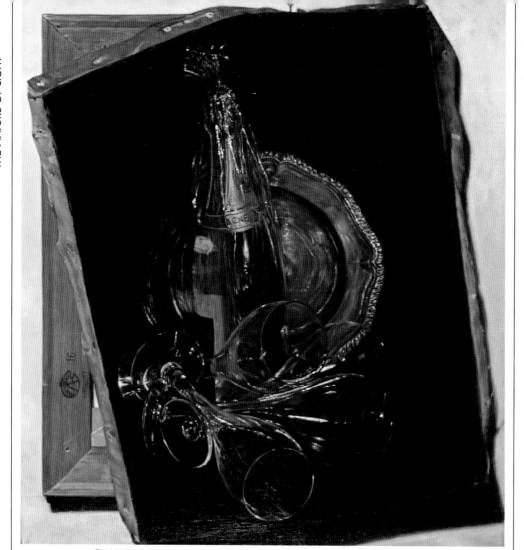

CHAMPAGNE CRYSTAL, oil on canvas, 22″ × 20″ (55.9 × 50.8 cm), 1982

CHAMPAGNE CRYSTAL,
oil on canvas, 22″ × 20″
(55.9 × 50.8 cm), 1982

Highlights on glassy and shiny surfaces have harder edges than those on matte surfaces, and the value change is sharper.

ing "egg" modeling may be present but much less pronounced than on matte surfaces. Shiny surfaces are not necessarily modeled the way skin is. Changes of value on shiny objects can be extremely abrupt and unusual because those surfaces may reflect whatever surrounds them.

As always—with highlights too—the best approach is to observe openly and constantly compare our work with what is happening on the model. Usually, if highlights seem to jump out of context like excessive little explosions on the picture surface, that indicates they are too light in value for the form under them. If the texture in the picture doesn't seem shiny enough, that usually indicates either that the value of the highlight is too dark or that the edges are not sharp enough.

THE FORESHORTENING OF LIGHT

Everyone is familiar with the phenomenon of foreshortening. As they are turned edgewise toward

us, the actual physical lengths of forms appear to shorten. To some extent, in fact, all forms are seen as foreshortened, since only a point directly opposite our eyes is not, to some degree, slanting either toward or away from us. Whatever is not directly perpendicular to our eyes is being foreshortened. Since we are aiming toward a perfect agreement between line and value, drawing and modeling, we must understand the foreshortening of light. If the form appears foreshortened, so must the light falling upon it.

Although the gradation of light on a form may be evenly distributed, certain areas on the form will face us more directly, and others will be turned away from our sight line and foreshortened. Particularly on rounded forms, foreshortening will create an irregular progression of light gradation. Many art instruction books present systems of shading based on a perfectly equal gradation of values in the light. These systems are false because they do not account for foreshortening effects.

We have already discussed how the

Suppose we have a ring made up of planes; obviously, each plane has a different tilt with respect to the observer. Plane C faces the light most directly, so it is the brightest; plane D is darker, but because of linear foreshortening it appears larger than plane C. The other planes are narrower and darker. As a form is foreshortened, the gradations of value will also be foreshortened. The widths of the gradations will vary in an uneven progression.

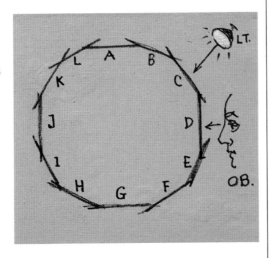

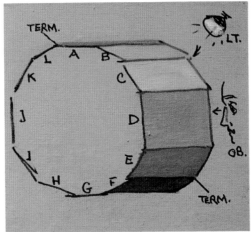

FISHERMAN'S COTTAGE, ST. JEAN DE LUZ, oil on canvas, 8½" × 11½" (21.6 × 29.2 cm), 1977

This diffuse gray daylight emphasizes local-color differences and the flat poster quality, rather than contrasts of light and shade.

shapes and proportions of light to shadow depend upon the interrelations between the positions of light source, observer, and model. This is also true for the apparent proportions of light gradations that we see. The effect is especially apparent in the light, although it also exists in the shadow.

We can understand the foreshortening of light more clearly if we imagine a ring made of facets, like a sort of squared circular form. We can then diagram the foreshortening effects in both line and value. In our diagram, planes C, D, and E face us more directly than A, B, F, and G. Plane D will appear widest, followed by E and C. B and A will progressively narrow as they tilt away from our sight line, as will F and G. Plane C, however, faces most directly to the light; although it will be lighter than D, it will also be slightly narrower. Planes E and B will progressively narrow and darken, and A and F will be both the narrowest and darkest areas. Planes G, H, I, J, K, and L will be in shadow.

Foreshortening of light is very obvious in front-lighting, where the observer and the light source are in about the same position relative to the model. The observer looks into the lighter area of the model, which is consequently wider. The darker light values will lie toward the edges of the model and appear very narrow due to foreshortening. These darker values will look as if they are "squeezed" into a very narrow band at the edge, like a dark line. Because the darker light values are so narrow, the variation of value change appears reduced in the light and thus seems "flattened." This flattened effect of front light gives a "poster" quality to the picture because it emphasizes local color differences more than light and shadow contrasts. Front-lighting accentuates the abstract shapes of different areas of local color and has been preferred down through the centuries by artists who want to emphasize the flat nature of the picture surface and concentrate on linear design.

The reverse of front-lighting is variously known as rim, edge, or back-lighting. It occurs when the model is directly between the observer and the light. The observer looks into the shadow side of the model, so that whatever light appears at the far rim is highly foreshortened. The transitions in the light appear compressed into a narrow band, and the change from light to shadow is comparatively abrupt. In rim light, the brighter lights seem "squeezed" toward

the far edge of the form. This produces the effect of bright light glaring into the eyes, reflected very directly from the source. Because the eye, like a camera lens, cannot accommodate itself equally at the same time to extremes of light and of dark, this glare causes a field effect, making the shadow appear even darker than it otherwise might. Highlights also will be shifted closer to the terminator, increasing the effects of high contrast.

In front and rim light, we see quite extreme effects of foreshortening. In three-quarter light, we see a more apparent variation of value as the light gradually darkens toward the shadow. In three-quarter light, the lightest area is slightly foreshortened. This foreshortening makes for very subtle value changes. We can say that there is a narrower "range" of variation in the lightest zone.

This idea of a *range* of variation is another way to describe foreshortening effects. We can speak of a wide range of variation or of a narrow range of value change that has very subtle differences. For clarity, we can imagine our smooth transitions in value as instead being composed of bands going from black to white. In some situations, we may be able

to use the entire range. In others, we may have to do all our modeling in a very narrow range. In all cases, the modeling of the form by light must be described. If we must model in a very narrow range, we need to observe the differences of value very sensitively and mix our values with great precision. When the light is somewhat flattened, we still must avoid painting the form as flat. We need to paint a "flat" light effect on a full, rounded form. Although they are slight, the value changes are still present. Sometimes, when the range of value change is very narrow, the range of hue or chroma becomes wide.

Allow me to remind you once more to check all methods and theories about the proportions of light distribution against your own careful observation. In the world of art instruction, there are many arbitrary symbolic preconceptions.

SHAPING THE LIGHT

The idea that light effects are "shaped" is a natural outgrowth from the concept of light being directional and also foreshortened. Light

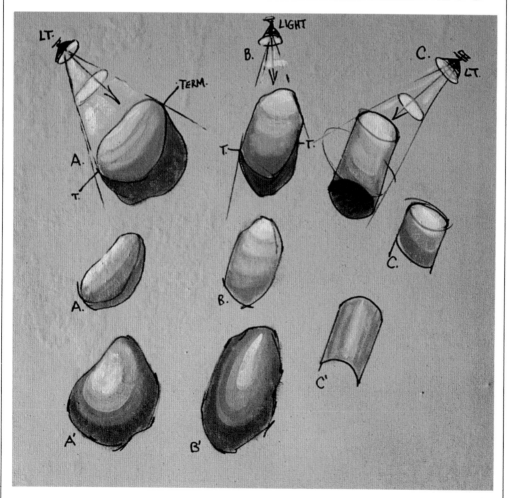

In figure A, the light arrives on the irregularly shaped form like a flat disc, slicing across the object. Line T indicates the terminator, or tilt of the shadow. Immediately below, we see the shape of the light on the same form without the cast shadow. This is what is meant by "shaping the light." At A', the form is modeled incorrectly in concentric, parallel shapes of light and shadow. The two upper versions of figure B show the shapes of light and shadow on a less rounded form; B' shows incorrect shaping "with" the form. In figure C, the top and center diagrams show the cuts of light on a cylinder. The shadow is seen as it would fall on the underside of the cylinder, parallel to the contour. The cylinder in figure C' is modeled in one direction only, without the perpendicular cut.

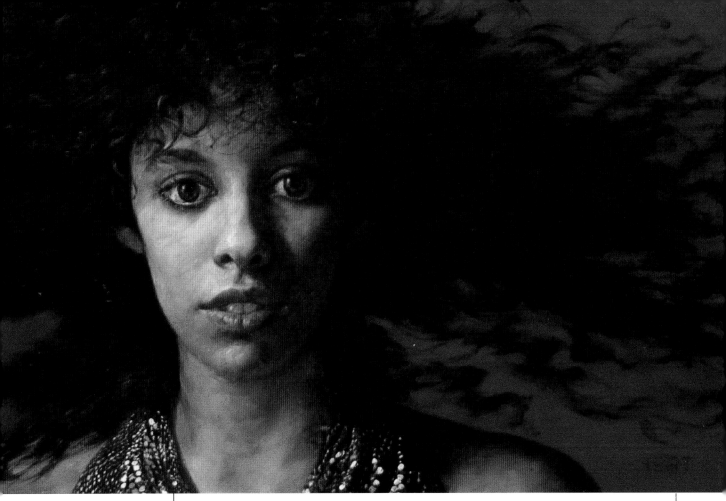

ELLEN,
oil on canvas, 12" × 24"
(30.5 × 61.0 cm), 1987

Notice how the lighter values are shaped to spill onto that part of each form most turned toward the light. The light on each form is then shaped to grow darker in value as the form rolls away from the light, toward the shadow. These gradations must be carefully shaped in order to produce both the sculptural shape of each different part of the form and the shape of the light on each part.

moves outward in rays or beams. Its voyage through space is linear. What we have, then, is a beam meeting forms or being intercepted by them.

Very simply, if light comes from the model's upper right, it will spread more across the upper right of the model and less across the lower left. If light arrives from above, there will be more of it on the tops of things. When we draw or paint, we must "shape" the light so as to distribute it correctly. Failure to shape the light properly produces two anomalies: The forms are not modeled correctly and there is no sense of a light direction. Without shaping, the forms flatten. When painting, we can think of shaping as spilling the light off the brush over the part of the form that faces into the light and grading the light values down as the form rolls away from the source.

It is necessary to shape each brushstroke. Otherwise we will paint the shape of the brush, rather than the shape of the form in a certain light direction. Since shape is the province of drawing, we could say that we must draw with light as well as with line. This shaping of the light mostly depends upon the combined factors of light direction, shape of form, and position of the observer. The shaping of light does not run parallel to the outlines but tends to cut across the form.

Light arrives on forms like a curtain being drawn across them or a shade pulled over them. Light moves like the flat edge of an oncoming tidal wave, washing across forms. Our diagram shows the cut of this leading edge as forms enter its path. Each of these simple illustrations shows us the shape made by a specific direction of light on a particular form.

To show the incorrect effect of non-shaped light, we will give the same forms but show the light as parallel to the contours, rather than as cutting across them. Here we see quite a different effect. The light rays appear to curve around with the forms. This does not suggest light arriving as a beam or ray. If we separate the areas cut by the curtain of light in our diagram, we find that they make the shapes as illustrated.

Sometimes these shapes of value are not very obvious when we gaze at our models. We realize, however, that unless we shape the values, the form does not have the same inside shape as what we see, and there is not the same sense of directionality of light. In pictures where the artist has followed the effects of light, there is a sense of something very speedy moving through the work of art; there is no turgid heaviness or "stickiness." Classical Chinese artists spoke of a wind, a

breath, passing through a good painting, and in Western art, too, we can find this wind, this breath of life.

If we cannot decide what a particular shape of light should be, we can find it on the picture surface by trial and error and by rigorous comparison to the model. This is, indeed, perhaps the best way to learn how light works. When we compare constantly, we develop a sharp awareness of dissimilarities—even very minor ones—between the art and the model. If the form we have created doesn't look "right"—if it does not give us the same feeling as what we are looking at—then we need to change the shape of the modeling. When we find the right shape for the light, everything seems to fall into place and the form also appears modeled *according to the light direction.* If we constantly scan the picture surface for anomalies, this comparison process itself will gradually teach us how light works on form. This process will be discussed in more detail later.

As we refine our match of picture to model, it will be necessary to adjust and modify our shapes of light and also to break them down into ever-smaller "subshapes." In order not to lose the shaped nature of light effects, sometimes we need to pull one shape into another to merge adjacent areas. At such moments, we must decide which area to merge into another. For example, do we need to bring the darker value into the lighter, or vice versa? We must then judge how far one should be pulled into the other and the shape of the mixed zone that results. This is quite a different approach from evenly blending together two adjacent values or brushing the edges to make them smoothed out. Ideally, every action on the picture surface should be meaningful, in the sense that it describes light direction arriving on a particular shape or form.

THE SENSE OF FORM

"The sense of form" is one of those ambiguous technological phrases that sounds very meaningful . . . and, in fact, is! The sense of form is all-important. It is difficult to imagine how an artist can have much stature without it. Like all such qualities, it seems easier to recognize than to pin down with exact definitions. Perhaps that is because a sense of form includes various elements. It could be described as a feeling for how everything fits together: the harmonious

SUNBATHERS, oil on canvas, 18" × 34" (45.7 × 83.4 cm), 1972

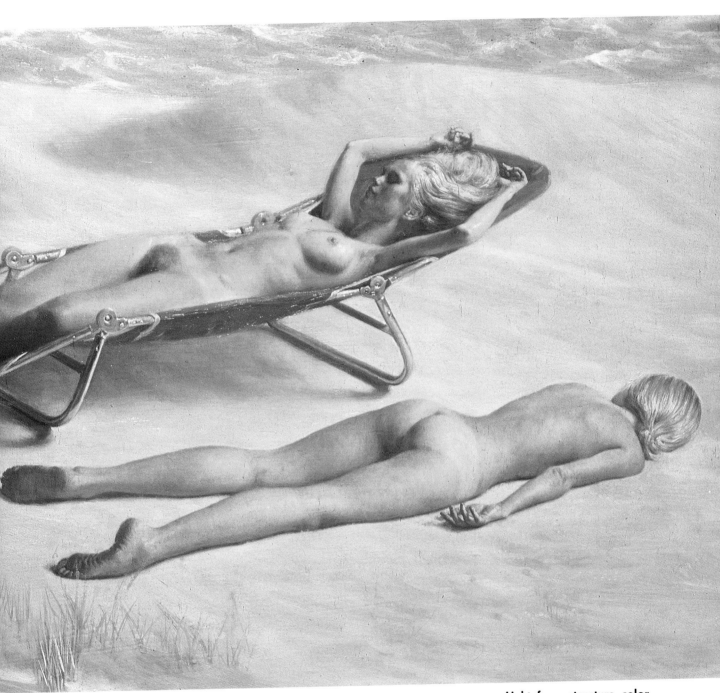

Light, form, structure, color, line, and movement must be in harmonious agreement. That is what is meant by a sense of form.

appreciation of light, shape, color, line, texture, movement. The artist who has a deep, innate sense of form seems to possess an instinctive sense of how light moves on forms and of which way the patterns and shapes of light need to be pulled. It is a sense of which way the form must be modeled in any given situation. This sense of how to express the form in harmony with the direction of light is quite different from a purely sculptural sense of form. The sculptural, or three-dimensional, sense of form gives us an innate feeling for how the body is put together. With a sculptural sense of form, we understand the physical shapes of things; we have a sense of the "style" of living, growing form. That also implies a feeling for how one form relates to another—how forms very subtly slide into one another and interact. This sense of form also includes a sensitivity to the way the body and other living things move. It is a grasp of the continuity of living form. An artist may have a highly developed sense of sculptural form and yet not understand the actions of light. In such cases, the forms may be modeled by shading systems but not *lit*. This is a fundamentally different way of describing form. The optical artist needs a sense of form that registers equally the subtleties of light and the structure of form. The one is expressed through the other.

THE MAGNITUDE OF LIGHT

In relation to the immensity of space, we can think of our round earth as being like a speck of dust floating in the ocean of the sun's light. This rounded speck will, of course, show all the characteristic gradations of value. However, when we see it on a cosmic scale of observation as a tiny speck, these gradations become virtually indistinguishable. Similarly, for us human observers, the difference in intensity, or strength, of sunlight from here to a point fifty miles away is too slight to be distinguished. At sidereal distances, the magnitude of suns can be appreciated. In comparison to the "size" of the sun's light, a fifty-mile distance on the earth's surface is minute. We can thus speak of the "size" of the light in relation to the size of the model.

Sunlight. This question of size has its importance here on earth, both in the studio and outdoors. Outdoors, we cannot see far enough to register a very significant amount of the value change due to

ELAINE KUDO, conte over prepared pastel ground, 16" × 14" (40.6 × 35.6 cm), 1981

The forms are suggested by the action of light, and all parts of the body flow and move with harmonious continuity.

POSTCARD VENUS,
oil on canvas, 30" × 24"
(76.2 × 61.0 cm), 1986

This is one of a series of paintings of postcards. The diversity of styles represented shows variations of emphasis on the sculptural and optical approaches. The more recent and modern artists often favor the sculptural, as do Valloton, Magritte, Modigliani, and Puvis de Chavannes.

FISHING PORT, ST. JEAN DE LUZ-CIBOURE, oil on panel, 11" × 15" (27.9 × 38.1 cm), 1977

SAGRES, PORTUGAL, oil on panel, 7½" × 20" (19.1 × 50.8 cm), 1980

either the curvature of the earth's form or the diminishing intensity of the sun's light. The light values, therefore, are not graduated in the same manner as they are indoors, because the "size" of the light is so much larger than the size of the subject, our little planet.

Aside from local color differences and the modeling on forms, values outdoors change principally because of changes in the tilt toward the light—the tilt of plane. For example, on cloudy days, with the light coming from overhead, vertical planes will be darker than uptilted horizontals. For this reason, the massed value of trees may be darker than the values of the ground plane, for example.

There is a wide range of value change on the sunlit figure as forms turn toward and away from the sun. There will not, however, be a difference in value due to one part of the body being closer to the sun than another. On our scale of sensitivity, what is five or six feet compared to astronomical distances? This is our dust-speck-in-the-ocean effect.

Some art instruction books and art teachers treat sunlight as an obliterating blast that washes out all gradations on human-sized objects. A visit to a populated sunny beach will show how false this treatment is. What happens is that one cause of light gradation has been removed: the decrease in strength caused by moving away from the source. The elimination of this one modulating effect will cause some "flattening" of the light. However, variations of value due to turning and tilting of the form remain very much in evidence.

Suggesting sunlight on the round forms of the body by flattening all variation in the light will produce results that look like a painting style rather than reality. This style may suggest the effects of a badly exposed photograph.

One well-known effect of sunlight is the characteristic sharply defined cast shadows it produces. The sharply focused directional beams of sunlight cause this effect. The scattered light of an overcast sky causes more penumbral effects and softly edged cast shadows.

Artificial Light. The dust-speck-in-an-ocean-of-light effect also plays its part indoors. We can think of our lamps and artificial light sources as little suns. Artificial lights vary greatly in watt intensity, and it is useful to keep in mind the effects caused by the varying "magnitudes" of our miniature suns. Our indoor sources can range from a candle to a powerful electric spotlight. We must take

into account the size of the light source in relation to the size of the subject. The size of the light determines to what degree the strength, or value, of the light will diminish as it travels away from the source.

For example, the light of a candle is very small compared to the size of a room. Consequently, there is a very sharp drop in the strength of its light as it travels through space. There will be a marked darkening of light values over even relatively small distances. The darkening as forms turn away from the candle will also be pronounced.

Conversely, if we put a brilliant spotlight in the same room, the size of the light becomes much larger in proportion to the room and any model in it. In this case, there will be very little noticeable darkening due to distance from the light. This produces less overall gradation and a "flattened" look to the light.

Magnitude and Light Effects. If we consider the two sources of value variation—turning or tilting of the form and distance from the source—we can understand that when both effects are present, there will be a stronger variation in value change. If we remove one of these two, we may expect to see only half as much variation. We illustrate this effect on page 84 by showing three cylinders in a wash of light. Cylinder A shows only those variations of value caused by turning of the form. Cylinder B shows only the effect of light darkening as it travels through space. Cylinder C shows the two effects combined. We see that A is less modulated—"flatter"—than C. In A, it is as if we "peeled away" the B set of value gradations. This same flattening effect will occur as the size of the light becomes larger than the size of the model. This effect can also be caused by moving the light source closer to the model so that, relatively, the light increases in size.

In order to suggest the quality and strength of the overall light in different situations, painters should understand the effects of the relative sizes of light and subject. Each light condition is distinctive. Avoid formulae that cause all your work to appear as if done under the same type of light. The key, or intensity, of the overall light, its color, and its size must all be suggested. This can prove difficult for students who are accustomed to working in only one kind of light. For example, an artist used to a studio north light may not know how to depict the harsh glare of a powerful spotlight.

I would also mention in passing that in

Sunlight creates clearly defined cast shadows.

Sunlight defines forms as well as differences of local color, texture, and other qualities.

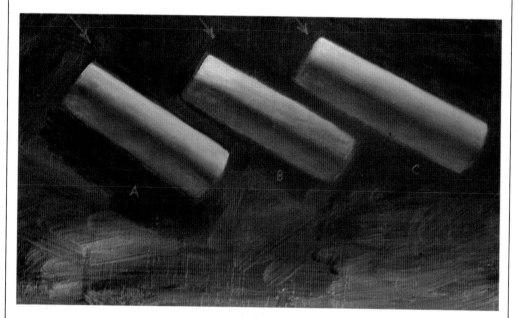

order to study and learn light effects it is much better to work at first with only a single source. Students who come from studios where a multitude of artificial lights from all directions are used usually have very little understanding of the action of light on form.

I also mentioned earlier that variations or gradations of values do not necessarily proceed in a perfectly equal progression because of foreshortening. The flattening of the modulations due to the size of the light may also cause an unequal distribution of modulation.

Relative size also has an important influence on field effects. We usually will see more marked field effects as the size of the light proportionately increases. The intensity of the light then accentuates variations of local color and degree of contrast. The flattening effect of an increase in the size of light creates a somewhat posterlike quality, where one flat field will collide with another. Where they meet, strong field effects can be expected. A notable instance of this is sunlight, which heightens field effects, as does a strong spotlight. Conversely, light from a candle, a weaker bulb, or a studio north light will accentuate modeling and roundness while softening field effects to a more subtle, delicate quality.

LIGHT AND COLOR

It is helpful to discuss light and color effects in terms of various scales, even though, in actuality, we see unified effects, because we can only suggest these effects through our paint mixtures. In order to understand what happens when we combine paints,

and to find our best match, we must know how to orchestrate all the scales. There is always the danger that when mixing our paints we may cause changes in some scales but neglect to simultaneously change some others. For example, when concentrating on the variations in the value scale, we may forget to change hues. We must remember that every paint mixture causes changes in all the scales.

Chromatic Variation. Chromatic variation refers to the relative purity, or brightness, of a color or hue. Or, we can say, it refers to the comparative grayness of a hue. Chroma means the *intensity* of a color, not the kind of hue. We have a chromatic scale that runs from the purest state of a color, as it comes from the tube, down toward an undistinguishable grayness.

As mentioned earlier, light tends to accentuate and define differences, as shadow tends to weaken and obscure them. For this reason, we usually find a wider range of chromatic change in the light than in the shadow. When painting the figure, we often will see the chromatic intensity dropping with the value as the form turns into the darker values, approaching the shadow. Similarly, in the shadow the reflected light often raises the chroma. As the shadow darkens toward the terminator, the chroma usually drops. This weakening of chromatic intensity also contributes to a lowering of contrast. Failing to change the chromatic intensity can flatten the form, even when the change of value may be correct. This error causes the chroma to jump out of context and create an unwanted high contrast. Under a warm light source, the

GERANIUMS, ST. JEAN DE LUZ, oil on panel, 20″ × 7½″ (50.8 × 19.1 cm), 1980

The relatively large size of the light outdoors tends to raise the level of chromatic intensity.

darker lights may often become grayer, or cooler, or more complementary to the hue of the lighter values. Some painters exaggerate this effect and paint the darkest light values next to the shadow excessively gray or "cool," causing the dark light zone, in context, to appear as a highly chromatic bluish area. This can create a high-contrast zone where the opposite may be needed. It can create a strong field effect. In such a case, the idea of grayness has been turned into a stylized symbol that no longer accords with seen reality. We must be careful about ideas linked to words such as "grayness." They can easily prevent us from noticing what the eye sees and can cause anomalous effects. The same thing happens when painters overdo the chromatic intensity in places like the lips, the cheeks, or the nose. These exaggerations may destroy the unifying effects of light or cause the form to appear spotty or choppy.

Chromatic intensity may vary according to whether our line of sight is aimed directly at the surface of a form or skids or skates across the edge. Commonly, when we look directly into a form we see greater chromatic intensity and variation. Local color changes are more apparent because they are facing us head-on. When we look edgewise across the surface of a form, it often seems grayer. This could be called a foreshortening of chroma. When we look across the edge, the chromatic variations of local colors are foreshortened and often appear as a graying of the edge as it turns away from us. However, field effects may also occur at the far edge of the form that may *increase* the chromatic intensity. Also, the relative position of the light source can cause the farthest edge to glow with color. We must remember that any general principle can be modified by unusual or extenuating circumstances. If we follow any idea blindly, it becomes another non-optical symbolic preconception. In general, though, we may expect that changes in the direction of the form and changes in value will be accompanied by changes on the chromatic scale. A change in any scale resonates through all others.

Changes in Hue. Hue refers to the kind of color we see: red as distinct from orange, for example, and whether a red is more red-orange in hue or more purplish-red. Describing hue is a bit tricky. Like the taste of something, hue is registered by the senses and cannot successfully be translated into words. The eye cannot speak, as the mouth

In this style, popular with sixteenth-century Flemish painters and some nine-teenth-century schools, such as that of Munich, chroma variations are highly stylized and exag-gerated. They are deliber-ately painted to "jump" out of context. The result is that these variations become a theme in them-selves.

Painters sometimes unin-tentionally overdo chroma variations, with the result that the picture becomes "spotty," with small explo-sions scattered on the sur-face. In the purely visual style, these disharmonies are to be avoided.

cannot see. Without getting too involved in complicated philosophical questions, we nevertheless ought to avoid trying to pin down observed color effects with words. When we give names to the colors we see, we are likely to overlook their subtleties. All colors are essentially un-nameable. Of course, they are also essen-tially unpaintable, because paint cannot ever match the living process of sight. What we can try to do is more and more convincingly suggest the colors we see. The whole idea of describing colors with words is a literary, rather than a paint-erly, approach. The painterly way is to discover the best solution on the surface of the picture within the context of all the interrelations on that plane. This picture surface will show us what is needed. We don't need any words in order to find our best equivalent. To some extent, perhaps, we cannot totally escape verbal associa-tions. If we must use words to describe colors, it is at least better to use the words relativistically. For example, rather than naming a seen color effect as, say, "bluish-green," it is more useful to say that compared to what is now on the

canvas, the color we see seems to contain more blue. Rather than verbally predefin-ing the color we see, we may modify our mixture by deciding which named paint color we need to add. This may seem like a nitpicking distinction, but in practice many painters and students overstate color variations because they mentally name the color before they try to "find" it through observation and comparison. For example, the painter who decides that the shadow is violet very often will make it too violet and too unvaried in color. It also seems to me that as we study any color, we can find a thematic opposite kind of color within the dominant. The color of any object is broken and vibrat-ing. What we see is a shimmering optical illusion made of light. The plane of vision can be described as an infinite variety of field effects. We create color effects with colors, not words.

Naming colors often tends to blind artists who think too dogmatically in terms of "warm and cool." Personally, I have always found this to be a highly symbolic stylization. If colors have the characteristics of warmth and coolness,

PORTRAIT OF JANET ADAMS JACOBS, oil on panel, 10" × 11" (25.4 × 27.9 cm.), 1969. Collection of Janet Adams Jacobs.

Shadow can be considered another kind of dark radi-ance. The darks are not dead areas but dark col-ored values.

PORTRAIT OF CAROLINE LEAKE, oil on panel, 10″ × 9″
(25.4 × 22.9 cm), 1978. Collection of Caroline Leake.

Hue and chroma should change with each change of value. If only the value is modulated, it is as if the picture were painted in monochrome— a black-and-white approach.

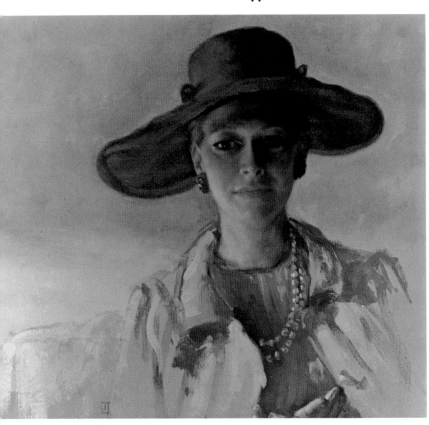

whatever we look at seems actually to contain elements of both. I don't quite know how to classify colors as warm or cool. Warm and cool are sensations felt by the skin, not seen by the eyes. As applied to colors, these terms seem rather to indicate what one is predisposed to find. It is also fundamentally impossible for me to call light either warm or cool. All observed effects are profoundly unnameable, as far as I can determine. The naming of seen color effects desensitizes our perceptual powers.

The Color of Light and Shadow. Even the principle that light tends to define, and shadow to obscure, can be turned into another symbol. Some painters tend to think of shadow as a zone of nonexistence. Classical painters sometimes used the shadow as a foil to show off the light. They made the shadow a monochromatic field, a blank darkness. In these styles, the shadow is thought of as a dead area, an absence.

In contrast to this approach, the shadow can be considered, in fact, as another kind of light. Although fundamentally different in its qualities and appearance, the shadow is still just as "alive" as the light. The shadows can be seen not as dead areas where nothing is happening but rather as zones of dark color. We need to try just as hard to "find" the best colors in the shadow as in the light. Shadow should be seen as colored values. Nothing that we see is dead. Nothing is without vibration. All the tones we see resonate against one another. We must find a vibration that suggests those resonances.

A Note About Black Paint. Some artists refuse to use black paint, on the grounds that it is colorless. In the context of the other colors on the palette and the other colors on the picture surface, black can simply be considered another color, rather than a noncolor. It will appear to change color depending on what surrounds it. Very often, in order to make it resonate, we need to "inject" color into it. It can be very useful as a base to mix into, where very dark values are needed. In nature, we try to see it as a "colored" black and match it accordingly.

The same ideas apply to white paint. Incidentally, white may not always be the closest match for the lightest values. Like black, white may require delicate staining with color in order to make it alive and resonant. A "colored" white may appear brighter than pure white paint.

Complementary Color. Much has been written about, and painted in, complementary colors. The idea is at the base of many styles. As always, it is important not to be blinded to the nuances of nature by an attachment to verbal description.

The idea of complementary effects of color is based upon the assumption of opposing actions between light and shadow. Just as we speak of the duality of light and shadow, we can assign to each its family of opposite, complementary colors. The generally underlying hue of the shadow will be complementary to the color of the light. If the presence of light causes a certain spectrum of colors, its comparative absence will produce a different end of the spectrum. Although I think that this occurs, it still seems, from observation, that there exists some sort of exchange of their basic colors between the two families of light and shadow. Although altered, the kind of colors seen in the light can also be seen in the shadow, and vice versa. Nature seems to create a tapestried effect by weaving the colors of one group through the colors of the other.

Changes of hue can, of course, be due to variations in local coloring. Changes in hue are also tied to variations of value. Gradations of light cause changes of color. In general, as the intensity or value in the light drops and approaches the darker values of the shadow, the color also changes toward the kind of color found in the shadow. The color of the light source itself colors what it touches. As the light weakens, there is less of its color on the model.

Reflected light bouncing back into the shadow will carry some of the hue of the primary light back into the shadow. The color of reflected light, however, also contains the local color of the reflecting surfaces. Furthermore when the primary light bounces from reflecting surfaces, part of its color spectrum is absorbed, so that it is not the same color of light entering the shadow as leaving the source. The reflected light color is a degraded version of the direct light and is different in hue.

The Inseparability of Value and Hue. Many painters, such as the surrealists, for example, lighten values only by adding white. They treat the value scale as if it were only a lightening and darkening of the same hue. This is a serious mistake for the optical artist. It is an essentially "black-and-white" approach. The result is similar to a colored drawing, with local colors washed over

ROOFTOPS IN THE MARAIS, oil on canvas, 9″ × 7″ (22.9 × 17.8 cm), 1979

Sunlight produces strong vibratory field effects and high contrasts.

the value changes, and does not take into account the fact that the light is colored. Value and color change together, organically. We cannot run up and down the value scale without constantly varying the hue.

For example, if the light source has some kind of (unnameable!) yellowish coloration and the shadow turns correspondingly complementary, as the values darken the yellowness will also drop. We need to incorporate this hue change into each value change. We must see each change as a *colored* value. Otherwise we are essentially painting in monochrome. We also must avoid "tinting" value changes with the same color. For example, if the light itself is yellowish, we ought not to put the same intensity of yellow everywhere in the light.

Also take care not to give the shadow the same kind of hue as the light. The color of the shadow can be deceptive. For example, when the body is under a yellowish light, the reflected light in the shadow may be very warm. However, approaching the terminator, where there is the least influence of reflected light, the shadow may show more of its complementary nature. Some students notice only the very warm reflected lights and paint all the shadow warm. This makes for a warm-on-warm effect that does not correspond with optical reality. The effect is rather heavy, or hot, and the picture will not have the feeling of light speeding through it. The hue will be turgid if it is too similar in the light and the shadow.

FIELD EFFECTS

Unfortunately, the study and use of field effects have been confined almost exclusively to various forms of nonfigurative art. However, field effects are a very important element of our visual experience. In fact, all that we see could be accurately described as field effects—optical illusions. Consequently, painting that is meant to suggest the seen world but does not employ field effects has a certain dead, "painted" quality. It will lack vibration and resonance. The use of field effects gives the picture a quality of internal vibratory life. The surface of the painting becomes physically active, since field effects are in essence the result of the interactions taking place in the eye, between tones. Sight itself is a living process, a human reaction. Field effects constitute an obvious example of the living and changing nature of perception.

Different Types of Field Effects. We are probably all familiar with the optical illusion that occurs when two gray squares of equal value are placed against different backgrounds: one against a white field, one against a black field. The gray seen against white will appear darker than the gray seen against black. This is a clear example of a field effect

Extremely subtle field effects and afterimages against the sky can be seen in this subject.

STRAWBERRY TART, ST. JEAN DE LUZ, oil on canvas, 5″ × 7″ (12.7 × 17.8 cm), 1980

and its illusionistic nature; in this case, the field effect is caused by value alone. Field effects of value are often very subtle but are nevertheless present. We have already discussed how a brilliant highlight can cause its surrounding area to appear darker than it otherwise would.

Field effects can be defined as an apparent third tonality produced by the interaction between two tones. There are different observed phenomena that can be classified as field effects. They can be caused by the position or intermingling of light reflected from different objects. Sometimes different surfaces seem to reflect their light over one another like overlapping auras. This is essentially a sort of mechanical field effect. An illusionistic field effect can take place in the eye when, for example, two contrasting colors are contiguous. In all kinds of field effects, colors are heightened by increased intensity of light and contrast. As with the other scales we use, light defines differences and intensifies contrast. For this reason, field effects are very pronounced in sunlight and under strong artificial lights.

When we see a brilliantly lit form in front of a very dark background, we can often see light radiating off the form in front of the background, like a corona from the sun. This radiance forms a very diaphanous curtain of light between us and the darker background. This is a *mechanical* effect. The light object will also cause an *illusionistic* effect against the dark background. The background colliding with the bright light area will appear to darken. Both the auric radiation and the darkening effect dissipate rapidly with distance. This radiant light off the surface is very small in size and drops off quickly in intensity. What we see in the above case, then, is a brilliantly lit edge of the form, followed by a very narrow darkening-down effect at the edge, followed in turn by a faintly lightened auric zone over the dark background. Sometimes a derivation from the local color of the radiating object will also be projected as a nimbus against the background. Transparent colored surfaces can become highly chromatic when they shine through one another. Sometimes the background zone, seen though the aura, can increase in chromatic intensity. Subtle as they may be, field effects cause all our scales to resonate.

Field effects may subtly alter the shape and contour of things. For example, an aura of light may spill over into a dark zone that collides with a very bright light.

In such cases, the bright light often optically expands against a dark zone, deforming its contour. This effect can be clearly seen if we look at the dense leafage of a tree when the sun is behind it, shining toward our eyes. The brightness of the sun seems to cut round bites out of the shapes of the dark, silhouetted leaves. Although this is a fairly obvious example, this field effect can be seen in more subtle forms when a dark edge meets a bright value of light. If we look through the dark frame of a window or a door that is seen against a lamp inside another room, we can observe how the contour of the frame bends aside where it passes in front of the lamplight and then returns to its narrower shape when the lamp is no longer seen behind it.

Another common field effect takes place when different hues are contiguous. As is the case with highly contrasted values, the eye cannot always accommodate to these conditions. It can become fatigued by strong, harsh contrast and react by producing an opposite afterimage. In strong sunlight, if you stare for a short time at your own cast shadow on the ground and then look at the sky, you will see a light afterimage of the shadow on a darker ground. In situations of harsh contrast, the eye accommodates its opening to one element and is slightly blinded for the other. This lack of complete and equal accommodation causes an apparent distortion, or field effect. All our scales are affected by these actions in the eye. When in proximity, some colors will appear to vibrate, change, and alternate as we look at them. The process of perception is itself a living entity. No color that we see has a fixed, inherent tonality. Time, then, especially evident in strong field effects, plays an important part in the visual process. Artists, more than non-artists, are aware of the changes in appearance of tones caused by the observation time, because they are accustomed to gazing at a tone for a long time. The eyes have a variable adaptive ability when confronted by different situations. We also supposedly cannot separate the physical reactions of our eyesight from our mental or emotional condition. This factor is very important, because unless we put ourselves into a certain special state of being, we will be unable to register the most subtle nuances of tone and light effects. All these observations emphasize the fact that what we see is not a fixed image but, rather, a living process. The observed world is not external to us nor independent of our state of being.

YORK AVENUE FRUIT STAND, oil on canvas, 9″ × 13″ (22.9 × 33.0 cm), 1987

This small quick sketch shows how a brilliant light value, such as a light source, seen behind or next to silhouetted forms will distort their contours. The lamps, for example, will cut into the edges of the vertical poles and the horizontal awning. We see the optical field effect, not the physical shapes of things.

UNE FENETRE AU MARAIS, oil on panel, 16″ × 12″ (40.6 × 30.5 cm), 1979

The sunlit wall behind the flowers and leaves will cut into their contours and sharpen their silhouettes.

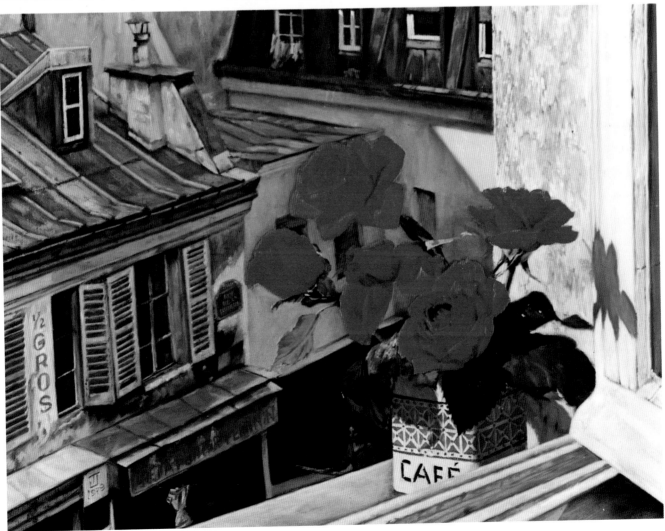

When studying field effects caused by colors colliding, remember that every patch of color is also, so to speak, dressed in a certain value. The field effects we see are simultaneously effects of color and value. In the same way, too, all contiguous values undergo a degree of field effect. As has been observed, the whole perceptual process is one big field effect.

The Field Effect of Visual Accommodation. The eye has difficulty in accommodating equally well to highly contrasted elements. We can observe this uneven accommodation in rim lighting. With the model between us and the light, we see a dark silhouette with a bright glare of light on the model's far edge. We are looking into the light, and it rakes off the form's edge into our eyes. The light edge is also highly foreshortened, so that a high-contrast effect is created between it and the shadow. When looking into a bright light, the lens opening of the eye narrows. This prevents the eye from seeing well "in the dark," so we cannot register the subtle variations within the shadow. To see in the dark, our eye openings must enlarge. In rim light the shadows seem darker and flattened in variation, more massed.

Because of this physiological field effect, the appearance of and relationships on the model will change depending upon how long we look. The longer we look, or the more we focus on the shadow area, the more differences we will be able to distinguish in it, and the lighter it will seem to become. The factor of observation time is important to field effects. Over a lapse of time, field effects change as the eye accommodates better to high contrast or becomes more fatigued by sharp colors. The seen world is not like a frozen photographic image.

The Field Effect of Edge Absorption. In certain conditions the farthest edges of the form will appear to disappear, absorbed by the tones of the background. More precisely, what we can see in these instances is not the outermost edge but rather a zone on the inside of the form. The values at the edge merge with those of the background.

For example, in a front light, with the model seen against a dark background, the dark tones at the edge of the form will usually be absorbed into the background. We may actually be looking at the darker lights. This causes a softening of the edge that is often not noticed when painters think of symbolic definitions of

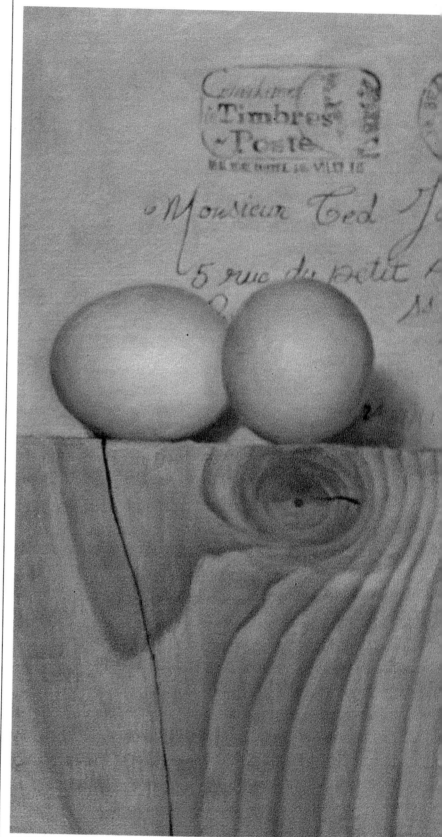

EUROPAMERICA, oil on canvas, 9″ × 13″ (22.9 × 33.0 cm), 1987

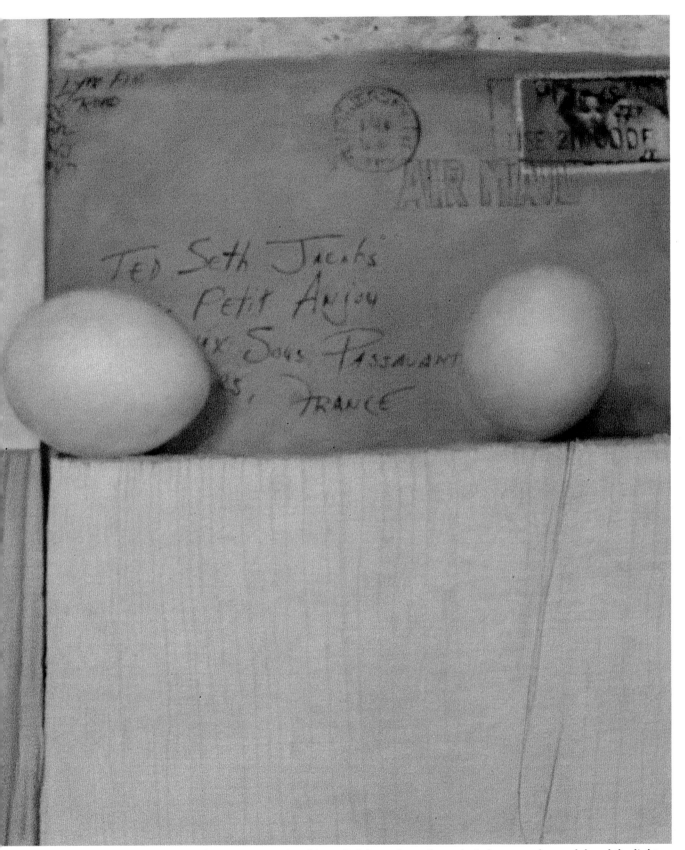

This is an example of front lighting, where the artist is between the model and the light, looking into the light halves of the forms. As the eggs turn away from us, and the light, they darken. They will be darkest at the far edge, which stands out clearly against a light background. Against a dark background, however, this dark edge is absorbed and disappears. In that case, we see the inside of the form, in the dark light zone, as the edge. This edge will characteristically be quite soft.

In many areas of this backlit figure, we are actually seeing not the physical contour of the form but the terminator edge of the shadow. With the light opposite us, the contour will be the lightest part of the form; against a light background, it is absorbed and disappears. This is happening, for example, on the forehead, the nose, the lips, and the upper raised leg. If we were to put a dark background behind the model, we would see a bright edge on these forms. Note, too, that where we see the terminator as the edge, it will not be very sharp.

THE MONUMENT, oil on canvas, 16″ × 20″ (40.6 × 50.8 cm), 1987

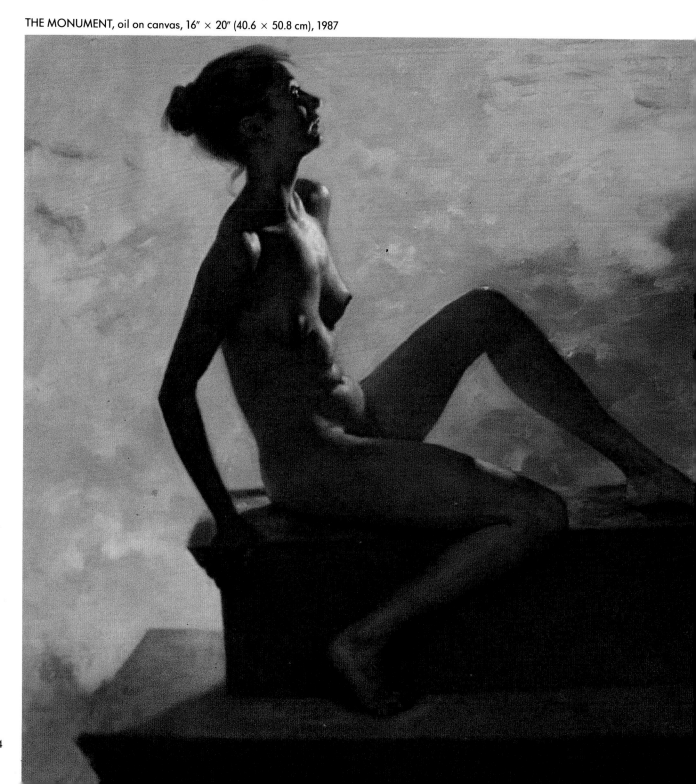

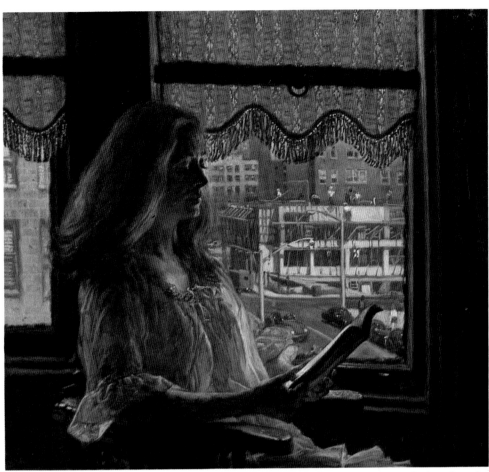

ON COLUMBUS AVENUE, oil on panel, 9″ × 9¾″ (22.9 × 24.8 cm), 1967. Collection of Edward Pawlin.

objects. We must always work very carefully at the edges, where model meets background. Otherwise, the edge seems paper-thin, without roundness, and unlike an effect of light and vision. When you have a dark edge against a dark background, hold a piece of white paper between the model and the background and the dark edge will show up. You can then see and understand the difference between the actual tonality at the edge and the visual effect caused by its absorption.

The edge can also be absorbed in rim lighting if there is a light background (as is often the case). For example, if we see the model against the light, in front of a window or the sky, the light zone on the edge may be more or less wholly absorbed. What we see in that case is not the far edge of the form but either the dark light area or the terminator of the shadow. Because we are then seeing an area on the inside of the form, its shape may appear quite unexpected and unlike the contour we may be accustomed to.

Field Effects Create Space. Another frequently seen field effect occurs when a dark form is silhouetted against a lighter background. In fact, this field effect is a composite of mechanical and optical actions. Next to the dark edge of the form, a very faint and vary narrow zone of extra-light tone will appear in the background. It looks like a faint aura next to the dark edge. The mechanical cause of this effect is that when we see the shadow edge of the model against the light wall, for example, it is inherent in the relative positions of model, light, and wall that the wall will be lighter in value as it "emerges" from behind the silhouetted edge of the model. This can be seen in the illustration. The strong contrast caused by this positioning also causes an optical field effect in the eye because of its inability to accommodate to both light and dark equally at the same time. The dark will appear darker and the eye will also create a lighter afterimage at the edge of the form.

Conversely, this field effect can also be seen along the edge where a form is lighter than the background. In this case, a slightly darker narrow zone of background seems to be squeezed up against the light edge of the model. The model will not seem to be sufficiently detached from the background until we create

these two field effects at the edges. They cause the model to stand out from the ground. These field effects create space between objects.

It is also to be noted that as the eye travels along the edge of a form, that edge may change from lighter in relation to its background to darker. The field effect at each point along the edge will change accordingly. Stay alert for the variations.

There are also other extremely subtle auric field effects, but I think that any artist who has reached the state of being able to see the effects just discussed will be able to find the others.

Creating vs. Depicting Field Effects.
Students often ask whether they ought to actually paint the suggestion of field effects on the canvas or rather cause them to take place in the eye, as they do in nature. Although this is a book about light, not a book about how to paint, it is perhaps appropriate, nevertheless, to discuss this question. My personal preference is for the organic, or internal, method. This is the process of discovering the colored tones *on the surface of the picture* that will produce a living field effect in the eyes. This is different from painting a picture of a field effect. Owing to the limitations of our medium, sometimes we need to do a little of both. However, if the artist only tries to paint a picture of the field effect, rather than to create the effect itself through the opposition of the appropriate tones, the result looks more like paint. Perhaps this is one of those questions of taste and style that is best left to each individual's preference. Some artists deliberately try for a "painty" look, with lovely results. If an artist is more dedicated to suggesting the appearances of light, it may be desirable for the work to look less like paint. In this case, I think the internal, organic style is better suited to the goal.

The inorganic, or external, style paints a description of an effect; the organic style actually creates it on the surface, in the context of the relationships of tones, "internally." The inorganic could be described as static and descriptive, the organic as dynamic and alive. If we do not want a mixture of paint to look like dried paint, we must find the tones that will vibrate as they meet. I think this can be best achieved not by predetermining which tone is needed or by mixing it on the palette, but rather by "finding" the necessary mix *on the surface of the picture*. In this way, we are not describing an observed effect with words but

matching an optical effect to another optical effect. We are using strictly visual means to suggest visual effects. The painted field effect not only ought to suggest what we see, it also must work. It must produce, in the eye, the shimmer of colored lights interacting—a vibration. These living field effects seem a bit easier to produce in a nonrepresentational mode. It is somewhat more difficult to find the needed mixtures in the context of a highly representational style.

Very often we will find that it is necessary, so to speak, to "inject" a very minute addition of a given color into our mix in order to make the field effect happen. Once we are in the habit of painting field effects, it becomes fairly easy to tell whether we are producing them on the picture surface. Until we grasp the creation of living field effects, the tones on the canvas will have the look of dead paint. When the best tone is found, the patch of paint will appear to subtly vibrate before the eyes and physically interact with its neighbors. In this way, the whole picture surface can come alive!

THE NATURE OF EDGES

Edges are considered in painting as the limits, boundaries, or horizons between things: the edge of this page, for example, seen against a tabletop. There are additional edges at the limits between certain tonalities, such as where the shadow meets the light. We deal also with the edges between similar forms, such as the edge of an arm against a chest. These are all the edges of observed phenomena—optical edges. Wherever two shapes of paint touch on the canvas, or where values on a drawing are contiguous, there is an edge. Let us call this type the medium edge, since it is created by the medium in use. What we need to do is to create a suggestion of the optical edge by variations of the medium edge.

The conception of optical edges is, however, misleading. It is not strictly in accord with the effects we see. Optical edges are based upon the false idea that the visual continuum can be divided into separate, nameable objects. This is, in fact, a symbolic-verbal definition of our visual experience. It is not what the eye sees. The attribution of edges divides what is seen into book, table, arm, hand. What the eye registers are optical effects of light, not named objects. It is therefore

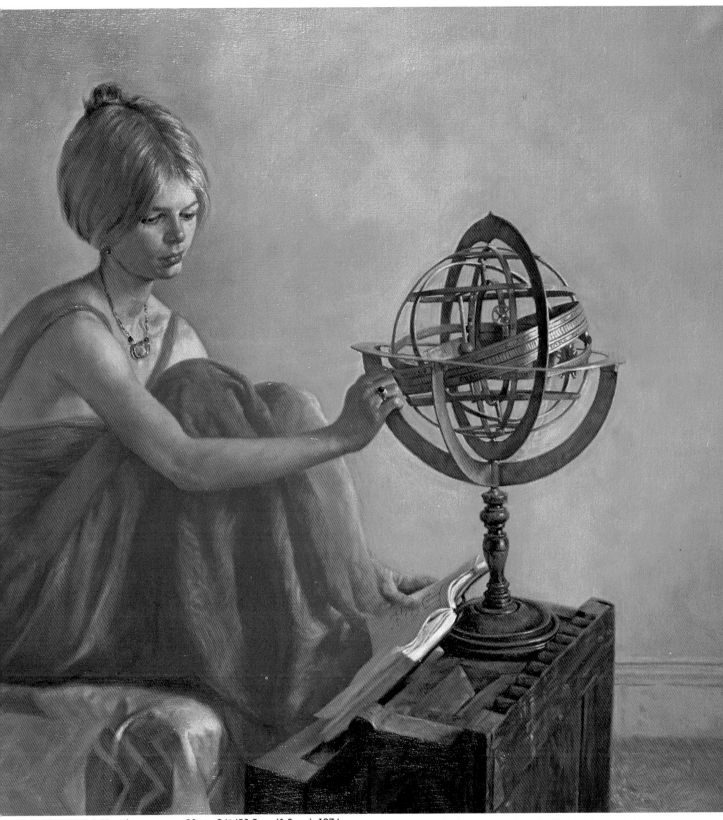

THE ASTROLOGER, oil on canvas, 20″ × 24″ (50.8 × 61.0 cm), 1974

As it approaches the light edges of the model, the background appears to darken. Conversely, it appears to lighten next to the dark shadow edge. Without these field effects, the figure will not sufficiently detach itself from the background.

FISHING BOATS, QUIBERON, oil on canvas, 9½″ (24.1 cm) in diameter, 1982

The edges appear softened in this gray, hazy atmosphere.

As light washes over a form composed of recognizable curved masses packed one on top of another, the value transitions in the light will be smooth and gradual on these curves. Where one of these "packed" masses ends, and another begins, the transition will be sharper.

As a mass curves into the light, its inner edges will appear softer than the edge where that mass, turning away from the light, meets the adjacent mass beneath.

preferable, I believe, to think of edges in terms of field effects between tonalities.

If edges are considered as field effects, rather than definite borderlines, they become zones of interchange. As such, they occur not only between verbally constituted entities but everywhere. In the strictest sense, optical edges do not exist. The whole visual field is an indivisible continuum of interpenetrating light effects. In that visual field, there are no absolutely definite limits between things.

However, we may usefully consider optical edges as constituting another of the scales at our disposal. We can treat optical edges as varying in their degree of sharpness while realizing that none are absolutely sharp. In order to suggest the effects of light, we need to constantly orchestrate a wide variety of edge effects. If we do not work very carefully on our edges, our work will appear unnatural and stylized. It is just as false to appearances, by the way, to make all edges uniformly soft as to render them too hard. As with all our other scales, we must play up and down the optical edge scale, trying to suggest the differences we see.

Sharper and Softer Edges. In general, edges will be sharper where the differences between adjacent tonalities are greater, that is, where there are greater contrasts in some or all of our scales—where something very light is seen against something very dark, for example, with few intermediate tonalities between. Also, edges may appear sharper where greatly differing hues collide and where chromatic variation is abrupt. Usually, strong field effects are accompanied by sharper edges. Or we could say that zones sharing sharper edges tend to propagate strong field effects.

We have already discussed how the higher contrasts will occur more often in the lighter light areas. Sharper edges are usually found there and will also often be seen where an object receiving light is placed against a background in shadow. Similarly, when an object of a very light local color is seen against another that is quite dark, the edges usually will move toward the sharper end of the optical edge scale.

Lack of definition and accompanying softer-looking edges are general characteristics of shadow. In the zone where the light ends and the shadow begins, we must study the edges carefully. The terminator is a subtle demarcation area

VISITATION, oil on canvas, 30″ × 28″ (76.2 × 71.1 cm), 1981

**All the edges must be treated very carefully; otherwise,
they will look more like paint than like seen effects.**

NAZARE, BEACHED BOATS, oil on panel, 12″ (30.5 cm) in diameter, 1980

The high contrasts seen in sunlight produce strong field effects.

between light and shadow, but since the light at that point is usually at its darkest, the contrast at that edge may not be very strong. The degree of contrast and sharpness of the shadow edge is also dependent upon the size of the light relative to the size of the model. As the size of the light increases, the contrast at the terminator generally will also increase. Where the darkening light values meet the shadow, field effects are usually at their weakest, so a very sharp edge will look inappropriate.

The Visual Edge and the Painted Edge. In almost all cases, the "medium edge," or meeting of two patches of paint, if left completely untreated, will look more like paint than an optically perceived effect of light. If we wish our picture to suggest the living process of sight, we must avoid creating effects that look more like paint itself. In this style, we use the medium to suggest visual experience. Therefore, we don't want to have the art object look only like the medium we have used. We want the medium to create vibrations on the surface. There are many other styles in which the artist wants us to remain aware of the medium. Even in these, however, I think there is a desire to make the picture surface come alive, in some sense. Otherwise, it is difficult to see any difference between the paint on the palette and on the canvas.

If totally unmodified, the medium edge can become an inert place where one tonality simply stops and another begins. Even this treatment will generate a field effect, but it is not very likely to suggest the way things look to the eye. The collision of two unmodified medium edges also divides the painted field into discrete zones. The continuity throughout the whole field becomes everywhere interrupted. This creates a uniformity of edge sharpness—a striking of the same note throughout. As the eye travels over such a picture surface, it will be jolted or stopped at each juncture. This produces a very staccato rhythm and also seems to slow the movement of light through the painted world. Even where the optical edge appears to be very sharp, something must be done to the medium edge to cause it to appear alive and vibrant.

There are essentially two ways to suggest the effect of a softening of edges. One way is to fuse two contiguous patches of paint by brushing them together. The other way is to paint the intermediary tones between two tonalities by mixing and painting suc-

cessively smaller, changing tonalities. This can be carried to the point where the variations become so small that they seem like a "granulation" of the light effects. If we use the first approach, carefully brushing one edge into another, we must then shape the light, as has been already discussed. If we don't shape the light, we are putting down the shape of the brush rather than the shape of the light on a particular form. In practice, we may often use both these methods in combination. That is, we can break the variations down to very small sizes and then delicately fuse the medium edge between them all.

Vibrant Edges. The high end of the contrast scale virtually always produces field effects at the optical edge. These are very often extremely subtle. The overexcited, tense, or lethargic observer is not likely to notice them, and they will usually slip past someone who is too preoccupied with symbolic verbal definitions. We have already discussed various types of field effects. We often see a curious exchange between highly contrasted tonalities, where each appears to throw its delicate radiance over the field of the other. It is often easier to see this field effect where a lighter tone casts its faint glow over a darker one, but it can also sometimes be seen as a darker tone appearing to cast a sort of ghostly darker image over or into the lighter. This can be seen often, for example, when a dark object, such as a building, is seen against a lighter sky. The sequence may then be: darker object, exchange of field effects at the edge of object and sky (light radiance over building, darkening at edge of building, lightened zone in the sky where it meets building), and finally, slightly darkened afterimage "ghost" of building, projected against the sky above like a faint, nonreversed reflection or mirage. The optical edge, as we can understand, is quite complex. However, if we remain very alert yet very relaxed, all these effects can be seen in nature.

These effects are extremely subtle. In general, for artists working in this optical style, there is not much point in becoming too preoccupied with delicate field effects until such time as the margin of error in our other scales has been greatly reduced. That is, if you can't hit the values, for example, very well, don't bother about very subtle field effects for the time being. It requires a very advanced level of ability to be able to suggest field effects with the required delicacy. Nevertheless, it is useful to be aware of the

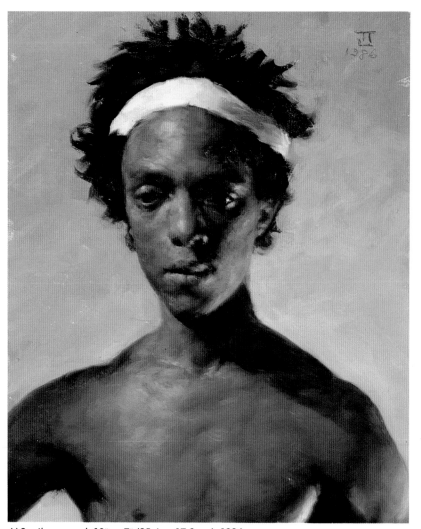

JAS, oil on panel, 10" × 7" (25.4 × 17.8 cm), 1986

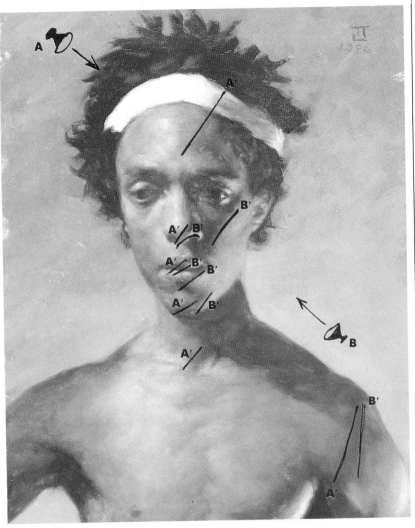

The model for this portrait study is lit by two light sources. Note how the shadow and the direction of modeling in the light tend to cut across the forms, each shadow somewhat perpendicular to its own light source.

existence of these phenomena, and their influence on your paintings at any stage of your development.

MULTIPLE LIGHT SOURCES

Sometimes we need to represent a subject illuminated by more than one light source. Although they may be somewhat masked, all the principles we have been discussing will of course be in operation. In confronting complicated multiple light sources, it is useful to remember that each effect derives from its own source. Each individual source produces its effects of directionality, gradation, and so on. The situation will be clarified if we are able to assign each observed effect to its own source. This allows us to better understand and follow the actions of the light.

For example, the light from every source will tend to cut across the form relative to each light direction. In our illustration, the terminator of the shadow, as well as the gradations in the light, from source A, will lie at angle A'. Those from source B will lie at angle B'. We will therefore see two shadow terminators, each nearer its own source. If we fail to give each shadow its proper angulation, its light will not appear to arrive from the proper direction.

In multiple-source situations, it is also important to assign to each source its own variations among our different scales. Each light may have a different intensity and a different coloration. Different lights may travel over different distances before striking the model. The actual strength and color of each source may be different. Different sources may project light from different angles relative to the positions of model and artist.

If each light is a different color, the corresponding color of each shadow will be different. In our illustration, if A and B are differently colored sources, the complementary shadow hue will be strongest at the respective terminators before the two colors merge.

If the "size" of light source B is larger than A, that will produce a field effect causing the B' terminator to appear darker and more contrasted to the light.

Where two or more sources originate from about the same direction, they tend to merge as one source with a larger size factor. Of course, we cannot have two sources coming from exactly the same place, so we will still see some slight effects from two sources.

BATHSHEBA, oil on canvas, 15″ × 13″ (38.1 × 33.0 cm), 1987

In this illustration, there is one light source at lower right and another one at upper left. The resulting dramatic and irregularly shaped cast shadows create unusual patterns between the two sources.

To repeat once more: Try to distinguish the actions of light that are produced by each source, much as a musical composer can establish and interweave different themes.

Twisting Ribbons of Cast Shadow. Cast shadows caused by multiple light sources often have a quite unusual and distinctive appearance. With only one source, the cast shadow, when it reaches the form-shadow zone, will merge indistinguishably with it. We have noticed that the cast shadow commonly is darker than the form shadow. With multiple light sources, however, the trailing edge of the cast shadow from one source, instead of merging with the form shadow, may become the terminator of the form shadow from another source. The effect this may produce resembles a very dark, irregularly shaped band of shadow, like a peculiarly angled dark ribbon running down the form between the two light sources. This effect can be seen often in theatrical lighting, where intense Fresnel spotlights, often of different colors, are placed at opposite ends of the stage in the wings. Often these spots are large in light size, so that they create an effect of rather flattened, brilliant light on either side of the model, with the oddly shaped, very dark ribbon between.

COLORED LIGHT

All light is, of course, colored. We are most familiar with the colors of cloudy-day light, sunlight, candlelight, incandescent and neon bulbs, and other artificial lamps. In some circumstances, however, we find quite unusually colored light. At sunset, for example, the whole landscape may be drenched in a highly chromatic light of a hue related to the sky's color. Artificial lights can also come in strikingly brilliant colors.

In these highly colored light sources, we first notice that whatever is directly touched by their rays will be washed in their color. This is, of course, obvious, but painting students and artists unaccustomed to working with these odd effects are often so absorbed with the value nuances that they neglect the color variations and chromatic intensities. For example, when painting a model bathed in a yellowish light, they may raise the values in the higher lights by adding only white. This causes the higher values to appear too gray, as if they were not bathed in the same color of light as everything else. The same holds for more unusually colored conditions. It is vital that the whole painted world should appear to be illuminated by the same kind of light. On the other hand, it is not true to nature to think in terms of glazing the color of the light evenly over the whole picture, because, as mentioned earlier, chromatic intensity varies with value change.

As in more usual light conditions, where the shadows will tend toward a more complementary color to that of the lights, the shadows from highly chromatic sources often are very markedly complementary in color. Highlights, as always, will tend to mirror the color of the source itself. It is necessary, when moving into the higher values, to "inject" some of the hue of the source into the mixture.

It is also interesting to study the effect of highly chromatic sources on various local color hues. A colored light will tend to reinforce the chromatic intensity of similarly colored local hues and neutralize the chromatism of its opposites. For example, a red-colored source will give an orange local color an intense red-orange hue, while graying down a green object.

We have previously discussed how the initial reaction of shadows is to turn somewhat complementary to the hue of the source, and that reflected light bouncing into these shadows will carry a variant of the color of the source combined with a variant of the color of the reflecting object.

The artist must always be careful not to allow intellectualizing to influence the perceptual process. There are always exceptions. For example, in a reddened sunset light, the artist may suppose that the shadows will turn complementary and fail to notice that the whole scene, and the air itself, may be bathed in redness, so that the complementary color of the shadow may be offset by other circumstances. An insufficiency of data, or the extenuating effects of a given situation, may prevent us from noticing what the eye is actually registering. We must all always be careful about following our assumptions too rigidly.

Teaching experience has shown me that when using highly colored sources on the model, students often grossly misjudge the "key," or general intensity, of the available light. Very often, as the source becomes highly chromatic, it emits less light. Theatrical lighting is designed

SAMEDI SOIR, JUAN LES PINS, oil on canvas, 18″ × 24″ (45.7 × 61.0 cm), 1981

to overcome this effect, but the sort of colored light bulbs or colored filters we can buy more readily usually give off a relatively small size of light in relation to our model. Students often paint the model in the higher key that they are accustomed to. This leaches out the depth and richness of a low-keyed source. The picture takes on a "pastel" look or seems too "airy." If the key is misjudged as too dark, everything will feel excessively "heavy."

Pictures can also have this heavy or painty look if the colors of the light and shadow are not varied sufficiently with complementary effects. For example, in a yellowish light, although the shadows generally seem quite warm because of reflected light, they "start out," so to speak, somewhat complementary. If the complementary base of the shadow is overlooked, the result is warm shadow and warm light. This gives too "hot" a look, which again makes for a heavy feeling, unlike the freshness of nature. We should always try to see values as *colored* values. Sensitize yourself to become aware of the color of the value at all times. Nothing is more beautiful than color! Don't be afraid of it!

PAINTING THE LIGHT SOURCE

Artists are confronted by the limitations in range of their medium when they try to represent the source of light in a picture. A painted lamp or window, for example, can never light up a room as does the original source. The nineteenth-century critic John Ruskin wrote at some length about that. All we can do is suggest as best we can the observed effect. I think it is safe to say that no object or model can reflect more light of a higher value than the source itself. We thus have to key down everything else in the picture in order to save our brightest values for the light source.

If we are depicting a highly colored source, such as a colored incandescent bulb, we have the difficult problem of working in extremely high values while trying to keep the chromatic intensity. The difficulty is that as we lighten a mix of paint, it tends to lose chromatic

This scene shows two light sources of different intensities and colorations. One source is the darkening evening sky; the other is the colored artificial lights of the streets.

intensity. Paints are most often at their highest intensity out of the tube and unmixed. Adding another color, even white, usually lowers the chroma. There are also not very many paints that are both of high chroma and high value. Reds and scarlets are very limited in this respect, as are most blues, greens, and violets. Yellows, on the other hand, lose chromatism in the darker-valued paints. Unlike paint colors, light sources can be of high value *and* high chroma. Because of the limitations of paint colors, we are obliged to some extent to trade off one scale against another. To suggest the effects of a red light bulb, for instance, in some cases we may want to give up some of the redness in order to suggest the brightness of the source. In other instances, we may give up some of the brightness in order to keep the redness.

In general, though, in order to suggest that they are emitting light, sources need to be rendered in very high values.

The effects we see when looking at sources suggest that nature is also obliged to cope with these problems. That is, right up against the source we see an extremely dark field effect squeezed into a narrow band around the edges of the light. As the background approaches the optical edge of the source it very abruptly drops in value until at the edge it becomes an exceptionally dark, narrow border. This is partly due to the inability of the eye to accommodate both to the brightness of the source and to the darkness of the background. When we look into a light, the receptivity of our eyes is somewhat reduced—we are slightly blinded. We have already seen this effect in rim lighting. I don't think we

OREJONA,
oil on canvas, 24″ × 20″
(61.0 × 50.8 cm), 1975

The light source itself appears in this painting. The woman is lit by front light, with its characteristic flattening effects.

THE JEWISH MUSEUM,
oil on canvas, 16″ × 27″
(40.6 × 68.6 cm), 1967

**This painting also depicts
the light sources.**

can suggest the brightness of the source without the darkening field effect around it. Even when the source is seen against an otherwise light background, as a light bulb against a light wall, the strong field effect will be in evidence. If we are confused by the symbolic idea that a white wall must everywhere remain very white, we will not succeed in making the source in front of the wall look bright enough.

When painting the very dark and narrow band of field effect around the source, we usually need to tint the darkness with complementary color in order to create a convincing vibration. It is interesting to discover that by adding color we can suggest a brighter value of light, and a darker dark, than can be had with untinted white or black paint. We can increase our range by generating field effects through the use of color. Sometimes, in fact, we can produce the

effect of a black that is darker and more lustrous than black paint by mixing only dark colors together. Here, too, we can extend our range with color. We can always find our best equivalent for what is seen if we permit ourselves to be guided by what takes place on the picture surface. If white paint doesn't produce the effect we need, we must find a way of forcing a coloration into it that will create the needed effect in the beholder's eyes. We may need to find a combination that will shock the retinal receptors. These extreme contrasts may need to be somewhat "buried," so that what appears on the canvas doesn't look like contrasted patches of paint but rather an optical effect.

These extra-dark field effects in and around light sources are very important. For example, the frame of cross pieces of a window or the struts or frames of a lamp shade, if they are not made dark

enough, will not bring out the brilliance of the light source. This does not mean that we should omit seen planes of light, such as where a windowsill or frame catches the light, but that we must not leave out the darkest accents where they appear. Without these accents and field effects, we will again get a somewhat stylized "pastel" look that is more of a symbol standing for a light source than its optical appearance.

THE RANGE OF VALUES

Because light defines, accentuates, and causes high contrast in all our scales, there is a corresponding lack of definition and contrast when the source of illumination is weak. In darker sources, such as moonlight, we will be working in the lower range of all our scales. Even the highest values will not be very bright. The darks will become extremely dark, and there will be very little intensity of reflected light. The chromatic intensity will dramatically drop, and it will become more difficult to tell local colors apart. In other words, when there is not much light, *everything* becomes very dark. This effect of a narrowing of range can easily be seen in the diagram. Band A might represent the value range that we might use to suggest sunlight. Band B shows the range we are limited to in moonlight. Both bands go into very dark values, but B does not go very far into the light. In the contrast range, we could superimpose very dark on very light in band A, but in B we can only put darkish light against the darkest darks.

We can think of the width of the range we use in a picture as the key in which that picture is set. This suggests the strength of light shining on the subject. If, for example, we were painting a picture in the range of band B, and we mistakenly used a value from the high end of A, that would raise the whole average value, that is, heighten the key, and would suggest a stronger source of light. This question of key is thus very crucial. Artists who do not understand key, or who do not control the values so as to keep within the given range, tend to represent all their subjects as if illuminated by the same light. This is a disastrous limitation if you wish to suggest the multiplicity of observed effects.

Key can be defined as the amount of color and light available on the subject being represented. If the subject of the picture is an interior, showing a whole room, the key would suggest the amount or intensity of light in that room. If, on the other hand, the picture shows only the model sitting in the middle of that room, the key would represent the light strength available in the middle of the room. In a bust portrait, for example, the key should show the light intensity that envelops the head and shoulders. This would be quite different from the amount of light falling on the feet of the same model, were they the subject. In a north-light studio, the key will vary widely from one area in the room to another. Outdoors, the intensity of light falling on a landscape is very variable, according to time of day, weather, season, and geographic location. In order to suggest and also to maintain the value range of any

picture, the artist must have a very sure grasp of key and firm control within it.

Poster Studies. As I mentioned before, this is a book about the actions of light, not about how to paint. Nevertheless, I would like to advise painters to get into the habit of doing frequent key exercises. Treat them strictly as studies. Don't be concerned with making a pretty picture. Key exercises are designed to deal with *one* problem of painting *only*. They have nothing to do with painting the roundness of form. They have nothing to do with drawing. Do not use key exercises for any of these other problems. The *only* purpose of key exercises is to train yourself to register and suggest the major tonalities of a subject in very broad, general, highly simplified terms. I stress this point because students inevitably try to make "little pictures," rather than key exercises. Don't try to show off, to yourself or others, how well and deftly you can do a small, quick study of the model. If you start getting occupied with other problems, such as drawing, you will not be looking at the key, and mistakes will occur. In practice, we often don't have a great deal of time in which to do a key exercise. Light conditions outdoors change rapidly, for example, and in art schools we may only have a few hours. Even at home, where we may be able to take as much time as we wish, it is in fact better for training our

Scale A shows a wide range of values, from very light to absolute black. Scale B shows a narrower range of values, from a dark gray to black. Scale C juxtaposes the lightest and darkest values of scale B to show the maximum value contrast that can occur on that scale. Scale D juxtaposes the lightest and darkest values from scale A to show the much greater contrast available on that scale. Most often, the value range in the shadow is much narrower than that in the light. Therefore, the shadow area is usually low on the contrast scale and the light area is usually higher.

A

B

C

D

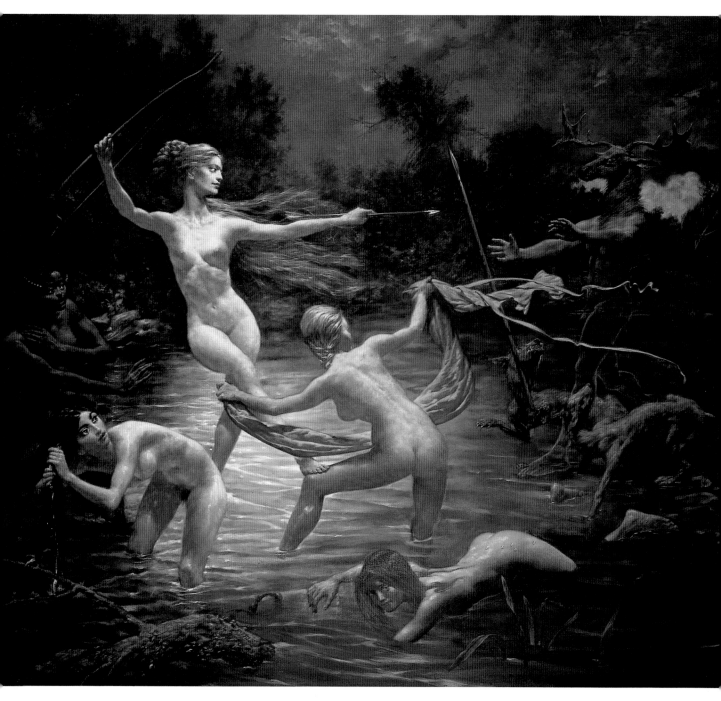

DIANA AND ACTAEON, oil on canvas, 30″ × 36″ (76.2 × 91.4 cm), 1988

In this picture, done entirely from imagination, a light source of relatively small size was assumed. The drop in light intensity is marked, from the values on Diana to those of the foreground swimmer, and from the lighter to the darker area in the pool.

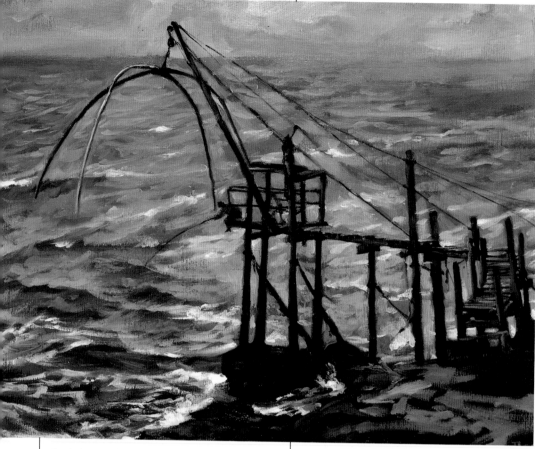

decision-making faculties to get the key study down quickly. With these time limitations, there is simply not enough time to take on other problems. But the real purpose of eliminating all these other aspects of painting is to concentrate all our attention on getting the key right.

In key exercises, we want to find the *flat poster-like averages* for each major element in the picture. For this reason the exercise is also called a "poster." It takes more time to cover a large canvas, so poster studies are usually kept small. They are highly simplified and in that sense abstract. We eliminate all the small shapes and variations. Wherever there is a major area of a single tonality, we find one flat color equivalent for it. It is as if we have to pick a piece of colored construction paper to suggest each major tonality. Poster studies can occupy a large chapter on their own, and this book is not the place for it. An accomplished painter should be able to do them very quickly and fairly accurately. What is important is to be able to see the subject in poster terms. A good poster study accurately suggests the key.

You may ask whether this concept of poster and key can be applied everywhere. On a portrait, for example, should

CARRELET, BRITTANY, oil on panel, 13″ × 16″ (33.0 × 40.6 cm), 1982

The key of this painting is quite low; darker values predominate to create the gray atmosphere of a cold, cloudy day.

STE. BARBE, ST. JEAN DE LUZ, oil on canvas, 18" × 24" (45.7 × 61.0 cm), 1977

This painting is high-key, which evokes the brilliance of a sunlit day; small, scattered dark areas add contrast and accentuate the light values.

PARIS, THE OLD, THE NEW,
oil on panel, 13″ × 11″
(33.0 × 27.9 cm), 1980

I was interested in the un-usual juxtaposition of some of the oldest with some of the newest archi-tecture and in the contrasts of sunlit and shaded areas.

POSTER STUDY FOR PARIS, THE OLD, THE NEW

As you can see, I was not concerned with drawing, proportions, or details in this poster study of *Paris, the Old, the New.* The idea is to simplify as much as possible. The most impor-tant phase of poster stud-ies is toward the end, after you have covered the can-vas with your first approx-imations. Then go back and check every tonality; try to find an even closer match for each one. Pay close attention to how the colors look in the poster, rather than on the palette. What happens in the pic-ture is what counts.

This poster study is for *Nausicaa,* which appears on page 46. The same ap-proach applies to a figure as to a landscape. No at-tempt is made to draw or model forms. Keep it sim-ple and flat, and make those tones ring true.

POSTER STUDY FOR NAUSICAA

we think of the forehead as being in one key, the cheeks in another, and the neck in another? This is, of course, one way of looking at things, but if you divide comparatively small areas into separate keys, you may separate them too abruptly in general value. In most condi-tions, the transition of values on rela-tively small forms is very gradual and continuous. It usually is more useful to gauge the general tonality of the whole head against the background compared to the white collar or the dark jacket, for example. To establish the key, it is easier to think in flat terms for generalized areas. The change of value from fore-head to cheek to neck, for example, is better understood in terms of the model-ing of form and the tilt of plane. In a case where the forehead is very markedly separate in value from the rest of the head, then it can be considered to be in a different key. We must adapt our meth-ods to specific situations. In general, we can define the key as the range of all our scales for a given picture.

A Note About Value Numbering Sys-tems. Some teachers divide the value scale into numbered steps. I personally don't think this is a good idea. The gradations of light are infinitely subtle and varied. Artists who use systems of numerical scales are too prone to com-partmentalize what they see. That is, they tend to separate into units what is more like a continuum. Even if we conceive of that continuum as divisible into separate units, in order to suggest what is seen we would need scales on the order of thousands, rather than tens, of divisions. At that level of complexity, there is not much to be gained by using finite divisions.

The greater danger of thinking in terms of numbered scales is the strong tendency to try to find a way of squeez-ing our observed experience into our system of subdivisions. Artists who use systems of numerical scales very often have a mentality that assigns certain numbers to certain phenomena. They will, for example, postulate that shadow will always occur between such and such numbers on their scale of values. This is, basically, a highly symbolic approach. It is an attempt to quantify our living experience. It is an inorganic method, insofar as it predetermines the values put on the canvas, as opposed to an organic approach based on comparison. Rather than comparing the values seen on the model to an imaginary scale, it is better to compare them to what is hap-

pening on the canvas. It is not useful to use any kind of system that tends to blunt your sensitivity or limit your mental flexibility. We must avoid trying to fit our observations of life into numbered cubbyholes. We search and discover—we are not accountants!

UNUSUAL LIGHT DIRECTIONS

We should familiarize ourselves with as many effects of light as possible. This includes light sources from any conceivable angle. Most commonly, we see the model lit from somewhere above or to the side. It is extremely instructive to study effects where the light arrives from other, less common directions. For example, we can place artificial lights below the subject. We can get the same results by posing the model in different ways. When the source is somewhat sideways, for example, and the model reclines with the feet toward the light, the underplanes will face the light and the top planes will turn away. Use back-lighting sometimes. With the model lit, say, from above, add a light from another direction, such as the side or from below or behind, in order to study the effects of multiple sources. As well as being beautiful in themselves, unusual light directions jog our attention and shake us out of our habitual reactions. They help us to challenge our assumptions. They make us more aware of the effects that result from the directional quality of light. They help us to understand the angular cuts of light across forms. They also widen our repertoire of possible effects and give us a broader range of expressive possibilities. We need to develop the painting experience of as many situations as possible. Much as an actor or actress needs to draw upon the experiences of many emotions and situations, the artist needs a vast visual repertoire.

LIGHT ON SHINY SURFACES

On very shiny surfaces, such as glass, polished metals, gilt surfaces, highly polished woods, glazed ceramics, and porcelains, light does not usually behave in the same way as it does on more matte surfaces, such as skin, cloth, and walls. On shiny surfaces we sometimes can see the more familiar gradations of light mixed with other special effects. Very shiny textures have

ASIAN JEWEL, oil on canvas, 16" × 24" (40.6 × 61.0 cm), 1987

The highlights on these shiny surfaces are often minute mirror images of the light source itself (in this case, an incandescent bulb). Inside the blue bowl we can see an example of a darkening field effect around a highlight on a white surface. When painting the field effect, we must be careful not to "dirty" the whiteness of the surface.

mirrorlike qualities and often reflect tonalities from the surfaces of objects around them. A shiny steel surface, for example, may be very dark even where it is turned toward the light, if it reflects some other dark object. A shiny object in the shadows may glisten with the reflections of bright things. This ability to reflect tonalities from the surrounding environment can cause unexpected effects and transitions. If you are only accustomed to painting skin, highly reflective textures may confuse you. A highly polished cylindrical form, for example, may present the appearance of abruptly contrasted alternating "stripes" of lights and darks without much apparent relation to the usual gradations on a rounded form.

Because of their mirrorlike surfaces, shiny objects may reflect miniature images of the light source itself. A glass may reflect the tiny image of a nearby window or, at night, of a lamp. We then encounter the problems of painting light sources, as has been discussed, with their attendant field effects. The edges of

these light-source images are usually rather sharp. If they are painted as too soft, they will look not like glistening reflections but like zones of lighter light. Their special character will then be lost. Crisp mirror-image highlights are usually required to suggest the texture of shiny surfaces. These highlights will sit in the middle of strong field effects because of their position high on the contrast scale. However, even the optical edges of these tiny, glistening highlights will be varied.

Another characteristic of the shapes of highlights on very shiny surfaces is that sometimes they will be stretched and elongated the length of cylindrical forms or along sharp corners—along the stem of a wineglass, for example, or along the edge of a sharp-cornered metal object. These highlights, while they may be the reflections of the light source, are elongated. Generally, the brightness of one of these elongated highlights will subtly vary as the object moves to a less direct angle to the source.

Another curious effect that can be seen

EAST-WEST STILL LIFE, oil on canvas, 30" × 28" (76.2 × 71.1 cm), 1976

A lens effect occurs in the lower right, where light is projected by the glass spheres.

THE FLOWERS OF GEOMETRY, oil on panel, 13″ × 24½″ (33.0 × 62.2 cm), 1978

Here is another example of a glass object projecting light onto another surface. This painting also illustrates the problem of painting a colored light. Because the blue paint must be lightened with white or a lighter color to depict the projected blue light at its proper level, the chromatic intensity tends to drop off. In such cases, we must choose between brightness and chroma.

119

FIVE CHINESE PORCELAINS, oil on canvas, 16" × 24" (40.6 × 61.0 cm), 1983

**Designs painted under shiny glazes
present their own problems to the artist.**

on glass is that the light striking the part of a rounded glass facing the source may not be as bright as the light "emerging" from the side farther away. This, of course, is quite the opposite of the effects on a matte surface. The light "exiting" a round glass object often seems to undergo a lens-magnification effect; the light looks as if it is trapped and intensified, like a sunbeam through a magnifying glass. We can see this, for example, in a glass of wine, where the edge of the wine farthest from the light appears to brighten. In an empty glass, too, we often find an accumulation of brighter highlights opposite the highlight nearer the source. Similarly, solid glass objects such as paperweights or crystal balls may also act as lenses and project a spot of intensified bright light on a background or tabletop. I once painted a still life of a lace-maker's lantern, which was a hollow glass globe on a stand. It was filled with water and placed next to a lit candle so that a bright disk of light was projected out the side opposite the candle to illuminate the work area.

Clean, pure glass is more or less transparent. If it were completely so, it would disappear so that we would only see whatever is behind it. Therefore, glass normally does not show the usual effects of light on opaque matte surfaces. However, as a glass turns edgewise to us and becomes foreshortened, we look more into its thickness and see it as less transparent and more subject to normal variations. For this reason, round glass forms can show effects of more or less transparency.

Glazed china and porcelains present another subtle problem. When painting white or pale glazed objects, we need to judge the overall key of the form in the light very carefully. If the object, in the light, is mistakenly judged too high in key, there will be no "room" left to go high enough for the brightness of the highlights. There will be nothing dark enough for them to shine against. In a picture, a white porcelain may in general be of a quite high value, which can make it difficult to estimate. We then have to make it look very light yet be able to superimpose a shining highlight upon it. These highlights will almost always be surrounded by a subtly darkened field effect, which helps to overcome the difficulties. If we make the key of the porcelain too dark, it may look like a gray, rather than white, material.

When suggesting extremely dark, shiny surfaces, we must again be careful about the overall key. For example, the side of a black porcelain bowl facing the light will seem to make a "hole" in the picture surface if we judge it too dark next to its highlight. If we don't get it dark enough, it will seem to show a sort of "smokiness" and will not suggest the deep, glistening richness we see. Remember, there is no fixed rule about how dark or light something can be. What is important is that our paint mixture resonate true on the picture surface, in harmony with all our other surrounding choices. Arbitrary dicta produce work that looks painted in a certain style and does not correspond to what we see. Whatever reality may be, *it does not look like a style of painting.*

Glazed porcelains can be included in another category of surfaces. These are essentially opaque ones, over which a transparent shiny glaze has been added like a varnish. Varnished violins and porcelains with a design painted under a glaze are examples of this type of texture. On objects of this kind, one surface often shows up more than the other, in alternation. At some points the shiny effects may completely obliterate the underlying patterns, while elsewhere we may look into the more or less unobstructed subsurface design.

There are some other special surfaces that produce somewhat unexpected effects of light. Hair is one such. Most often, hair seems to soak up most of the light falling on it so that its "poster" value may be darker than what we expect. This is true even for blond hair. In such cases, the hair becomes a sort of dark cap or frame around the face. The lighter lights and highlights on shining hair may be confined to small islands on a darker surrounding value, like the highlights on other shiny surfaces. A grasp of the "poster" is very useful when estimating the general tonality of hair and furs.

Some fabrics, such as velvets, create strange effects. When a piece of velvet turns away from the light, it may abruptly turn lighter at its farthest edge instead of darkening. Glazed fabrics also produce unusual sequences of value change. In these cases, try to sort out and understand the separate themes and effects. The surfaces of bodies of water outdoors can also surprise us with oddly alternating bands of tonal change.

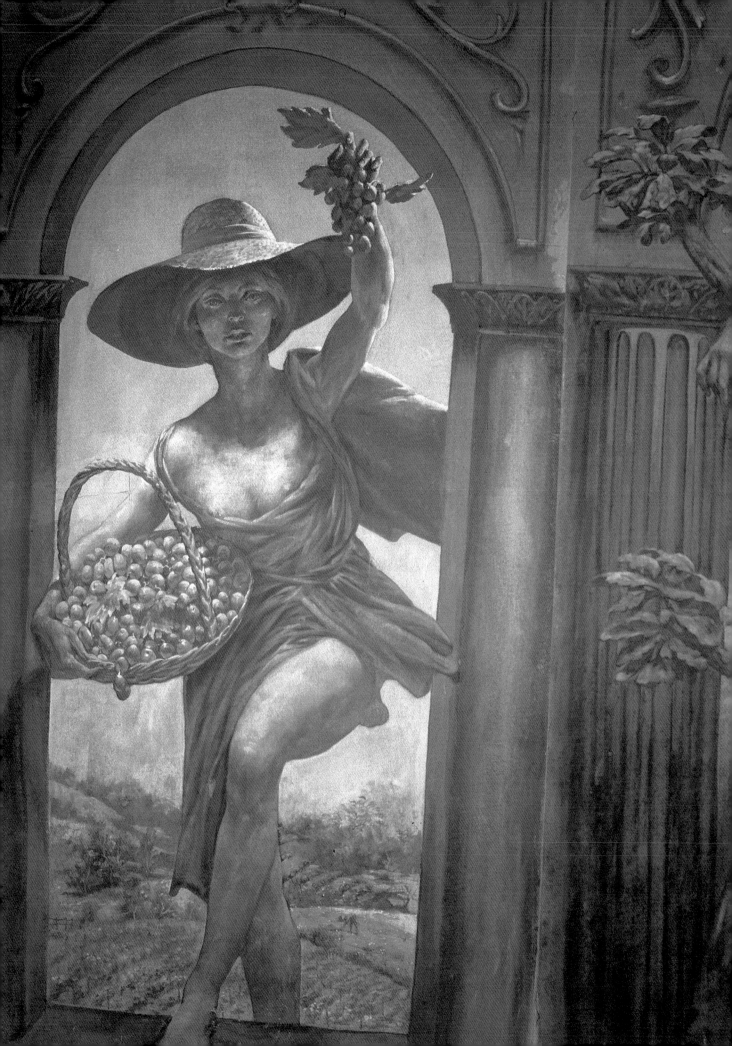

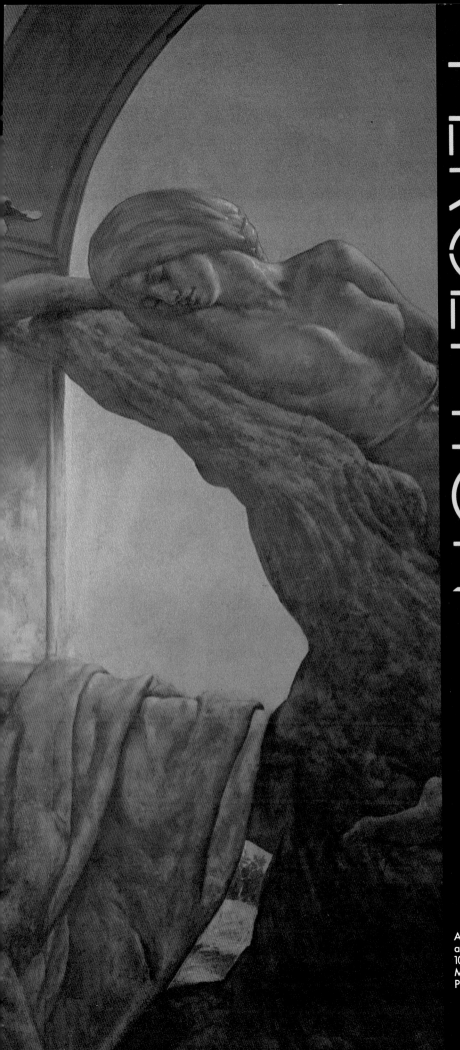

TOWARD A PHILOSOPHY OF PERCEPTION

AUTUMN AND SUMMER,
acrylic on canvas,
10' (304.8 cm) high.
Mes Illusions, France.
Photography by Bernard Mazeau.

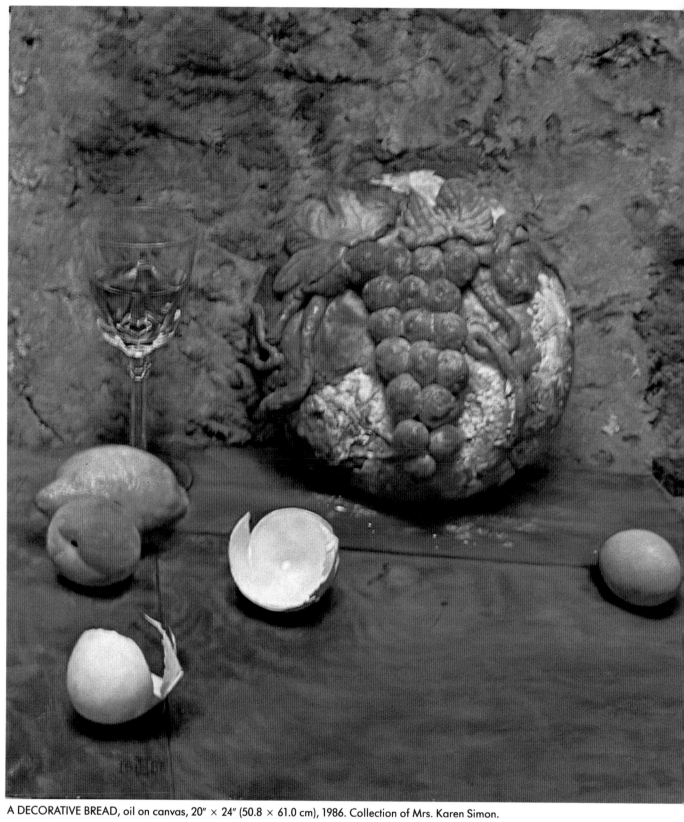

A DECORATIVE BREAD, oil on canvas, 20″ × 24″ (50.8 × 61.0 cm), 1986. Collection of Mrs. Karen Simon.

Focusing attention on the manifestations of light and the perceptual process itself tends to de-materialize the painted world somewhat. This does not render it any the less "real," however. The painting looks real because it suggests the way things look.

ALTHOUGH THE DIRECT SUBJECT of this brief survey is not metaphysical speculation, for those readers who are interested in these things, certain parallels can be drawn between light and consciousness. Readers who are not interested will, I hope, excuse this digression and skip ahead.

LIGHT AS A PARADIGM OF CONSCIOUSNESS

Earlier, I described light as a "hidden factor" of our experience. For great numbers of people it is not so much hidden as totally unnoticed. It is a question of where our attention is focused. Most often our attention is centered on what we think of as tangible objects that interest and attract us, rather than upon the light that reveals these objects to us visually. This is the cause of most of the difficulties we encounter when trying to represent the appearance of our world. It is unbalanced to focus all the attention on only one aspect of our experience. As artists, especially, we must learn to redirect our attention toward the manifestations of light. As long as our focus is fixed upon our habitual verbal-symbolic definitions, we will fail to notice how these objects are described by light. Experience teaches us how deep-rooted our symbolistic preconceptions are. It seems as if they have been ingrained and reinforced since beginningless time. It is not surprising that they seem almost impossible to uproot. By constantly trying to interpret our visual experience as movements and actions of light, we can chip away at this petrified block of symbolic preconception.

Curiously, a number of researchers in the spiritual, mystical, and religious fields tell us more or less the same things. They too speak of an over-emphasis, an imbalance, in our focus of attention. The advice is that we are much too centered on what we think of as the outer, as contrasted with the inner, realities.

If for a moment we separate our experience into perceived objects and perceptual process, I think we will agree that most people, most of the time, are largely preoccupied with the objects. For instance, when we feel like eating an apple and reach for one, we rarely bother much about our perception and consciousness of the apple. The mystics tell us that this causes a troublesome imbalance in the way we perceive our own experience of life. In order to compensate for the effects of this imbalance, the mystics advise us to pay as much, or more, attention to consciousness itself. Instead of being conscious only of supposed objects of consciousness, we must be equally conscious of consciousness itself. Consciousness, or mind, looks at the world, but who looks at the mind? The goal of the mystic is essentially to focus the attention on the mind—on the light of consciousness. Consciousness is a living power, a vibrating energy, an illuminating process that is the substratum of our experience. The mystic's way is to study this vibrating process as intently as its apparently perceived objects. The artist asks, "What do things really look like? What is my perceptual process registering? Void of all preconceptions, words, and symbols, what remains to be seen? What is there?" The mystic similarly asks, "What is consciousness? What is that power by which I live and perceive? Who, or what, perceives? Is there any difference between perceiver, perception, and perceived? What is there?"

As artists who try to suggest the seen world retrain their attention to focus on the effects of light, the mystic retrains the mind to focus on mind, on consciousness itself. We could say that both these researches tend to "de-materialize" our experience. They both balance an excessive preoccupation with the so-called objects of perception with an intense study of the medium of perception. It is also interesting to note that in both processes this balancing of the attention creates a different state of being. The mystic becomes as attached to consciousness itself as he or she was formerly attached to its perceived objects. The artist becomes absorbed and identified with the medium of perception, light, rather than with the objects it reveals.

The Buddhists speak of the dissolution of the interdependent knotted links of the *skandhas*, those illusions that tie together our customary perception of everyday reality. Once the attention has been balanced, both mystic and artist are apt to realize that there cannot in fact be any separation between consciousness and its objects, between the so-called spiritual and material, perceiver and perceived. All these can be understood as aspects of one universal vibration, where each exists as a mirror-image of the other.

For the artist, the study of light can be treated as a mystic discipline that will progressively liberate the mind from its customary imbalances and attachments.

LIGHT AS THE TEACHER

The approach set out in this book is, simply, to follow the light. Allow the light to lead you. This is an attitude, a way of looking at things. It is characterized by a receptive openness. Rather than imposing a preconceived idea upon our visual perceptions, we try to follow the actions and shapes of the light. By observation and comparison, we can discover how light moves across forms. We learn from light what things look like. This practice develops a mental pliancy. We adapt our conceptions to the always unexpected movements of light. We increase our ability in this way to suggest whatever effect is presented to our field of vision. We accommodate to whatever shape the light may take with fluid ease. Through identification with light we can increasingly become liberated from our symbolic restrictions. Light is far and away our best teacher. It is always infallible, without any bias, ever available, and always perfect.

How to Learn from Light. The great key to this approach is comparison. We can turn light into our teacher only by constant and rigorous comparison. We must incessantly compare our pictorial suggestion to the observed world, until this becomes a reflex. Only by this tireless back-and-forth comparison can we utilize light as our teacher. We must learn to constantly scan back and forth between the surface of the picture and our model—between our two worlds, the painted and the seen. If we do not compare, even for a moment, we will fall back upon deep-rooted symbolisms. We will, in effect, paint a self-portrait. It is doubtful whether we can ever avoid that, but by following the light we can somewhat counterbalance this urge to reproduce our own image.

When the scanning reflex becomes highly developed and sensitized, we can immediately notice inconsistencies on the picture surface. Anomalies of tone and line will "jump out" at our awareness. As we learn to better orchestrate our various scales, we will quickly recognize even small disharmonies in any of them.

Dogmatism vs. Discovery. There are two quite different ways to suggest the effects of light. One way consists of studying the model, deciding what tone needs to be mixed, mixing, and then applying that mixture to the canvas. The

THE BREADS OF PARIS,
oil on panel, 17" × 15"
(43.2 × 38.1 cm), 1982

Learn what things look like from the observation of light. Paint the light, and all the different surfaces and textures will appear by themselves.

QUE FAIS-TU LA, TED?,
oil on canvas, 24" × 30"
(61.0 × 76.2 cm), 1984

In general, I do not consider myself a
trompe l'oeil painter, but occasionally, as
in this painting of fifty-two French post-
cards, I do paint in that manner.

AN AMERICAN IN PARIS,
oil on canvas, 25" × 30" (63.5 × 76.2 cm), 1984

The picture surface will show us whether
the effect we wish to create is actually
occurring. It is only necessary to compare
what is happening there with what is
happening on the model.

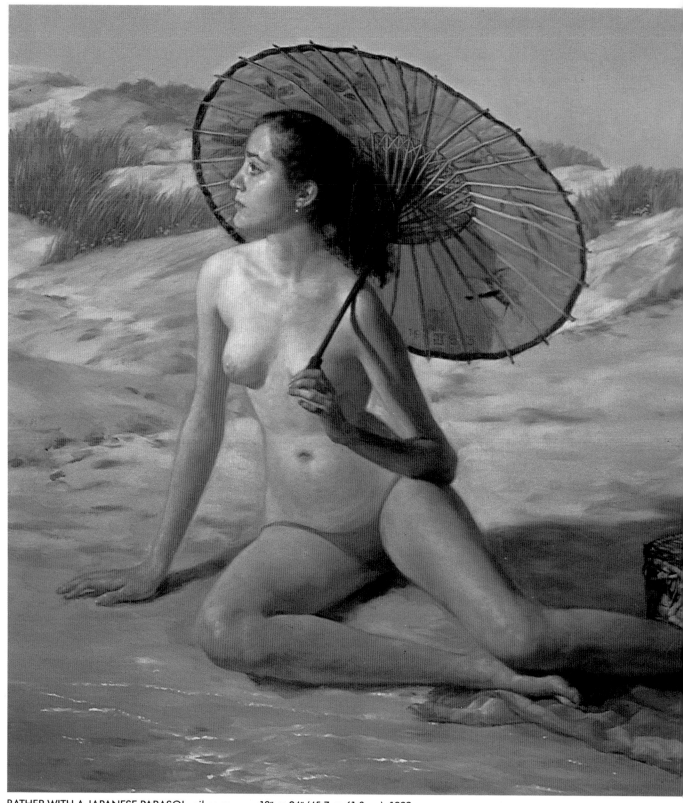

BATHER WITH A JAPANESE PARASOL, oil on canvas, 18" × 24" (45.7 × 61.0 cm), 1983

It is not necessary to try to verbally predetermine whether the shoulder is lighter than the breast, for example. Bring these values into balance in the picture by fine-tuning them until their note rings true.

unconscious assumption that we have made the best mixture is implicit in this approach. We assume that by studying the model we will know how to mix what is needed. The weakness of this approach is our assumption of infallibility. One of its strengths is that if it is done honestly and rigorously, the painting will usually show a strong internal consistency, a quality of conviction, and the freshness of direct observation. Thus, we can profitably take advantage of these strengths, while modifying the approach to avoid its weaknesses. In effect, we can use it as a first step. From careful observation of the model, we can provisionally decide the mixture that will best suggest what we see.

The second approach, however, differs radically. Rather than assuming that our prejudged mixture is correct, we use the surface of the picture, *and what happens on it*, to find what mixture is needed. We never assume that what has been mixed on the palette is our best solution. What counts is what takes place on the canvas. This difference in approach is extremely important. It is the heart of the observational method. We look at the surface of the picture to see whether the effect we want to suggest is taking place. As carefully as we study the seen world, we must study what is happening in our painted world. This style of painting can be described as both the suggestion and creation of field effects; as we work, we check the picture to see whether those effects are taking place.

This approach treats the picture surface as a living, reacting organism. This painting process is not a mechanical transfer from palette to canvas. It is, rather, a process of discovery, of *finding* how to cause our mixtures to vibrate and resonate. It sounds absurd to advise artists to look at what they're doing, but it is quite easy for them to become so absorbed in the study of their model and the search for equivalent tones that they can forget, or become too excited to notice, what effects are actually taking place in the picture. Artists have a strong tendency to assume that once an effect has been observed, it will necessarily be transferred to the picture. Painters also tend to transfer mixtures from palette to canvas, rather than *create effects on the surface*. What counts is what happens on that surface. Our first method of observing, mixing, and transferring—no matter how well it may be done—will not give as dynamic, organic, and alive a result as the second practice of creating the effects

on the picture plane. With the second approach the painting resembles the model in that it too becomes an optical effect. The picture surface shows us what needs to be done.

Learning from the Picture Surface.
Very often both students and painters will study the model carefully and then ask themselves (or their teacher) questions such as, "Which is the highest value on the figure? Is the shoulder lighter than that raised knee? How dark is the shadow on the neck compared to the hair?" It is not actually necessary to ask such questions!

One reason is that such questions are framed in words. We cannot translate a visual effect into a verbal message. Optical stimuli do not translate into literary forms. The artist who tries to do that is creating another symbolic form. It is like the well-known problem of describing the taste of chocolate. You can try to describe it, but to know it, you have to taste it. With tonalities, you have to see them. We are better advised to try to translate or suggest what is seen through visual means: optical to optical. Painting is not literature.

The other important reason why it is not necessary to determine our discriminations beforehand is that we can *more accurately* find the answers to our problems by very carefully studying what is happening on the surface, in the context of the whole picture and its relationships. They are all interdependent and interrelated. The surface will tell us whether our value is correctly situated in the scale. By comparing what is happening in our seen world to what is happening in our painted world, we can pick up any discrepancy and adjust it to a more correct match. The *painted* shoulder will then immediately tell us whether it needs to be lightened or darkened in relation to the raised knee. In relation to all the other values in the picture, it will "come forward" either too much or not enough or it will sit just right. When we get it very close to our best match, the value will immediately appear to resonate harmoniously, in tune with the value on the model. It suddenly seems to "get right," or stay in the right place on the surface. This process applies to the other scales—such as hue and chroma, as well. When you paint in this manner, it is as if the mix you are creating *on the surface* is on a rheostat control. You can gradually modify it and fine-tune it with great precision till it comes into synchronization with what you are compar-

ing it with on the model. This is a completely organic way. We then do not "write" a description of effects with paint, but create them within the painted world. Do not ask what value something should be—find it!

This approach trains us to consider the picture surface as a unity, an interreactive field, a set of interdependent relationships. It also reinforces our understanding of the painting process as a suggestion of the relationships between things, rather than a description of the things themselves. When the relationships become harmonious, the things will appear. This method focuses our attention on the perceptual process, rather than on what we call its objects.

Just as light teaches us what is taking place visually, the picture surface teaches us how best to suggest those effects we see. That empty white field is our very best instructor. Indeed, like light, it is impartial and always there. The picture surface is a true, clear mirror of our state of mind. It perfectly reflects all our attitudes toward our experience and our interpretations of it. The picture surface is our inmost nature made manifest. To make it into our teacher, all we need do is constantly compare what is taking place on it with what we are seeing. All our quirks, prejudices, attachments and preferences, blockages, incapacities, symbolistic ideas, hesitancies, and fears will all look back at us from the canvas or paper. As we overcome or supplant these limitations, our new freedoms will also announce themselves in the work. All that we need in order to develop to the highest possible levels is contained in that empty white field. All we need is to ceaselessly compare "what is happening here to what is happening there," and then constantly strive to improve our match, to refine our solutions further.

MANY FORMS, ONE LIGHT

This brief treatise has analyzed various aspects and categories of light effects. It is important to take note of a fundamental difference between how we see these effects and how we suggest them. Our visual perception is instantaneous. Our artistic renditions are cumulative, additive, sequential. They are constructed element by element over a period of time, using a medium, by various techniques. We are therefore always working behind our visual pro-

FISHING PORT, CIBOURE,
oil on panel, 16" × 20"
(40.6 × 50.8 cm), 1976

**It is best to avoid giving
verbal names to colors. We
can find our best color
match by judging each
tone in relation to all
others within the painted
world. The colors are never
"right" on the palette, only
in the picture as a whole.
Using this approach, you
will discover unusual and
original color mixtures. In
the process of finding the
color on the canvas, you
will create solutions that
have never been seen be-
fore, because your mix will
be a response to a specific
and unique stimulus.**

PORNIC,
oil on panel, 12" × 10"
(30.5 × 25.4 cm), 1982

**This very rapid oil sketch is
an attempt to seize the
character of the scene and
the look of the light.**

cess with no way to catch up. It takes a
great deal of time to convincingly suggest
what transpires in a lightning flash of
consciousness. It also requires highly
complex technical processes. These pro-
cesses include our media and our intel-
lectual conceptions. So far, we have not
found the way to instantly and directly
project our mental images to a picture
surface. Even the so-called "explosive"
style of Zen ink-painting still suffers
from these limitations. What is this field
of vision that is ever present before our
eyes? What, in fact, does it look like?
This question doubtless is as old as the
human mind and as new as each think-
ing person. I will only presume to give
my own answers at this moment in my
life. I hope that I can continue to elimi-
nate my own prejudices and find new
answers.

Things look to me now like a wide
field of infinitely varying colors, a tapes-
try of colored light, a kind of shimmer, in
fact, like a vibrating field of constantly
varying colors. What seems most charac-
teristic to me, whenever I look, is this
sense of luminous vibration—the sense
of living illumination—and the constancy
of variation. What is striking is that these
ever-present movements suggest a con-
sistency. Perhaps the idea of consistency
is something the mind superimposes on
the multiplicities. Perhaps there is some-
thing in the mind that tends to organize
change into pattern. It certainly seems
that the closer we look, the more vari-
ation we see. This effect depends upon
our scale of observation. This piece of
paper will look entirely different when
seen normally than when seen under an
electron microscope! I don't honestly
know whether it exists, but the sense of
consistency is a quality I feel in the
perceptual process. I suppose that if I
feel it, it exists for me. At present, that is
the way I see things. Therefore, to
suggest the process of sight, I must
suggest consistency. Since the medium of
sight is light (maybe we should give
away a T-shirt with each copy of this
book: "Sight is Light"), I must suggest a
consistent quality in light, a coherence.
To suggest perception, I need to suggest
consistency. I suspect that it is the
quality of inner consistency that causes
our painted world to look more or less
convincingly "real" to the observer. Light
seems to have its own coloration and
intensity. It seems to vary consistently.
Its action upon form seems consistent.
These elements all appear to unify the
field of vision. The more exquisitely we
can attune each of our various scales and

the relationships between them all, the
more convincingly consistent and unified
our painted field will look.

Keeping the Scales in Perspective. In
the last analysis, I think it can just as
reasonably be said that all our precious
scales do not actually exist. Probably
they are, in fact, merely another insidious
form of symbolism. In this sense, there
are no lights, no shadows, no edges,
nothing that can be *named with a word.*
There is only something seen, only the
vibrating consciousness. All our scales
are artistic inventions. They are neces-
sary and useful—even essential—but we
do not see them. They enable us to
recognize and correct inconsistencies in
our painted field. It is necessary to
harmonize and orchestrate as best we
can each thread in our pictorial tapestry.
To achieve this, we need the conception
of scales. Because we create our painted
field out of emptiness, we must con-
stantly ask ourselves whether we are
creating too much or too little in all our
scales. The effect of unity we find in the
visual field must be created decision by
decision, stroke by stroke, in the picture
field. The visual field is simply there,
fully formed, looking like itself. In at-
tempting to suggest it artistically, we
may introduce various inconsistencies.
We can check through all our scales in
order to find any inconsistencies. These
scales are as much one of our materials
as brush, paint, or charcoal stick. The
scales are part of our medium. They are
a conceptual branch of our materials. We
do not see the visual field as divided into
scales of value, hue, chromatic variation,
edges. What we see is a collection of
colored lights. The field of vision is,
finally, a flashing of consciousness. This
is what it looks like to me.

The Unifying Effect of Light. All the
characteristics we ascribe to light seem
to contribute toward an aspect of unity
and consistency. Each source of light has
its own intensity. Every field of vision, at
any given moment, is lit by a certain
strength of light. This is called the key.
Each picture must express its particular
and correct key. It is equally crucial that
the given amount or size of light be
consistently and coherently distributed
throughout the painted world. Each
source has its own coloration. In each
picture this coloration must subtly per-
vade everywhere. These elements, as
well as our other scales, are infinitely
variable, but the variations all seem to be
consistently controlled. All our intensities
seem to heighten and decline according

to principles. On the other hand, all the *surfaces* that light falls upon seem to change constantly. What that means is consistent actions of light on an infinitely variable surface. These surfaces are only visible to us through the actions of light. Therefore, the unpredictable diversity of forms is unified by the actions of light. It is as if the multiplicity of life has been enclosed by a unifying net of light thrown over all.

THE INTERCHANGEABILITY OF LIGHT AND FORM

In order for the phenomenon of vision to manifest itself, both light and form must be present. We cannot see one without the other. Light is invisible and self-effacing until it falls upon some object, some form. All forms are similarly invisible unless and until they are defined by light. For life to become visible, these two elements must be present. The seen world is their mutual presence. As artists, we deal with these two elements, light and form. Light travels as a ray or beam intercepted by the infinitely varied shapes of forms. We must suggest the interactions of the directional ray and the particular shape of each form it meets.

We can say that light and form are two ways of describing the unified process of vision. For this reason, when trying to suggest the actions and effects of light, we must describe the exact shape of the form. The shape of the light and the shape of the form are interchangeable

CONSTRUCTION SCENE, oil on canvas, 28" × 42" (71.1 × 106.7 cm), 1962

The infinite variety of forms and textures is unified by the consistent effects of light. This picture was underpainted in a warm monochrome and the color was added in glazes. Although this technique produces a beautiful luminous surface, it tends to tint large areas with the same hue and chroma.

LA LIEUTENANCE, HONFLEUR, oil on canvas, 12" × 16" (30.5 × 40.6 cm), 1982

The generalizing action of light is broken down into the details of the very particular and specific.

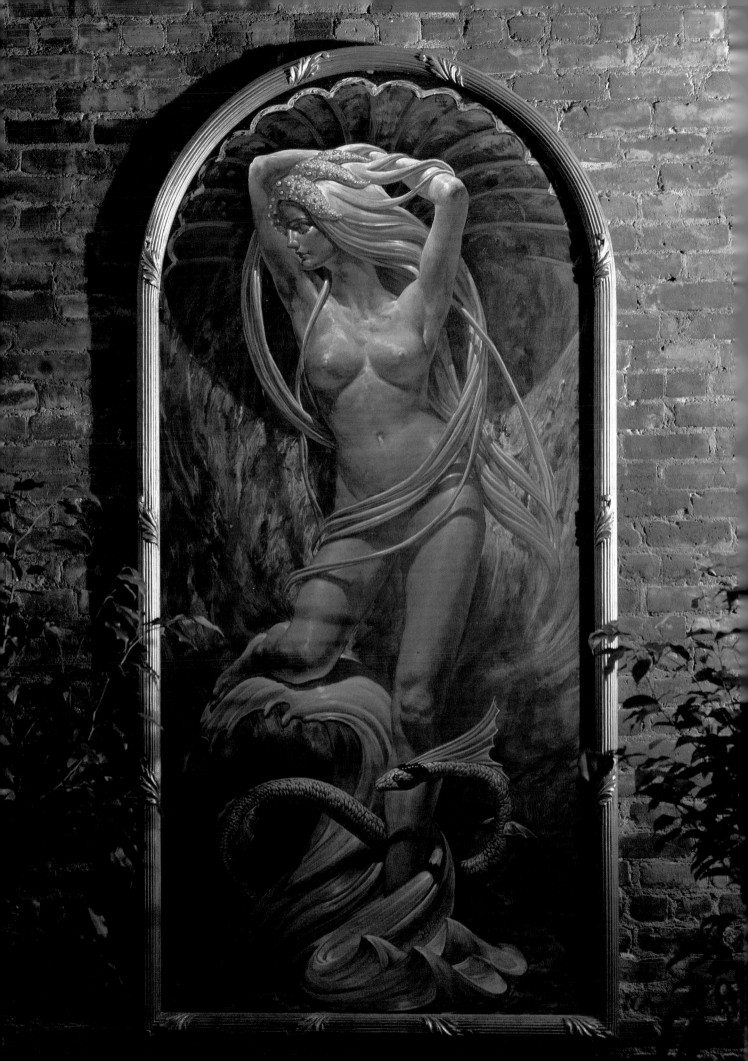

SEA-SIREN,
mural panel, acrylic, 84″ × 42″
(213.4 × 106.7 cm), 1985.
Wilkinson's Cafe, New York, NY.

A consistently graduated wash of light unifies a multiplicity of forms and angulations.

terms for describing what we see. In our art, the light must be exactly shaped to reveal the particular configuration of each form. The form must be modeled in exact accordance with the directional effects of the particular light falling upon it. The artist who distributes the light according to some principle of light action without exactly describing the shape of the form is symbolizing, or stylizing, the light. The artist who describes the form but does not suggest exactly the movements of light upon it is following an essentially sculptural or tactile approach. Historically, most artists have used a mixture of these two approaches. If we wish to suggest the way things look to the eye, we must avoid any imbalance between light and form. If you wish to work in some other non-optical style, your work will be stronger if you understand these differences of approach. Your style will, I believe, be weaker if you don't know when you are using which.

THE GENERAL AND THE PARTICULAR

The ideas presented in this book are general principles about the actions and effects of light. Their applications to specific models and situations could be thought of as the particular. We have, then, general principles applied to very particular situations. We suggest the particular within the matrix of the general. But the general only becomes visible in particular instances. The general is only manifest in specific applications. Just as with light and form, then, we can say that the general and the particular are only ways of describing a unified phenomenon.

The general principles in art can be applied to smaller and smaller particularities ad infinitum. Since each is a manifestation of the other, perhaps the general can never be truly suggested unless it is infinitely broken down into particulars. As artists, though, we must work within both our human and our material's limitations. We also must always remember that we are not reproducing what is seen but suggesting it. We must make a choice about how minutely we will describe the particular. This is an important element in determining our style. How far do we wish to go? We ought to perhaps also ask ourselves whether we are stopping at a certain point out of preference for a certain look or from a lack of determina-

tion and tenacity. Should we push ourselves harder? The artist who has developed the concentration and endurance to describe the very particular easily knows how to leave things out when a quick generalization is desired. But the artist who has worked only in generalizations does not have the ability to carry the particular very far. Having done much, it is easy to do less. Having done little, it is difficult to do more.

What is perhaps most difficult is to maintain a balance between the general and the particular. An extreme emphasis on the general produces a "soft" style. If too much is left out, all that remains is mostly a description of an intellectual principle, a sort of unmanifested idea. When the general is not deeply understood, and all the emphasis is on describing particular detail, the style becomes finicky and excessively hard. If a picture is too generalized, there is not much to hold the attention. There is not enough depth, and the picture gives up all its secrets too quickly. Artists who concentrate heavily on great detail most often lack an understanding of the underlying unifying general principles. They are often weak on the relationships between things.

Most rare in art is a style where the general is beautifully balanced by the particular. The general and the specific are manifested through each other. Works that show this understanding have a great breadth of vision. They are not mean-spirited, tense, or constrained. Like nature, they give us the sense of limitless multiplicity in harmonious, unified balance. They suggest the vastness of air and space, broad, full, and expansive. Without being overly sweet, they give a sense of amplitude, of a grandeur of outlook. Artists of this caliber seem identified with something profoundly natural. Their work is not fussy. The eye travels unimpeded over the surface of their pictures. This freedom of the eye gives us a sense of deep well-being. The imagination of such artists is big enough to hold the entire world of forms. In this acceptance we feel a largeness, a generosity of spirit. In these artists we sense the existence of a universal substratum, out of which, or as a vibration of which, all multiplicity has arisen. These artists know that what the Chinese call "the ten thousand things" are not different from the One.

The artist whose understanding is as broad as all of nature seems to hold in his or her hands the whole world of forms and to be able to spin it out at will

with great grace of execution, like silk from the body of the spider. For such an artist, nothing presented to the visual field is inherently more difficult than any other thing. Like a brilliant improvisational pianist, the artist has at his or her fingertips the ability to create form and light. The process of perception is open to receive whatever passes through the field of vision. When the artist gives up ego-centered symbolisms and identifies with the process of perception, the mind becomes mirrorlike, able to reflect and suggest all visual phenomena.

AN ART WITHOUT PREJUDICE

As people have observed for millennia, there is little point in discussing the relative values of tastes and styles. They are all different. All preferences arise from deeply individual and subjective depths and motivations. What has been presented in this book is but one approach among an infinity of possible others.

As a way of suggesting what is seen—the visual field—in its purest form, this approach is an art without prejudice for any one particular kind of effect. In this style, we must learn to try to set aside any bias in one direction or another in order to accept openly whatever presents itself to our sight. We try not to harbor, deep in the psyche, any hidden preferences for a certain "look" to nature. We try to avoid softening the appearance of the world just as we try to avoid making it too harsh. We try to get it as just, as true as possible. We try equally to avoid creating a picture-world that is either too dark or too light. We try to exactly suggest the look of life. We try to avoid the temptations toward clever but untrue effects. We do not allow ourselves to let stand on the picture surface a tonality that can be made truer. We do not knowingly lie. We must avoid attachments to stylistic exaggerations such as too-shiny highlights, excessive chromatic variations, and overdoses of alternating warm and cool. We remain on the alert against the insidious tendency to stylize or symbolize our way of suggesting the effects of light. We recognize that this suggestion can always be improved upon. We must be ever careful not to transfer to light itself our tendency to symbolize. As we move away from the suggestion of the word-symbol for things, toward the suggestion of things as visual effects, we must be careful not to stylize light. In this approach, we do not want to paint a sort of personalized light. Remember, visual perception does not look like any style of painting.

In fact, every time we come to some conclusion about how the world looks, if we then ask, "But does it really look like what I have put down?" I think we will always be able to answer, "Not quite." Knowingly or unknowingly, our innate preferences will intrude. In its purest form, however, the beautiful ideal of this style will always be "Not this, not that," that is to say, always something between whatever we can describe. There is something beautifully crystalline in this striving toward a way of accepting our experience, with no opinion one way or the other attached to it. In this conception, the eye registers effects of light without adding any verbal qualifications. This is like a perfect mirror-view. By identifying with this process of perception, our mentality too should become mirrorlike. Our perception of life will be purified of symbolic attachments. We can be liberated from the bondage of thoughts always linked to words. Our awareness will be balanced between identification with the process of perception and its so-called objects of perception. We will pay equal attention to the process of vision and to the model. When we balance our identifications in this way, we realize that consciousness exists in the form of objects and that objects are but movements of consciousness. This parallels the interdependence of light and form. Our art will then suggest the interchangeability of seer, seen, and seeing. At this level, the nature of the artist becomes like water, accommodating perfectly to the shape of whatever it is focused upon.

The way of suggesting the seen world that has been described here can be used either as an end in itself or as a vocabulary for the expression of other intentions. As a vocabulary, it trains the artist to convincingly suggest light and form—what the eye sees. It is a consistent way of creating a harmoniously orchestrated painted world. Using this method, we can paint or draw whatever we see. It is universally applicable, so we do not have to learn "how to paint portraits," "how to draw hands," or "how to paint flowers." We learn an equivalent for sight itself.

Once the vocabulary has been learned, we will then be able to "speak" in any accent or dialect. When we have a sure grasp of the actions of light on form, we will be free to apply our knowledge

MURALS OF THE SEASONS, acrylic, 10' high. Mes Illusions, France. Photography by Bernard Mazeau.

I would like to transform my house in France into a magical, illusionistic place. All the mural work is done from imagination, and the various areas and rooms in the house are designed as a unified conception throughout.

STAIRWAY MURAL

SUMMER

WINTER

SPRING

MURAL,
acrylic, 1978.
Maestro Cafe, New York. NY

Since this cafe is situated near Philharmonic Hall, I wanted the mural to convey an immediate message about both music and New York City. The mural is an illusionistic continuation of the actual cafe, beginning with the painted steps at the bottom and continuing within the actual arch. The architect, Ira Grandberg, designed this shape for a mural painting. It is a focal point of the space and attracts notice from passersby on the street, since it can be seen through a glass wall.

either broadly or in great detail. We will, in fact, be free to stylize in any manner we choose. We will be able to exaggerate knowingly in any direction. Of course, some may wish to throw the whole approach away and explore in a different direction. Many artists use the knowledge of light on form in combination with quite different—even opposite—styles. These are all questions of personal preference. When it comes to taste, everyone is his or her own master. The artist who decides to base the style in some manner on light—and this applies to the photographer or cinematographer—will have at his or her disposal a vast multiplicity of possible conditions and effects. No matter what the medium, the artist will be able to play upon a keyboard of light effects from which any mood or emotional coloration can be drawn. This keyboard or vocabulary can be put to the service of any personal expression.

The deep understanding of light on form gives us a tremendous freedom. What we all want is the least possible interference between conception and execution. Ideally, in fact, they ought to be unified. We should be able to envision our picture world in terms of the medium. We should be able to execute our vision in the medium without impediment. If the struggle to suggest the multiplicity of forms is too difficult, we feel choked, unable to get our vision down, unable to express ourselves. Rather than inhibiting the freedom of expression, the mastery of a form frees us. Light shows us how to paint anything. Imagine the freedom of feeling competent to suggest any texture you may wish—skin, hair, glass, wood, peeling paint on wood, fur, fabrics, pitted stones, trees, light, flowers, bread, whatever in the world you want! Master light and you own the world of forms!

You may use this approach as an end in itself. In that case, the artwork is the expression of the mirrorlike attitude of mind. The pictures are reflections from this mirror mentality. This free, nonsymbolic approach to life is the deep message contained in the art. We could say that the style *is* the meaning. The work of art expresses the nature of the artist. By trying to follow the light, artists transform their relationship to their own experience of life. As much as the artist creates the art, it could be said that the art is creating the artist. As the artist perfects the technique, the pursuit of that perfection refines the artist. The practice of following light deeply transforms our

most fundamental conceptions. As we identify ourselves more with light, we are progressively forced to discard all opinions about what life looks like. It feels as if obscuring veils are successively peeled from our vision. When we keep looking at light, we necessarily lose a lot of very murky, turgid, negative self-imposed roles. The study of light transforms the artist.

LISTEN TO THE VOICE OF LIGHT!

"What else is there, earth person, but light? Do not be deceived. Look deep into the nature of all things. All those things you name with words—what are they actually? What are they made of? They are modulations of my vibration. You have many words, but they all come back to me! Movement, vibration, heat, sound, life, matter and nonmatter, consciousness—they are all modalities of light. Just as form cannot be seen without light, nor light without form, my vibration exists in the form of things. There is nothing not made of me, and I am manifest in the shape of things.

"Love me, and you will become part of all things. As you read this, remember that words, page, book, table, thoughts, are all burning with my power, my energy. This is my hidden nature. Openly (for all the world to see!) I am the light by which things become visible to you. Your little sunstar burns with me. When your film of cloud opens, whatever on your ball of earth turns its face to me, becomes radiant and warm. Without me there is frozen blackness. Whatever I touch shines with my light and heat, color and vibration. What is deprived of my direct touch remains cooled and darkened. If you want to paint my portrait, make your image vibrate with my cosmic power. When I am strong, show my strength. Where I am manifested weakly, capture my subtleties. I am powerful as light and powerful as darkness. Capture the two sides of my nature. Artist, I am light. If you are going to paint me, forget your petty ideas about this and that. Open your heart to my splendor. I am the sun, but I am also the flare of a match, the flicker of the candle, and the energy passing through all your illuminating devices. My friend, you cannot escape me! I am, too, the light of your mind and dreams. Perhaps for me you are an illuminating device through which I pass!

"But let me tell you, if you concentrate on seeing my presence everywhere, all things will become extraordinarily beautiful. Nothing is more beautiful than light. If you look only at things as named objects, you fail to notice my shimmering presence. What you may name the ugliest piece of junk becomes my radiance and color, my incomparable beauty, when you look for my presence. I am beautiful because I am life! I am the essence of your being, your own light of consciousness. I energize and sustain you within and without. All your colors, artist, are gifts from me. To become one with me is ecstasy. Drink in my being, my nature. Let yourself become intoxicated with my beauty.

"Artist, if you choose to follow me, show my face to your world. With my beauty, my effulgence, my power of life, lift the hearts of your people on earth. As I do, nourish them with my color. Show humanity the beauty of its garden of earth. Just think, light is never ugly! I exist, and I shine upon what you call the sordid and the noble. But I am the burning movement of life, everywhere, in and on all things. If you want to paint my face, paint life.

"Don't pay attention to the poor fool who had the pretension to write a book about me. Throw it away! What can he know, really, of my nature? You don't need his little collection of words, his confusions. Look at me! That's all you need. Look for me in your mind, in your feelings, and shining on all the leaves. Feel me. Experience me. What are all your emotions for, if not to feel? Use them! Yes artist, love me. What else is your art good for, if not to love? Is not love becoming one with your beloved? You too, confused author of pictures, forget your piddling egocentric separations. Why are you trying so hard to put things in cubbyholes? You and them. Inside and outside. Mental and physical. Your pigeonholing is giving me a headache! Open your eyes. Open your head. Open your heart. Wake up. You will see only me."

MURAL DECORATIONS,
acrylic (frames painted in trompe l'oeil), 1978.
Le Restaurant, Regency Hotel, New York, NY.

It is interesting to combine trompe l'oeil elements with other styles. The two set each other off, which emphasizes their differences. The combination also creates curious spatial relationships.

INDEX

Edited by Brigid A. Mast
Designed by Bob Fillie